Origins of the
RUSSIAN AVANT-GARDE

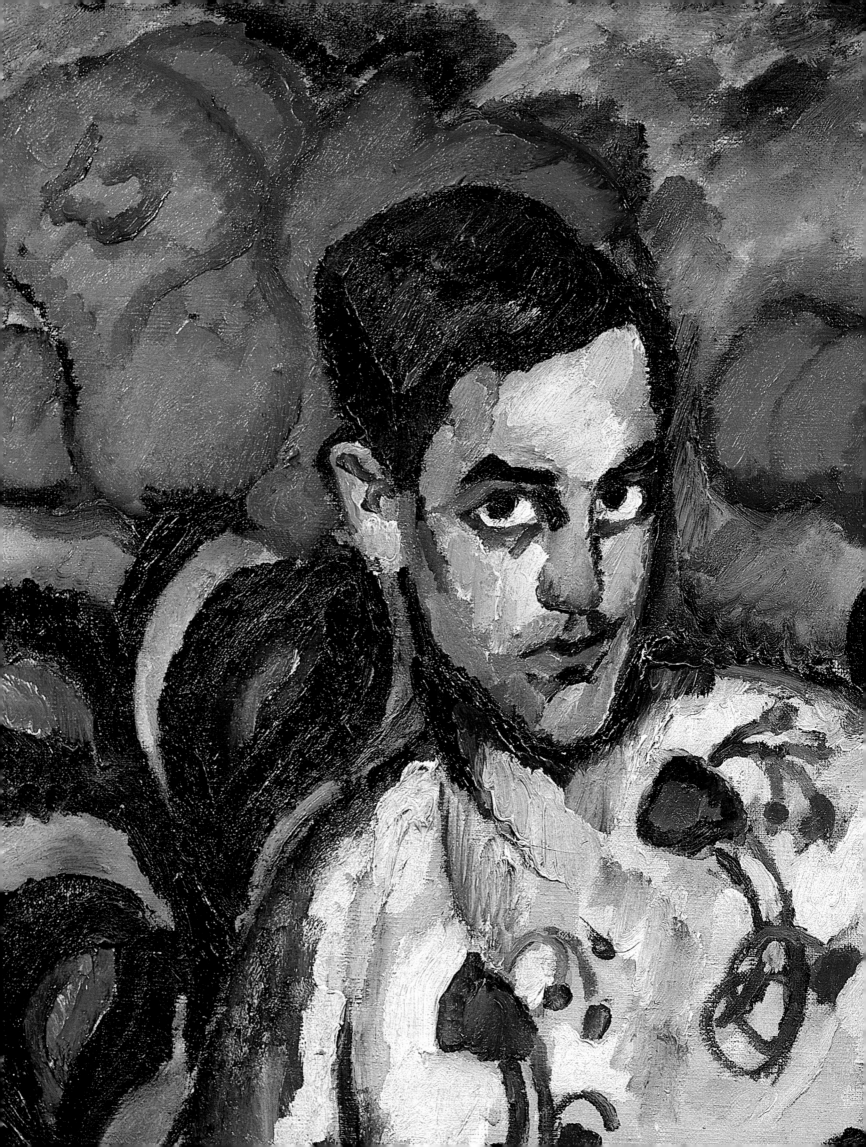

the state russian museum
st. petersburg

in collaboration with
the russian avant-garde
foundation

ORIGINS

OF THE

RUSSIAN AVANT-GARDE

celebrating the 300th anniversary
of st. petersburg

the walters art museum, baltimore
13 february – 25 may 2003

fine arts museums of san francisco
29 june – 21 september 2003

palace editions

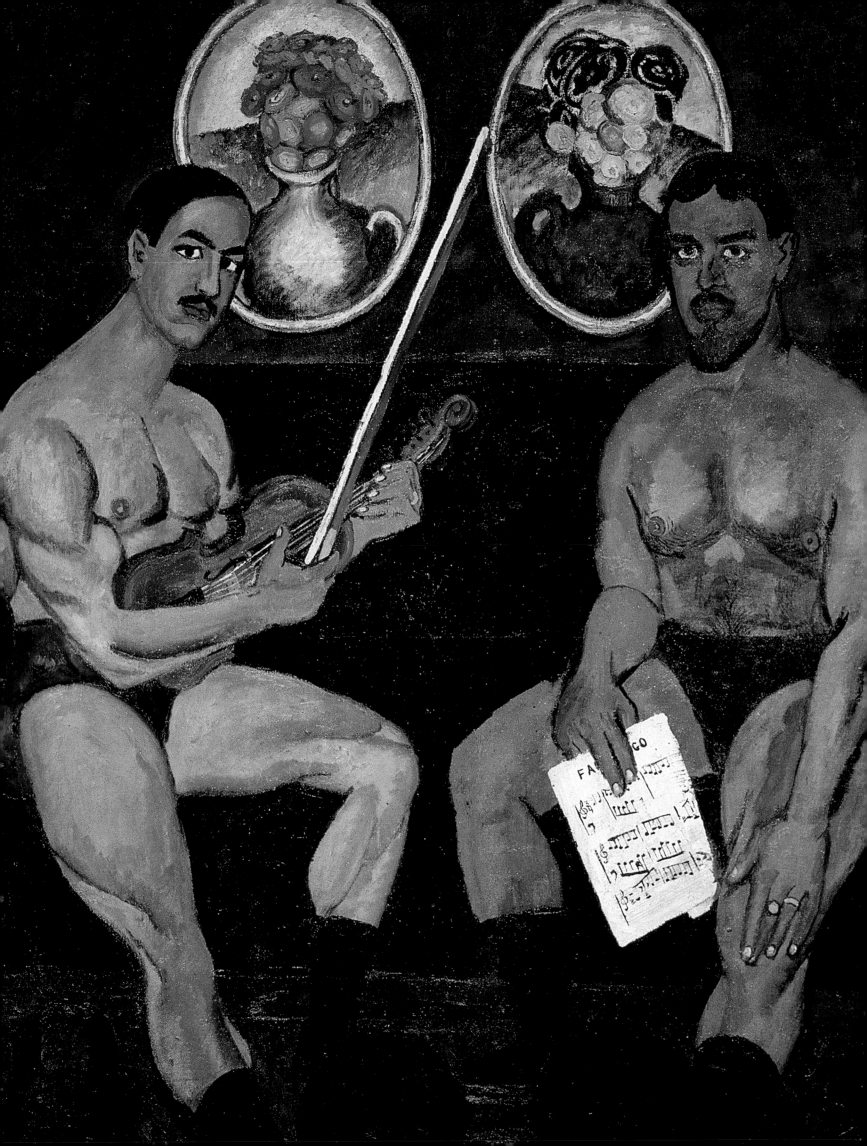

CONTENTS

5

Foreword

Gary Vikan

7

The Origins of Early Twentieth-Century Russian Art

Yevgenia Petrova

27

The "New Barbarians"

Nicoletta Misler and John E. Bowlt

47

The Creators of Neo-Primitivism in Their Own Words

Elena Basner

57

Globalization with a Russian Edge:
Russian Avant-Gardists and Peasant Village Culture

S. Frederick Starr

65

Folk Art and the Artists of the Russian Avant-Garde

Irina Boguslavskaya

69

Catalogue of the Exhibition

215

Artist Biographies

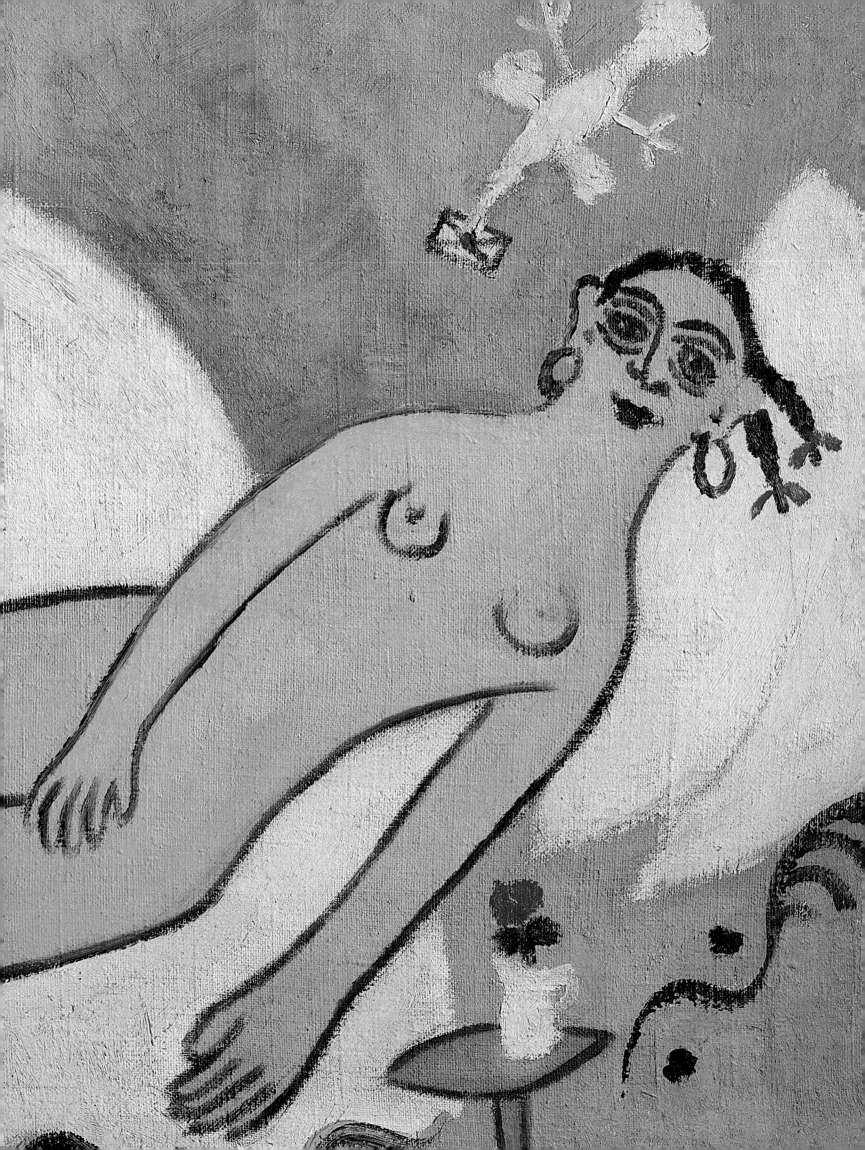

FOREWORD

The Walters Art Museum was, perhaps, not the predictable venue for an exhibition on the Russian avant-garde. While the museum's collection spans fifty-five centuries of art, its holdings essentially end right around the period when the Russian avant-garde movement began. But the Walters has always been the museum one thinks of for its innovative and scholarly exhibitions. So, it was with particular delight that we welcomed the opportunity to break new ground with this fascinating project. My own love of things Russian and of the beautiful city of St. Petersburg has only increased because of it. And, indeed, this celebration of Russian art has been assembled as part of the festivities throughout the city of Baltimore to mark the 300th anniversary of St. Petersburg. This Russian capital, founded by Peter the Great in 1703, has a rich tradition of art, culture, and cultural institutions like the State Russian Museum, our partners in this exhibition, and the Walters is pleased to bring some of the museum's most exceptional works to the United States.

The planning of this show and our research trips to St. Petersburg were made even more spectacular through the generosity and hospitality of the State Russian Museum, especially Yevgenia Petrova, curator of the exhibition and Deputy Director of Academic Research, who spent many hours with us selecting the objects and teaching us about the richness of Russian folk art. The result, we hope, is an exhibition that succeeds in enlightening our audience about the free play between high and low cultural forms during the pivotal, early decades of the twentieth century in Russia. The show features the works of Kandinsky, Malevich, and Goncharova, but also the lesser-known Konchalovsky, Lentulov, and Shterenberg. All of these irrepressible creative minds that constituted the Russian avant-garde fed off of the visual stimulus provided by these humble, colorful objects of their own collective past. If Cézanne and Gauguin, Picasso, and Braque impressed them, so, too, did the already abstract, "primitive" appearance of traditional icons, signboards, and *lubok* prints of their native land.

Any project of this scope consumes the energies of many individuals. In particular, I would like to reiterate my thanks to Dr. Petrova, without whom this exhibit could not have taken place. I would also like to acknowledge the other catalogue essayists, Elena Basner, Irina Boguslavskaya, John E. Bowlt, Nicoletta Misler, S. Frederick Starr, and all of the contributors. I am also grateful to Joseph Kiblitsky and the entire staff of Palace Editions for their work on the catalogue. All members of the Walters Art Museum staff have contributed to the success of this exhibition, including Johanna Biehler, Elizabeth Gordon, Eric Gordon, Deborah Horowitz, Eik Kahng, John Klink, Paula Millet, Catherine Pierre, Joan-Elisabeth Reid, Susan Wallace, Ann Wilson, and Nancy Zinn. Thanks also to Gregory Guroff, President of the Foundation for International Arts and Education, who facilitated our collaboration with the State Russian Museum. And finally, the Walters would like to express its gratitude to the Trust for Mutual Understanding, whose generosity allowed the research and coordination necessary for this exciting collaboration.

Gary Vikan
Director, The Walters Art Museum

THE ORIGINS OF EARLY TWENTIETH-CENTURY RUSSIAN ART

Yevgenia Petrova

Artists adhering to the modernist notion of truth to materials at the start of the twentieth century were united by a common mission to return to simple and organic forms, as well as a common desire to purify art of its narrative element. The widespread interest in primitive art was a logical consequence of this phenomenon. The wave of Neo-Primitivism, however, did not begin in Russia. Emulating the works of primitive peoples, Paul Gauguin, Amedeo Modigliani, Pablo Picasso, and other modern artists showed the world the new paths that art could follow.

Early twentieth-century Russian artists traveled widely, acquiring first-hand knowledge of the new developments taking place in western art. Many Russians became well acquainted with the primitive art of Africa and traditional Chinese, Persian, and Japanese prints. Unlike European artists, however, who sought inspiration from foreign sources — including African, Mexican, Egyptian, Chinese, and others — Russian artists mostly confined their attention to their own rich treasures of primitive art. The reasons why Russian culture returned to its own indigenous roots in the late nineteenth and early twentieth centuries lie in the special history of these traditions.

Most European countries revered the art of their own past. In Russia, the situation was slightly different. Prior to the westernizing reforms of Peter the Great in the early eighteenth century, there had been no secular art in Russia. For almost seven hundred years, Russian art had been confined to icons, religious objects, and domestic utensils. Since the tenth century, when Russia accepted Christianity, most people had regarded icons purely as objects of worship. Only a few prized these works as aesthetic objects. [1]

In Russia, the peasantry had always constituted the vast majority of the population and even life in provincial towns was more rural than urban. Objects made by neighbors, relatives, or bought at markets in nearby villages — decorated trays, embroidered towels and clothes, wooden and clay toys — were passed down from generation to generation, eventually making their way from peasant huts into urban apartments. Such items were part of everyday life for many Russians, right up to modern times. As so often happens, the aesthetic qualities of such works ceased to be noticed or appreciated; they were perceived purely as utilitarian objects.

This is not to imply that folk traditions were little known or remained unexamined prior to the early twentieth century. Throughout the nineteenth century, books were published on the various peoples of the Russian Empire and their ways of life, national dress, and customs. Archaeological discoveries and ancient works of architecture were a popular subject of study. [2] The pinnacle of professional interest in

Russian national culture, however, came in the late nineteenth century, with the formation of the Abramtsevo circle at Savva Mamontov's estate outside Moscow.[3] The turn of the century saw the appearance of Andrei Ryabushkin's nostalgic and slightly ironic images of seventeenth-century Russian merchants and the "heroic storytale" or *bylina* canvases of Mikhail Vrubel, Victor Vasnetsov, and Nicholas Roerich, which extolled ancient Slavs.

This new focus stimulated popular interest in Russian history, mythology, and traditions. Such artists as Philipp Malyavin were not so much interested in the actual subjects of Old Russia as the need to capture what they regarded as the inherent, primordial energy and vigor of the Russian people. A former monk, Malyavin made a number of trips to Ryazan province at the start of the twentieth century. His travels spawned a series of paintings full of tumultuous movement and color. His "wild" motifs and style of painting predate even the French Fauvists.

When addressing Russian folk life, such artists as Malyavin, Roerich, Vasnetsov, and Ryabushkin did so in forms traditional for the nineteenth century. They did not go so far as to employ the actual media and techniques of folk art itself. Rather they appropriated the bright colors and graphic use of line commonly found in these traditional objects.

This seminal change in the relationship between folk and fine art only occurred in the late 1900s and early 1910s, when many artists began to regard the work of native craftsmen as worthy of artistic interpretation. The result was an entire artistic movement known as Neo-Primitivism.

The Russian Neo-Primitive artists did not regard themselves as an organized group or school; their oeuvres were far too diverse. While folk art was the source of inspiration for many artists, it was not interpreted in a uniform manner. The concept of folk art encompassed archaic works, objects created by various nationalities in the eighteenth and nineteenth centuries, children's drawings, works by amateur painters, sculptors, and graphic artists, and even the creations of non-Russian artists.

Wassily Kandinsky left a vivid record of his original impressions of Russian folk life. Traveling as a student in Vologda province, he paid close attention to the appearance of the peasantry: "I entered villages where the people had yellow-gray faces and hair, and were dressed from head to toe in similar yellow-gray clothes. Others had white faces, rosy cheeks, and black hair, and were dressed in such vibrant and motley tones that they looked like moving pictures."[4] The artist goes on to describe his visit to a traditional Russian wooden house, an event that remained forever etched in his memory and was to be of enormous significance for his work: "I can still remember entering the hut for the first time and standing still before the unexpected image. The table, the benches, the stove, the cupboards, and every kind of object was painted and decorated with grand, multicolored images. On the walls were popular motifs: the symbolic representation of a hero, a battle, images illustrating a popular song. The

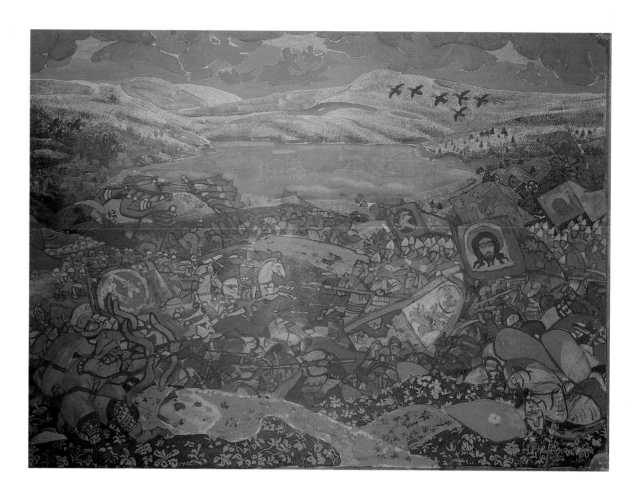

'red corner'[5] covered densely with images of the saints, painted and printed, and, before them, the shining red icon-lamp…. When I finally left the chamber, the painting enfolded me and I entered it."[6] Kandinsky's passion for the folk art of Russia and, later, Germany and other nations, made a major contribution to his oeuvre. This appreciation influenced his choice of subjects (St. George and images of Muscovy), his color schemes, and his compositions.

Kandinsky's compatriots soon discovered other sources of primitive creativity. Natalia Goncharova, for example, was drawn to the expressive power of Scythian sculptures, which she saw for the first time in the 1900s. She recognized that these archaic statues had inspired the European Cubists. Goncharova wrote in 1912: "Cubism is a fine thing, only nothing new. The Scythian stone stele and the painted wooden dolls sold at Russian fairs are also made in the Cubist style."[7] Such parallels may help explain the attraction Russian artists had for Cubism, and Futurism, before disavowing the influence of such movements in favor of their own, unique creative styles. The Russian avant-garde was more interested in rediscovering its own rich national culture, rather than merely imitating Fauvism, Cubism, and other western movements.

Many early twentieth-century artists collected works of folk art. Mikhail Larionov and Goncharova owned an impressive collection of icons, stone sculptures, *lubok* prints, and clay and wooden toys. Kazimir Malevich, Wassily Kandinsky, and Olga Rozanova also collected primitive works. Brothers Ilya and Kirill Zdanevich discovered self-taught artist Niko Pirosmani in Georgia in 1912. The following year, Mikhail Larionov held an *Exhibition of Icon-Painting Originals and Lubok* in Moscow, displaying 129 works from his own collection. Larionov also organised the *Target* exhibition in 1913, displaying children's drawings, signboards, and pictures by anonymous and Naïve artists alongside his own

works and those of Goncharova, Malevich, and other artists. Also exhibited were pictures by Larionov's younger brother Ivan. Although painted in the final years of the nineteenth century, the simplicity and monumentality of Ivan's oeuvre have much in common with the avant-garde.

Andrei Rublev's important icon, *The Trinity* (Tretyakov Gallery, Moscow) was restored at the beginning of the twentieth century. When it was put back on view in 1912, the public was stunned by its beauty, perfect tones, and rhythmic composition. The following year, Nikolai Likhachev donated his enormous collection of icons to the Russian Museum in St. Petersburg. The Russian press widely covered all these events, creating a growing army of connoisseurs of folk art.

When Henri Matisse visited Russia in 1911, he was particularly inspired by the icons he saw there. The leader of the Fauvists noted that with such outstanding national art at home, there was no need for Russian artists to travel abroad. The early 1910s were indeed the golden age of Neo-Primitivism in Russian art. The assimilation and interpretation of primitive traditions, however, can be traced back another decade.

Goncharova and Larionov were the first Russian artists to reject the conventional means of depicting the world. The distorted proportions of the figures, identical faces, and bright tones of Goncharova's works of the late 1900s emulate the artistic style of the wood carvings and decorative painted distaffs, toys, and the doors and window frames of houses.

Goncharova created scenes of rural life as though she were a part of peasant life herself. The massive form of the woman in the foreground of *Bleaching Canvas* recalls a stone sculpture. The black, white, and pink brush strokes representing the folds of the fabric in *Drying Laundry* echo the white strokes of paint (*probely*) on icons. The austere tree trunks in *Winter* imitate the *ajour* fretwork on distaffs and dec-

orative window frames. The thick, icon-like contours of the figures, the repetition of attire and physical appearance, and the pure red and white planes in *Peasants* do not distract from the most important element — the slow and rhythmic movement of the workers carrying grapes on their heads.

Addressing religious subjects in her *Evangelists* cycle in 1911, Goncharova cleansed her images of the academic subjects and high finish commonly encountered in works commissioned by the Orthodox Church at that time. Goncharova's *Evangelists* are more like wooden sculptures of sublime and spiritual ascetics. A deeply religious woman, Goncharova created primordial works that reached out directly to the human soul. This was so unusual that the authorities presumed the paintings to be a deliberate avant-garde provocation and ordered the removal of the *Evangelists* and several other works from the artist's one-woman show in 1912.

The return to national traditions was not always understood by the artistic, religious, and secular authorities. Mainstream society compared the simple motifs, compositions, and color schemes of folk art unfavorably to academic art. Folk creativity seemed too brutal and unworthy of the attention of "civilized" connoisseurs of art. The avant-garde, however, was undaunted. In their battle against the salon culture of the period, the artists of the 1900s and early 1910s regarded traditional folk art as both their weapon and their shield.

The avant-garde artists did not have a common program. Each artist found his or her own theme and stylistics. A confederate and Goncharova's future husband, Larionov followed other traditions, focusing on urban street culture. The artist was inspired by the advertisements and signboards hanging outside stores and workshops, painted by artisans who had never received any formal training. Larionov mimicked the works of these amateur artists, poking fun at their naïve attempts to copy professional masters and offering an original, new version of these prototypes.

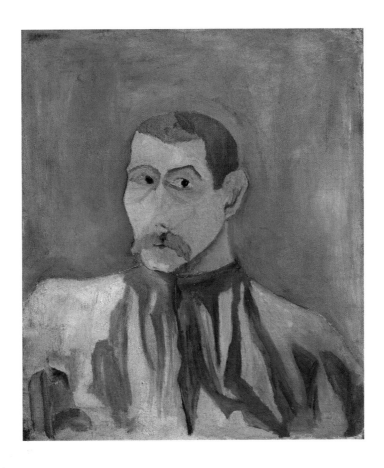

Larionov's *Barber* series evokes associations with the songs performed by traveling minstrels and the signboards hanging outside barbershops. The paintings depict amusing situations that arise when traditional roles are suddenly reversed, and the humble barber controls the fate of an officer or man of higher standing. Larionov wanted to capture the frivolous and unpredictable essence of life, in which unexpected changes are always possible. Utilizing the stereotypes of urban advertising, the artist breathed new life into its standard forms.

Similarly, in 1912, Larionov worked on his *Venus* series. The artist depicted nudes in much the same way as they were drawn on fences or the floor-cloths sold at markets. Rejecting the idealized forms of classical art in favor of unsophisticated spontaneity, Larionov's *Venuses* were often accompanied by inscriptions imitating the unskilled hand of an illiterate author and by censorious expressions. Such aspects of Larionov's paintings and drawings were another common example of urban folklore's contribution to the works of the Neo-Primitive artists.

Larionov introduced fun, games, and irony into art, ranking them equally with other means of artistic expression. Reinterpreted by the avant-garde artists, the aesthetics of the simple and the "artless" appeared in Russian culture in the late 1900s and early 1910s, overturning traditional ideas of what was permissible and what was not. Both Larionov and Goncharova were convinced of the merits of what they called "Eastern" art, and, indeed, the diverse forms and interpretations of folk sources inspired many Russian artists.

An exhibition with the unusual title of *Jack of Diamonds* opened in Moscow in 1910. This name was dreamt up by Mikhail Larionov as a direct contrast to the prevalent fashion for such Romantic or Symbolist names as *Blue Rose*, *Wreath*, and *Stephanos*. Like the French *Valet de carreau*, *Jack of Diamonds* means a rogue or swindler in Russian. Larionov's title for the show thus prepared the public for a

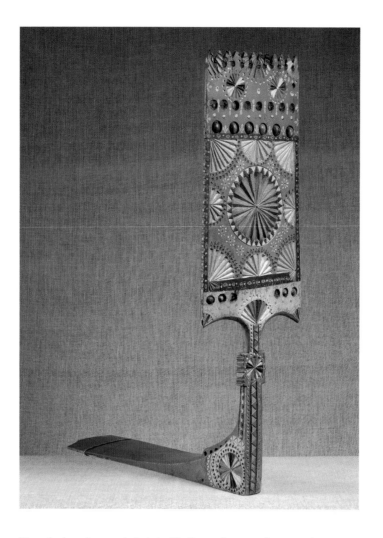

series of ironic and provocative exhibits. And as, besides icons, Larionov also collected toys and such examples of urban folk art as *lubok* prints and hand-painted playing cards, the exhibition heralded the introduction of card games — one of the most popular urban pastimes — into Russian art life. Larionov later introduced a military term into national art usage when he curated the *Target* exhibition in 1913.

The various artists united around the *Jack of Diamonds* group were particularly active between 1910 and 1913. The leading members of the society — Larionov, Goncharova, Ilya Mashkov, Pyotr Konchalovsky, and Aristarkh Lentulov — advocated a return to the primeval "barbarity" of primitive art, as exemplified by such non-professional artists as children and amateur craftsmen.

Ilya Mashkov's *Self-Portrait with Pyotr Konchalovsky* was one of the works shown at the first *Jack of Diamonds* exhibition. Mashkov's controversial painting closely corresponded to what Larionov was doing in his own *Barbers*, *Soldier*, and *Venus* series. *Self-Portrait with Pyotr Konchalovsky* manages, however, to take Larionov and Goncharova's interests one step further. Mashkov parodies his fellow intellectuals and their susceptibility to such prevailing fashions as Post-Impressionism, sport, music, and cinema. The artist brings together direct opposites in *Self-Portrait with Pyotr Konchalovsky*. Two refined members of the creative intelligentsia are depicted in an unusual setting. Virtually naked, they play music in between sporting activities. The muscles, tones, and proportions of their bodies are exaggerated and even slightly caricatured. The titles on the spines of the books — Cézanne and Bible — would appear to reflect the refined tastes of their owners, yet are contradicted by the vulgar pictures on the walls.

The scale of this painting, the exaggerated figures of the two artists, the simple painting style, the similarity to such fairground-style movies of the 1910s as Max Linder's popular film *Max Boxing*,[8] and the clear reference to the fashion for snapshots in frozen poses against exotic backgrounds were revolutionary new developments for Russian painting. The brutal frankness and the uniqueness of the composition — a self-portrait with a fellow artist — betray its key importance for Mashkov.

In the late 1900s, Mashkov and Konchalovsky switched their personal allegiances from Cézanne to Russian folk and urban traditions. Mashkov, Konchalovsky, and Lentulov, the artists who consti-

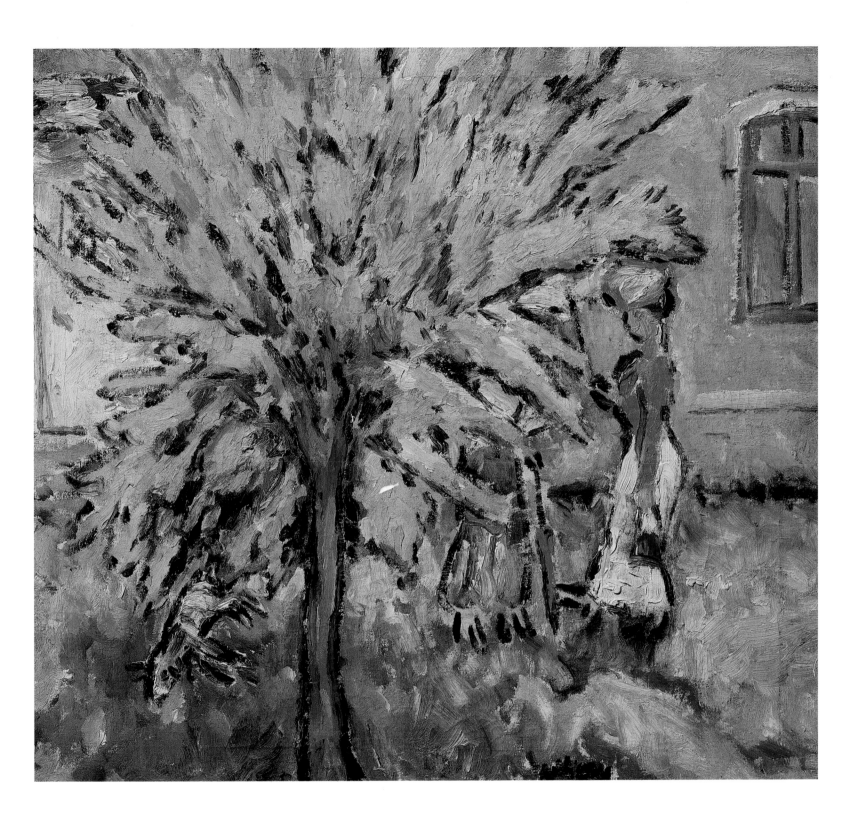

Mikhail Larionov
Tree. Mid-1900s

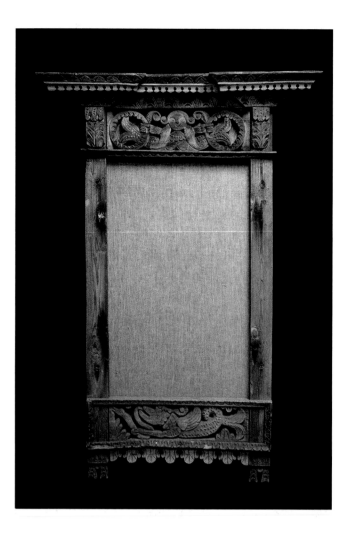

Carved window from peasant hut. Late 19th–early 20th century

tuted the nucleus of the *Jack of Diamonds* group, began to paint still lifes and landscapes in which the texture, color, and form were inspired by the painted designs on traditional trays, signboards, and wooden and clay toys.

The creative output of the *Jack of Diamonds* artists include many works clearly reflecting the original sources. Mashkov's *Still Life with Loaves*, for example, has much in common with the signboards hanging outside bakeries. The prop-like objects become the *dramatis personae* of the artist's rich and lighthearted world. Lentulov's churches and cathedrals also come to life, their forms seemingly swaying in rhythm. The festive attitude advocated by the *Jack of Diamonds* group is especially discernible in the oeuvre of this particular master, who employed such rich and vivid tones as crimson in his *Self-Portrait*.

Mashkov's *Portrait of a Boy in a Flowered Shirt* reveals the artist's enthusiasm for traditional Russian painted fretwork. Like Lentulov's *Self-Portrait* and the works of many other members of the group, *Portrait of a Boy in a Flowered Shirt* is not merely stylization. Just as the ancient world became the model and ideal for the artists of the Renaissance and the Neoclassical period, so folk creativity was assimilated and transformed by the Russian Neo-Primitives. They elevated national traditions into ancient myths. Aestheticizing the naïve, the *Jack of Diamonds* artists created a new form of art in various different genres.

This trend of Neo-Primitivism was closely linked to the Futurist movement in Russia. The provocative behavior of the Futurists—painted faces, promenades with wooden spoons in their jacket pockets and buttonholes—were all deliberate gestures recalling the traditions of the fairground, circus, and fair. The deliberate coarseness and primitivization of artistic devices and the choice of motifs—either closely linked to everyday life or exaggerating its simplicity—can also be traced back to folk traditions.

Besides their provocative and innovative canvases, the Futurists also revolutionized the aesthetics of book illustration and graphic art in general. The refined scenes of the Symbolist period gave way to an essentially new graphic culture in the books of David and Vladimir Burliuk, Natalia Goncharova, Mikhail Larionov, and Olga Rozanova in the early 1910s. The illustrations ceased to "relate" or embellish the text; they acted as an accompaniment to the narrative itself in rhythm and in tone. The artistic images often were independent of and began to dominate the text, themselves becoming active carriers of meaning.

Exploring the traditions of Old Russian books and their hand-written texts and drawings, the Futurist artists imitated these historical manuscripts in their graphic art of the 1910s. Published in limited editions, the lithographic images were frequently painted by hand. The texts were often written by the authors themselves or typed using children's printing sets, contributing to the uniqueness of the book or sheet. The spontaneous and even somewhat brutal images of the Futurist works returned book design and graphic art to their original sources—the wall paintings made since the beginning of time.

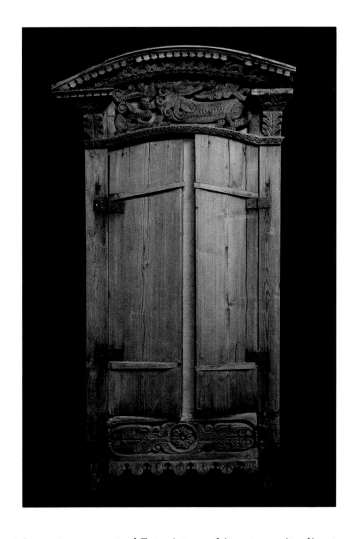

These Futurist books and graphic art played an important role in the history of the Russian avant-garde. The most important aspect of Futurist graphic art was its direct relationship with folk sources. Many Russian artists engaged in their first avant-garde experiments in book design, going on to develop and embellish these ideas in their painting.

Olga Rozanova introduced the concept of "transformed color" into early twentieth-century art. In practice, this implied the light-bearing attributes of color. Working in her own unique style, the artist transformed her childhood impressions of the painting of Andrei Rublev, seen in the Cathedral of the Dormition in her home town of Vladimir. Rozanova's pictures are noted for their pure and clear tones and the internal energy of the colors, recalling frescoes, icons, and wooden and ceramic figurines.

Pavel Filonov also displayed a clear love of folk art. The coarsely outlined hands and feet and "chopped-off" figures in many of his paintings are similar to the wood carvings and forms created by folk craftsmen. The sources of Filonov's inspiration can be easily spotted in several works; for example, painted toys, distaffs, and sledges appear in *Shrovetide*. In other paintings—*Dairy Maids* and *The Holy Family*—the composition, motif, and color scheme evoke associations with peasant back yards, with their steeds, cows, hens, shrubs, and wildflowers. The fractured nature of many of Filonov's canvases are like the images in a kaleidoscope or the bright, multicoloured rugs and mats found in Russian villages and small provincial towns.

The oeuvres of such masters as Kuzma Petrov-Vodkin and Vladimir Tatlin reflect a slightly different relationship with folk art. Developing his unique style, the former was inspired by the Russian icon, with its predominant tones of red, yellow, and green. Icons are clearly the source of such paint-

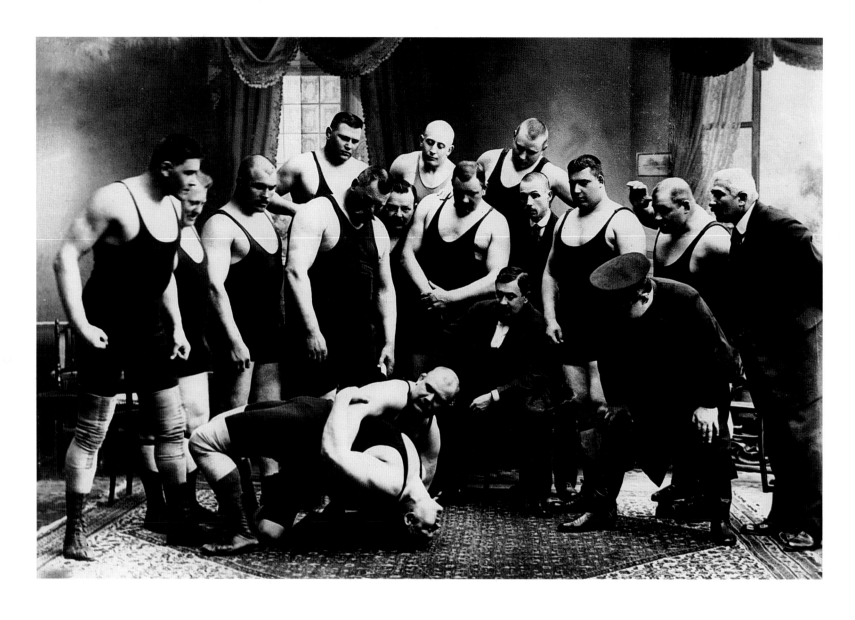

ings as *The Mother of God of Tenderness towards Evil Hearts* and *Mother*. Although employing traditional iconographic types, Petrov-Vodkin managed to create a whole new image of womankind as the mother, savior, and keeper of the world during the carnage of the First World War, which broke out in 1914.

Vladimir Tatlin was also active in the 1910s. The future Constructivist widely utilised the color red in such works as *Artist's Model* and sharp "hewn" forms recalling wood carvings in *Sailor*.

A contemporary and rival of Tatlin, Kazimir Malevich was inspired by folk art at virtually every stage of his career. In his autobiography, the artist writes: "I did not proceed further along the line of antiquity, of the Renaissance or of the *peredvizhniki*. I remained on the side of peasant art and began painting pictures in the primitive spirit. At first, during the initial period, I imitated icon painting. The second period was purely 'laborious,' i.e., I painted peasants at work, harvesting, and threshing." [8] Although Malevich is referring here to his first and second *Peasant* cycles, his direct and profound link with folk sources and religion are evident throughout his career.

In the mid-1910s, Malevich revealed to the public his concept of Suprematism — a movement destined to enjoy a short, yet exciting life. The term Suprematism derives from the Latin word *supremus*. Malevich, however, understood the concept of "supremacy" in a far broader and more profound context. Likening himself to Christ, the artist regarded his theoretical writings as "new Gospels in art" and himself as a Messiah, called not only to save, but also to transform the world.

At the *0.10. Last Futurist Exhibition* in Petrograd in 1915, Malevich hung his seminal *Black Square* in the corner of one of the rooms, like an icon in a peasant hut. Placing a square, circle, or cross on a white or grayish background, Malevich was returning to the canons of Old Russian art, reinterpreting them in his own original manner. In Russian icons, a light background traditionally symbolised purity, sanctity, and eternity. Black represented the chasm, hell, and darkness. Unlike Russian Orthodox icon painters, however, who illustrated biblical texts, the artist excludes all narrative from his compositions. He minimalizes the images, reducing them to pure forms. Innovative for the twentieth century, the artist's non-objective compositions are nevertheless closely linked to Old Russian meanings.

Malevich monumentalizes the squares, circles, and crosses employed by icon painters in the clothes of the saints, elevating them to the level of independent, multilayered symbols—implying more than just the movement of contemporary art beyond the bounds of "Nothing" or traditional figurative art. Malevich's oeuvre was reclaiming the icon for art, but in a new, updated form. Creating black, red, and white squares, Malevich believed that he had found a way to represent the universe in new forms of art. He was convinced that these forms could help him to construct a new "architecture" or, in other words, a new relationship between man and the world.

Malevich's *Red Square* is a model of the peasant image for the early twentieth century. The artist gave his painting the alternative title of *Painterly Realism of a Peasant Woman in Two Dimensions*. This reflects the artist's quest in the mid-1910s for a synchretic image in which an ideal and a symbol of Russia—the peasant woman—could be presented both simply and monumentally in the new Suprematist form, in much the same way as the Virgin was once depicted in Old Russian icons.

In the late 1920s, Malevich returned to figural painting. The main theme of these works was the Russian peasantry. Although his second *Peasant* cycle was representational, it was not a departure from Suprematism. Malevich's peasants of the late 1920s and early 1930s are non-realistic. They are "universal" people—the same *budetlyane* (people of the future) from the opera *Victory Over the Sun* that launched Suprematism, only cleansed of the elements of buffoonery and the grotesque pervading Malevich's costume designs for the Futurist opera.

Suprematism for Malevich at this time was a means of expressing the new religion and, correspondingly, art. Suprematism for him was a synonym of the new Church, a new faith cleansed of non-spirituality. A new religion, and a new people led by God to a new life—this was Malevich's ideology, expressed by him in several letters to friends and embodied in his second *Peasant* cycle.

For Malevich in the 1920s, Suprematism had become a vehicle for the creation of the artistic environment of this new religion. As the artist himself wrote in the late 1910s: "For many years, I was preoccupied with my movement in painting, discarding the religion of the spirit. Twenty-five years have now passed, and I have returned to or entered the world of religion. I do not know why this has happened. *I visit churches, look at the saints, and the whole active spiritual world; I see in myself and, perhaps, in the whole world, that the time for a new religion has come* [emphasis added]." [10]

Reflecting on religion in a paper entitled *God is Not Cast Down: Art, Church, Factory*, Malevich came to the conclusion that the Church and the Factory—implying the overall organization of a socialist society, with its palaces and clubs—were extremely similar: "The walls of both are decorated with

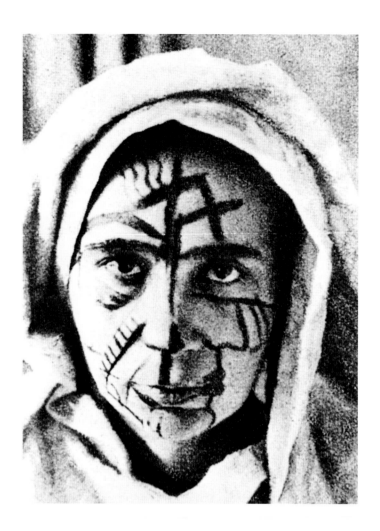

countenances and portraits, also arranged according to merit or rank. Martyrs or heroes exist in both the former and the latter; their names are also listed as saints. There is no difference; on all sides, everything is identical, for the question is identical, the aim is identical, and the meaning is the quest for God." [11] The profound links between Malevich's work and the concepts of church, temple, and religion—themes that constitute the basis of folk life—are evident in such statements.

Like Malevich, other artists continued to derive inspiration from folk art in the 1920s and 1930s. As before, this was communicated differently by each artist. For example, despite the seeming dissimilarity between David Shterenberg's still lifes and icons, they still have much in common in the depiction of the objects without the use of perspective. Like his predecessors, Vladimir Lebedev often employed appliqué (*Laundress*), focusing on embroideries and the signboards hanging outside stores and workshops (*Still Life with Boot*). Yury Vasnetsov was born in the provincial town of Vyatka, which produced its own original folk toys and whistles. The artist imitated their upbeat tones, humor, and simple forms in his genre scenes, still lifes, and book illustrations.

Popular in the art of Kazimir Malevich and the members of his circle, the peasant theme is also apparent in the works of the next generation of artists. Alexei Pakhomov and Vyacheslav Pakulin were two painters whose works clearly reflect the influence of Old Russian frescoes. Recalling the monumental forms of the past, Pakhomov and Pakulin sought a grand style capable of expressing the new realities of life.

The artists of the first three decades of the twentieth century who turned to native folk sources represented various different personalities, movements, and groups. The strength and skill of folk art appear to lie within this very diversity. Folk creativity did not restrict the possibilities of artists; each simply extracted what was closest to his or her own heart.

The comparisons made in this catalogue and exhibition do not, of course, imply any literal, direct, or concrete analogies. The reference is to indirect links and the atmosphere and environment in which Russian artists lived and worked between the 1900s and 1930s. Works of folk art often provided the impulse or stimulus for the avant-garde techniques, devices, and styles in Russian painting. Although

focusing on folk traditions, the early twentieth-century artists were working very much in the spirit of their time, in terms of the subject matter and energy of their creations.

NOTES TO THE TEXT

1 At the very start of the nineteenth century, Orest Kiprensky became the first artist to paint on wood rather than canvas, when designing icons for the Kazan Cathedral in St. Petersburg in 1804. The background of Kiprensky's *Mother of God* is gold, as in traditional icons. When planning his Church of Christ the Savior on the Sparrow Hills in Moscow, Alexander Witberg envisaged a cathedral decorated with real icons, and not just religious paintings.

2 The leading experts of the day and age were Alexei Olenin (1763–1843; president of the Imperial Academy of Arts and director of the Public Library), Pavel Svinin (1787–1839; collector) and Fyodor Solntsev (1801–92; artist and historian).

3 The Abramtsevo circle was a group of artists and art lovers, mostly Muscovites, united around the railway magnate and art patron Savva Mamontov. Seeking to revive national traditions, they gathered each summer at Mamontov's Abramtsevo estate near Sergiev Posad. Never a formal association, the circle flourished between 1878 and 1893. In Abramtsevo, there were workshops of traditional Russian crafts (pottery and ceramics). Amateur plays were mounted by the artists themselves, who also designed the sets and costumes (leading to the creation of the Moscow Private

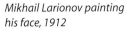

Mikhail Larionov painting his face, 1912

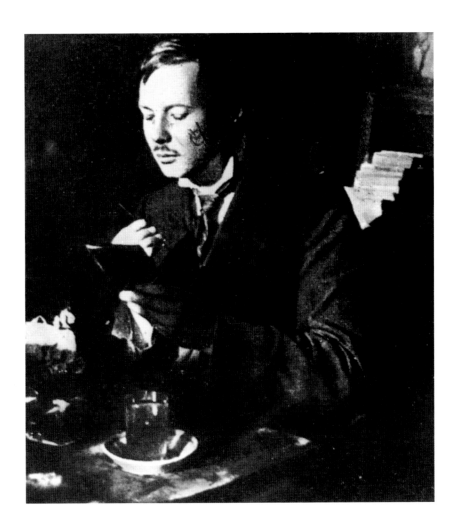

Opera in the 1890s). Among members of the circle were Apollinary and Victor Vasnetsov, Mikhail Vrubel, Konstantin Korovin, Isaac Levitan, Mikhail Nesterov, Vasily Polenov, Valentin Serov, and Konstantin Stanislavsky.

4 Wassily Kandinsky, "Stupeni. Tekst khudozhnika," *V. V. Kandinskii. Izbrannye trudy* (Moscow, 2001), 279.

5 In pre-revolutionary Russia, the red corner was the center of the house. The word red (*krasny*) was traditionally a synonym for beautiful and important. The icons and finest objects in the house were hung in the red corner, which also fulfilled the functions of *prie-dieu* and the place where the inhabitants gathered on festive occasions. In the Soviet period, the religious concept of red corner gave way to the political meaning of the word red. Red corners were rooms in factories and hostels providing recreational and educational facilities. They were adorned with busts of Lenin, portraits of other Party leaders, propaganda, and other attributes of Soviet life. For a more detailed discussion of the theme, see *Red in Russian Art* (St. Petersburg, 1997).

6 Kandinsky, "Stupeni. Tekst khudozhnika," 279.

7 "Pis'mo N. Goncharovoi," *Protiv techeniya*, 3 (16) March 1912, 3.

8 G. G. Pospelov, *Bubnovyi valet. Primitiv i gorodskoi fol'klor v moskovskoi zhivopisi 1910-kh godov* (Moscow, 1990), 105.

9 *A Legacy Regained: Nikolai Khardzhiev and the Russian Avant-Garde* (St. Petersburg, 2002), 164.

10 Letter from Kazimir Malevich to Mikhail Gershenzon dated 11 April 1920. Original reproduced in A. Shatskikh, *Chernyi kvadrat* (St. Petersburg, 2001), 438–49.

11 *Kazimir Malevich. Sobranie sochinenii v pyati tomakh*, vol. 1 (Moscow, 1995), 248.

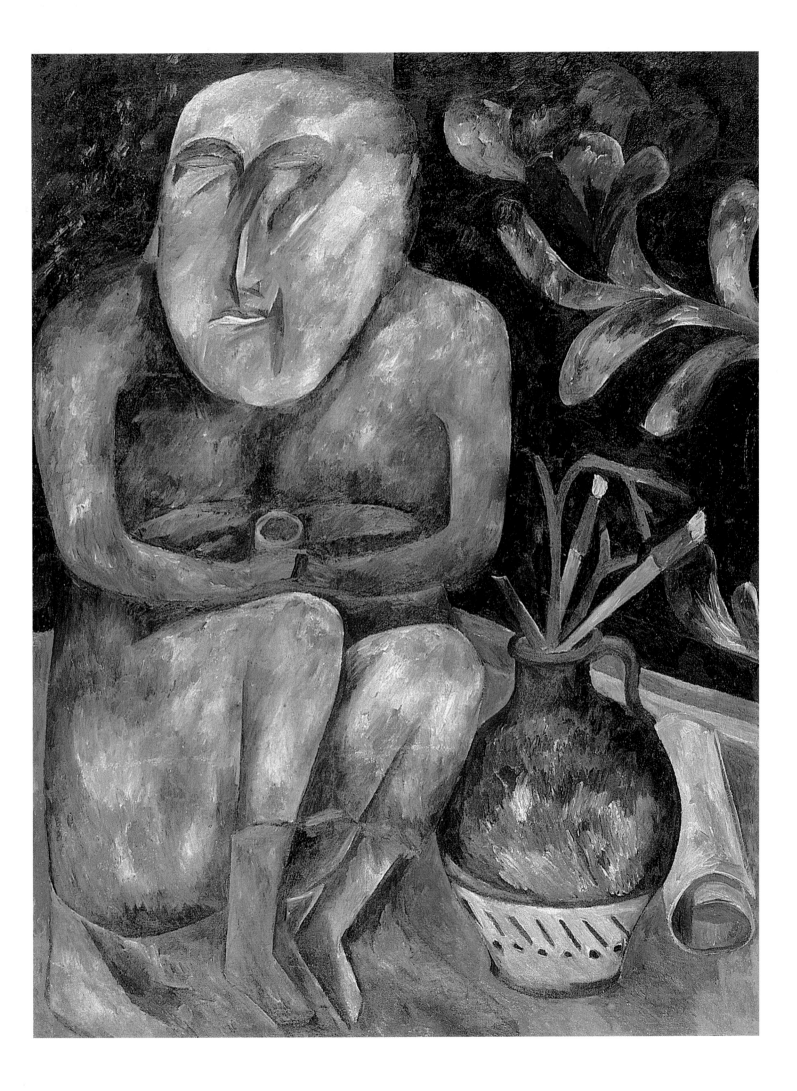

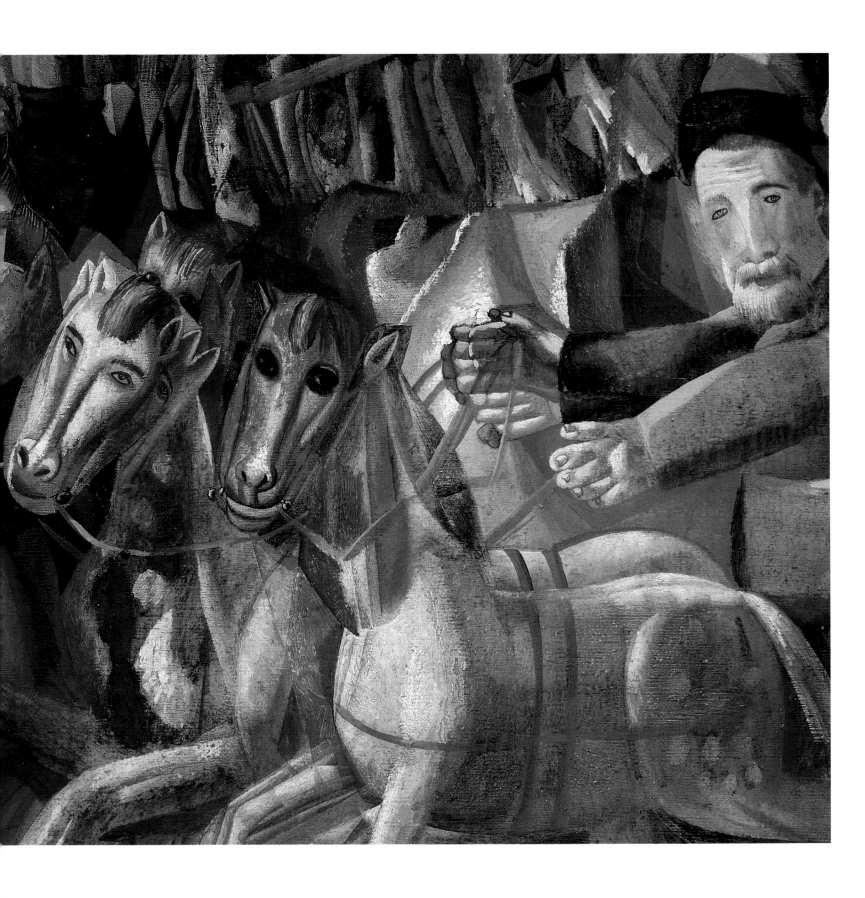

THE "NEW BARBARIANS"

Nicoletta Misler
John E. Bowlt

The issue of the interplay and interrelation of the Russian avant-garde and its "primitive" or indigenous sources is an extremely complex and dense avenue of inquiry. [1] Although it is clear that artists such as David Burliuk, Natalia Goncharova, Mikhail Larionov, and Kazimir Malevich were inspired by what they regarded as "savage" cultures, [2] they perceived and paraphrased them in an often indiscriminate and eclectic manner, identifying a new vitality of color or alternative spatial resolution in an icon, a clay toy, a children's drawing, a stone effigy, or a store signboard, and listing them all under the general rubric of "primitive." For the more pedantic critics of the time, such artistic promiscuity posed a serious threat to the established canons of beauty and good taste, while for the avant-gardists, it granted them the license to conclude that a common boot was aesthetically superior to the Venus di Milo. [3]

The subject is further complicated by the fact that the artists of the avant-garde were certainly not the first to rediscover their national heritage and to argue for the retention and preservation of the traditional arts and crafts, although some of their aesthetic reassessments, e.g., of the store signboard and children's drawing, were, indeed, strikingly new and had potential. The more closely we inspect the artistic currents of the Russian nineteenth century, the more we realize that it contained many diverse cultural strata and aspirations dependent not only upon the classical values of the Academy of Arts and the didactic narratives of the Realist painters known as the *peredvizhniki* (lit. "wanderers"). The professional Russian artist was encouraged to look to western models and counterparts (the Italian Old Masters or the German and French Realists), but a substantial number of artists, historians, and collectors found much of interest at home, organizing ethnographic expeditions, collecting native artifacts, and assembling detailed inventories of Russian ornaments and illuminations, folk prints, peasant embroideries, and ecclesiastical vestments. As early as the 1830s, the Imperial Academy of Arts in St. Petersburg commissioned the artist Fyodor Solntsev to study and sketch antiquities in the countryside, an experience that culminated in the magnificent portfolio *Pamyatniki moskovskoi drevnosti* (Monuments of Moscow Antiquity) [4] and in the establishment of specialist journals such as *Russkaya starina* (Russian Antiquity). [5] Even the strict Realists such as Ilya Repin, Andrei Ryabushkin, and Vasily Surikov, for example, seemed often to override their moral and social commitment with a purely aesthetic emphasis on the patterns of a peasant costume or the medieval forms of a village church. Towards the end of nineteenth century, the Neo-Nationalist or Neo-Russian retreats of Abramtsevo and Talashkino maintained this trend, assembling important collec-

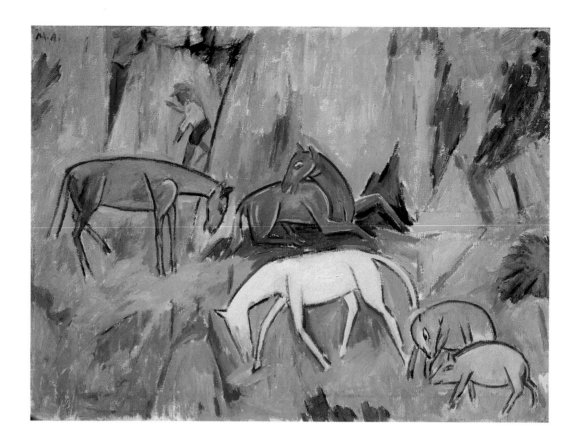

tions of domestic crafts and inviting young artists to produce furniture, ceramics, and textiles in accordance with the ancient recipes.[6] Finally, for all their Oscar-Wildean refinement and admiration of western European culture, the genteel and cosmopolitan members of the St. Petersburg *World of Art* group, such as Alexander Benois, Boris Kustodiev, and Konstantin Somov, were also charmed by the "other" tradition, collecting and promoting "primitive" manifestations such as the fable of Petrushka, the simple wooden toy, and the icon.[7]

Naturally, the artists of the avant-garde were aware of these precedents, and we can presume that Kandinsky made a careful study of the findings of Imperial expeditions into the hinterland,[8] that Larionov made ample use of Dmitry Rovinsky's inventory of *lubki*,[9] and that Goncharova consulted Vladimir Stasov's monumental compendium of Slavic ornament before embarking on her folkloric designs for *Coq d'or*.[10] However, the response of the "New Barbarians" to the primitive artifact was very different from that of the preceding generation, because their primary goals were to elevate the vulgar and demote the noble, to cancel the presumed differences between high and low, to explore alternative methods of perspective, proportion, anatomy, and coloring in their own studio paintings, and, ultimately, to contend that Russia's artistic renaissance would come to pass not from France or Italy, but from her national, indigenous traditions; and in pursuing this goal, they created one of the most spectacular moments in the history of Russian visual culture.

Convinced that Russian culture had much to offer the West and sure of the rightness of her own artistic mission, Goncharova declared in 1913:

> I have studied all that the West could give me, but, in fact, my country has created everything that derives from the West. Now I shake the dust from my feet and leave the West…. my path is towards the source of all arts, the East. The art of my country is incomparably more profound and important than anything that I know in the West.[11]

Even today, when twentieth-century Russian art has assumed its legitimate position in the hierarchy of modern or Modernist culture, Goncharova, if still alive, would have launched a similar argument against the now fashionable endeavor to make the Russian avant-garde "conform" to the European movements of its time. True, our task today should not be to try to construct some ideal, autonomous course for the history of the Russian avant-garde. That has been undertaken by Soviet and Russian critics who, in their own country and often against many odds, have done much to rescue names such as Pavel Filonov, Goncharova, Larionov, Aristarkh Lentulov, Malevich, Alexander Rodchenko, Shevchenko, and Vladimir Tatlin from oblivion or neglect by casting them as Russian representatives of French Cubism or Italian Futurism. The associations are reasonable and to some extent justifiable, but they are not exhaustive, and many other sources and conditions have yet to be explored — for example, the dynamic relationship between Symbolist deliberation and Cubo-Futurist action, the full impact of the French Impressionist and Post-Impressionist collections of Ivan Morozov and Sergei Schukin on young Moscow artists, [12] the public's reception of the avant-garde exhibitions and performances, and, not least, the intricate connections between Filonov, Goncharova, Larionov, and Malevich, on the one hand, and the traditions of native Russian — and Asian — culture, on the other.

The debt of such artists to the primitive aesthetic was profound and permanent, so much so that many of them tended to identify Russia's artistic renaissance with an awakening of the East and to regard the "freshness" and "simplicity" of the Orient — and of childhood — as the common denominator of their own radical and invigorating experiments. Goncharova's affirmation, therefore, seems especially apt inasmuch as she and her colleagues, divesting themselves of conventional bias and prejudice, were willing and able to elaborate an original synthesis that contained both the traditional perception of Oriental culture as the cradle of civilization and the reassessment of Russian folklore undertaken by revivalist centers such as Abramtsevo and Talashkino. Voldemars Matvejs (Vladimir Markov), an artist, ethnographer, and critic, and colleague of Goncharova, had this desired integration in mind when he wrote in 1912:

> The ancient peoples of the East did not know our scientific rationality. These were children whose feelings and imagination dominated logic. These were naïve, uncorrupted children who intuitively penetrated the world of beauty. [13]

Matvejs' sentiment brings to mind the reaction of the Symbolist philosopher Vasily Rozanov to the young dancers of the Imperial Siamese ballet that performed in St. Petersburg in 1900: those innocent children dancing "without a thought" [14] elicited comparisons with the inspired painter and poet who, dedicated to the vision or word, might also behave like a "barbarian" — and, like a barbarian, "think only of himself." [15] In his Neo-Primitivist manifesto of 1913, Shevchenko emphasized this connection between Russia's gravitation towards the essence of the East and the return to national roots:

> Generally speaking, the word "primitive" is applied not only to the simplification and lack of skill of the ancients, but also to peasant art — for which we have a specific name, the *lubok*. The word "primitive" points directly to its Eastern derivation, because today we understand by it an entire galaxy of Eastern arts — Japanese, Chinese, Korean, Indo-Persian, etc. [16]

It is not surprising, therefore, that the exhibition of icons and *lubki* that Larionov organized in Moscow in 1913, containing a total of 170 pieces from his own private collection, included Persian, Chinese, and Japanese specimens next to Russian originals, as if to confirm that domestic Russian culture was, indeed, of eastern derivation.

At least three interpretations of the "primitive" can be identified with the theory and practice of the Russian avant-garde. The first followed in the wake of the general European reassessment of the antique and the "savage," manifesting itself in a discovery of the primitive or, rather, archaic arts produced by the numerous peoples or ethnic groups within the Russian Empire (from the peoples of Siberia to those of Central Asia) and by the nomadic Eurasian tribes (from the Scythians to the Uns). [17] The second interpretation came with the actual ethnographic rediscovery of national folklore and the minor arts such as embroidery, store signboards, wood carving, and the *lubok*, a process that had been stimulated by the efforts of powerful and enlightened patrons such as Savva Mamontov and Princess Mariia Tenisheva to resuscitate an artisanship that seemed doomed in the face of industrialization and urbanization. This was virtually an "anthropological" enterprise in the sense that an indigenous and local culture was being rescued and evaluated by professional and cultivated — but extraneous — patrons or scholars. In turn, their encounter with the "primitive" led not just to the perception and reception of new forms, but also to a search for the "primitive soul," whether among the "barbarians" and the "Asians," or the Russian peasants and children. For example, in elaborating and applying their secret, transrational language called *zaum'*, the Cubo-Futurists seemed to be heeding and imitating the *yurodovyi* (village idiot) and the shaman who, traditionally, possess a divine command to utter the truth through the medium of mysterious rituals. This seems especially true of the poetry of Velimir Khlebnikov and Filonov; [18] Kandinsky, too, gave particular attention to the world of the Russian peasant and to the profound experience that he gained as the member of an ethnographic expedition in 1889:

> I can still remember entering the hut for the first time and standing still before the unexpected image. The table, the benches, the stove (which in the Russian peasant home is large and imposing), the cupboards, and every kind of object were painted and decorated with grand, multicolored images. On the walls were popular figures: the symbolic representation of a hero, a battle, images illustrating a popular song. The "red corner" covered densely with images of the saints, painted and printed. [19]

As Kandinsky implies in his anthropological descriptions, a direct consequence of this kind of encounter with national identity was not simply the praising of Russian roots, but rather a recognition of the great ethnic variety of the empire that included Georgians, Armenians, Jews, Balts, and many other nationalities. Jewish artists, for example, such as Nathan Altman, Marc Chagall, and El Lissitzky, drew immediate inspiration from the descriptions of Jewish ornaments and the Jewish Ethnographical Expeditions supported by Barons David and Goratsy Ginzburg (David and Horace Guenzburg) in 1911–14, [20] exemplified by Altman's inclusion of tombstone ornaments in his lithographic album *Yevreiskaya grafika* (Jewish Graphics) of 1923. [21]

The closer we examine the works of the Russian avant-garde, whether paintings, sculptures, or designs, the more we realize that native rituals, items of domestic use, religious processions, store sign-

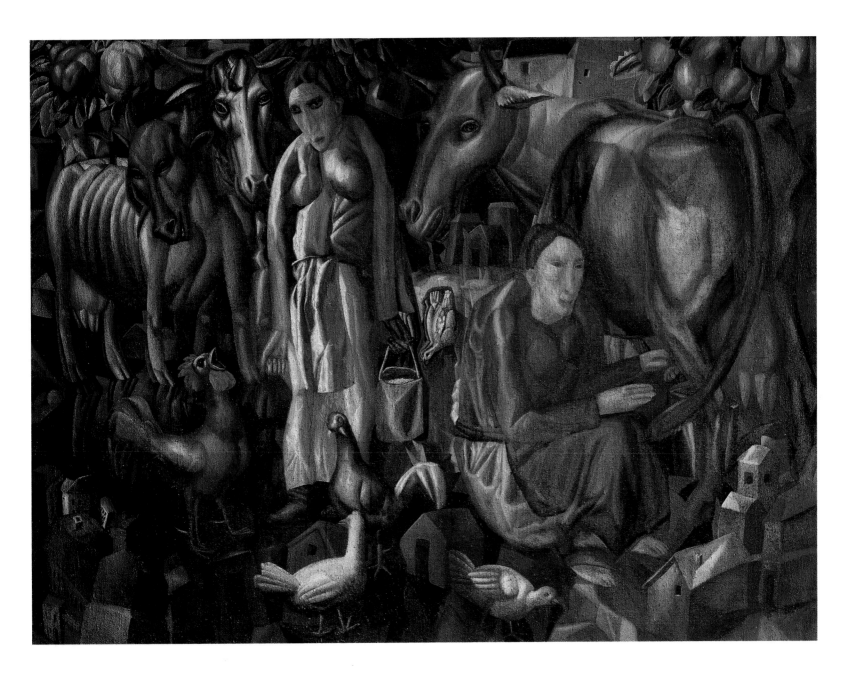

Pavel Filonov
Dairy Maids. 1914

boards, icons, and *lubki* were of fundamental importance. This should not come as a surprise inasmuch as the artists of that generation reached their artistic maturity in 1910–14, just as the antique icons were being cleaned, restored, and hung at professional exhibitions, thanks to the endeavors of historians and critics such as Igor Grabar, Nikolai Kondakov, and Nikolai Punin and collectors such as Nikolai Likhachev, Ilya Ostroukhov, and Stepan Ryabushinsky. A direct outcome of this activity was the organization of several key displays of icons and other ecclesiastical attributes such as the "Exhibition of Antiquities" in at the Stroganov Institute in Moscow in 1901 and the grand "Exhibition of Ancient Russian Art" twelve years later at the Imperial Moscow Archaeological Institute.[22] For the first time, at least on a high professional level and in a museological context, the Russian public was able to enjoy the beauty of religious objects (icons, metal utensils, vestments) outside of their religious function.[23]

Punin, in particular—one of the most astute champions of the avant-garde—pioneered in this approach to the object as an independent, aesthetic unit that had to be viewed independently of its ritualistic or symbolic purpose.[24] At the same time, most of the Russian avant-gardists were born and raised in the Orthodox faith, and specific elements of the church festival and procession, ritualistic

appurtenances such as the icon, and, of course, the "red" or "beautiful" corner, left a deep imprint upon them. Filonov and Goncharova painted icons, Tatlin analyzed their forms, and Malevich ensured that his *Black Square* (which he also described as a new icon, the "true and concrete representation of eternity"[25]) hung in the "red corner" of the "0.10" exhibition in Petrograd in 1915– 16. A number of studio painters of the Modernist era actually trained as icon painters, including Vasily Chekrygin, Filonov, Philipp Malyavin, Konstantin Redko, and Tatlin, while others such as Kustodiev and Victor Vasnetsov studied at Orthodox seminaries.

In any case, many artists of the 1880s and 1890s, not least Vasnetsov, were close to the Neo-Nationalist movement spearheaded by Abramtsevo and Talashkino towards the end of the nineteenth century. The proprietors of Abramtsevo, for example, Elizaveta and Savva Mamontov, encouraged artists to come to study the local, traditional arts and crafts such as wood carving, embroidery, tile design, and icon painting. This mission resulted in the construction of the church at Abramtsevo in 1883, designed according to an ancient Novgorod model and decorated with icons by Vasily Polenov, Repin, and Vasnetsov. Close to the Orthodox center of Sergiev Posad (in Soviet times known as Zagorsk), Abramtsevo served as a spiritual sanctuary for such young artists as Mikhail Nesterov, Vasnetsov, and Konstantin Yuon, who within a few years would be recognized as major contributors to the Modernist school. After the October Revolution, some of them, in sympathy with the priest, art historian, and mathematician Pavel Florensky, and in opposition to the atheist régime, even argued for the preservation of Sergiev Posad as a religious and intellectual monument and, with its gratification of all the senses, as a total work of art.[26]

The religious, or rather Orthodox Christian, connection, therefore, is important for understanding the development of the modern school of painting in Russia, in both the Symbolist and the avant-garde phase. We think, for example, of the decorative contributions to St. Vladimir's Cathedral in Kiev by Vasnetsov (*Descent into Hell*, 1885–96) and Mikhail Vrubel' (*Angel with a Censor*, 1887), of Nesterov's *Madonna* for the Parochial Church of Martha and Maria in Moscow of 1911–14, and of Nicholas Roerich's frescoes for the Church at Talashkino, so bizarre that they prompted Prince Sergei Scherbatov to dismiss them as paraphrases of Tibetan and Thai painting.[27]

Of course, these kind of paintings and designs, however novel and unorthodox, still belonged to a hallowed tradition, followed established formulae, and, as such, were rejected by the more radical generation of the avant-garde. At the same time, it is important to emphasize that if the Holy Synod approved of a certain leeway in interpretation and representation, Roerich, Vasnetsov, and Vrubel also disturbed Russia's complacency and "atrophy of artistic taste."[28] Not that the Church could forgive all deviations from the norm — finding Goncharova's *Evangelists* (1911), for example, to be "blasphemous" and insisting on their withdrawal from the *Donkey's Tail* exhibition of 1912 as the title of the exhibition was incompatible with the biblical subject. Yet it was the same Goncharova who maintained that the religious art of the past was the "most majestic, perfect manifestation of man's creative activity"[29] just as her close colleague Malevich was describing his own artistic praxis as "iconic"[30] and Shevchenko was announcing that "for the point of departure in our art we take the lubok, the primitive art form, the icon, since we find in them the most acute, most direct perception of life and a purely painterly one, at that."[31]

It would be misleading to assume that the avant-gardists, however, shared a common attitude towards the re-evaluation of the icon. Clearly, for Goncharova the icon remained a spiritual symbol and component part of the Orthodox belief, whereas for Shevchenko, one suspects, the icon was, above all, an interplay of formal devices, and for Tatlin the actual, physical construction of the icon seemed to hold greater fascination than any biblical association. At the same time, all were strongly aware of the particular visual resolutions of the icon — the inverted or reversed perspective, the semantic rather than anatomical proportions, and the vigorous color schemes that made the icon so very different from the academic easel painting. Larionov was especially taken by the ways in which the Old Believer icon painter often allowed the paint to flow beyond the "legitimate" contours, while both Kandinsky and Shevchenko identified a similar process in the hand-painted *lubok*, contending that these lapses were the result not of caprice or carelessness, but of a different intellectual logic and aesthetic system: reverse perspective rendered God's viewpoint from behind the horizon, and anatomical (dis)proportion was generated by sacred status or ideological significance rather than by position in real space.

The ways in which the art of the icon was reprocessed by the artists of the Russian avant-garde were very diverse, although Tatlin, above all, should be credited with approaching the icon as a "tactile experience of materials in the interplay of their surfaces and volumes."[32] Tatlin's departure-point was the texture of the preparatory layer of the icon and the ways in which the wooden board and slats were constructed and assembled (and he returned to this concern in his later paintings of the 1940s). In accepting the icon as a synthesis of many functions, Tatlin undertook complex iconic analysis of the surface theme, as in his formal scheme of the *Virgin and Child* (1913), but it was the back of the icon, with its clear, constructive function, that prompted him to incorporate pieces of wood into his reliefs and counter-reliefs.

Even Chagall, who, of course, paid homage to the Jewish traditions, also paraphrased iconic subject-matter and structures, as is manifest from his *Pregnant Woman* of 1913 (Stedelijk Museum, Amsterdam) deriving from the formulaic *Mother of God of the Holy Sign*, or his *Flying Carriage* (1913, Solomon R. Guggenheim Museum, New York), reminiscent of the iconic rendering of Elijah in his fiery chariot. Of course, the precise links are not always easy to delineate, especially when an artist had drawn upon the rich fusion of Christian and pagan motifs identifiable with Russian peasant art. Malevich's paintings, for example, may carry enigmatic references to iconic symbols, but never are they blatantly Orthodox — with its menacing frontal view, the *Man on the Boulevard* (1910, Stedelijk Museum, Amsterdam) may remind us of the icon of the God of the Fiery Eye, while *The Mystic* (1930, private collection) grants a prominent position to the Orthodox cross, but, even so, these are receptions rather than reconstructions of the Christian doctrine.

This kind of motif or, rather, combination of motifs was part and parcel of the peasant way of life — with which Malevich identified himself very closely and which Goncharova depicted so eagerly. The fact that many of the Russian avant-gardists were "rural" rather than "urban," provincial rather than metropolitan, and were in direct contact with the peasantry, may help to explain the comparative ease with which they appreciated and interpreted indigenous subjects. Even some of the radical, abstract works carry references to this condition, such as Malevich's *Red Square* (1915, Russian Museum, St. Petersburg) which is subtitled "Painterly Realism of a Peasant Woman in Two

Dimensions." That the world of the Russian countryside, replete with an archaic and pagan nostalgia, was the primary source for these artists and that they chose to rediscover the primitive by way of these native forms was both an ideological and a practical strategy.

Furthermore, most members of the Russian avant-garde did not study abroad and prided themselves on their national allegiance—something that Goncharova, Larionov, and Shevchenko, at least, identified as an Oriental connection. [33] Alexandra Exter's long sojourns in France and Italy in 1908 onwards or Kandinsky's in Germany in 1898 onwards are isolated cases, while Larionov's brief visit to Paris in 1906 (as a guest of Sergei Diaghilev) and actual confrontation with the work of Gauguin at the first retrospective only better prepared him for his acceptance of Primitivism and thence Cubism. In many aspects, therefore, Gauguin and Matisse, Black African sculpture and Old Believer *lubki* seemed to contain similar visual prerogatives—which may be why Paul Guillaume, the celebrated Paris collector of African art and enthusiast of the new French painting, saw fit to organize the first European Larionov and Goncharova retrospective in Paris in 1914 (by when, however, the two artists were already shifting their focus from Neo-Primitivist and Rayonist studio painting to stage design).

But Goncharova, Larionov, and their colleagues did not have to travel to Paris to recognize parallels between contemporary French painting and the old Russian arts and crafts. The Morozov and Shchukin collections of Gauguin, Matisse, and Picasso were readily accessible in Moscow; the Russian countryside was still archaic, largely untouched by the advent of technology and literacy; and all manner of Russian publications paid attention both to modern French art and to Russia's peasant legacy. An important mouthpiece for the propagation of "primitive" art in Russian intellectual and artistic circles was the Moscow journal *Zolotoe runo* (*Golden Fleece*, 1906–9 [=1910]) with which Goncharova and Larionov were closely allied. It was in 1906, for example, that *Zolotoe runo* published Konstantin Balmont's first Russian translation of part of the celebrated Mayan epic *Popol Vuh*. True, Bal'mont had published another version in the journal *Iskusstvo* (Art) the year before, but this was longer and was accompanied by 232 photographs of objects in Mexico City's Anthropological Museum and other collections. In 1910, Balmont's translation was reprinted, this time with supplementary text and twenty new photographs (taken by Balmont himself) of the ruins at Palenque, Uxmal, Chichén Itzà, and Mitlà. [34]

Two other essays fundamental to the new evaluation of Oceanic and African art were Markov's *Iskusstvo Ostrova Paskhi* (Art of Easter Island, 1914) and *Iskusstvo negrov* (Black Art, published posthumously in 1919), the latter written before Carl Einstein's influential *Negerplastik*. [35] In any case, both appreciations were well known within the St. Petersburg *Union of Youth*, of which Markov was not only a founding member, but also its librarian. Markov spent a great deal of time and energy studying Black African art in European and Russian museums before embarking upon an independent analysis, assessment, and photographic record of the art of the smaller peoples of Central Asia, especially the wooden artifacts held in the Ethnographical Museum of the Academy of Sciences in St. Petersburg:

> [There were] sections of tree-trunks, especially of birch, cut by some able blow of the axe
> (or by some other primitive instrument) to bring forth the stern visage of an idol or sim-
> ply a human face. The head was placed on this trunk-cum-torso which was often still
> covered with the bark. [36]

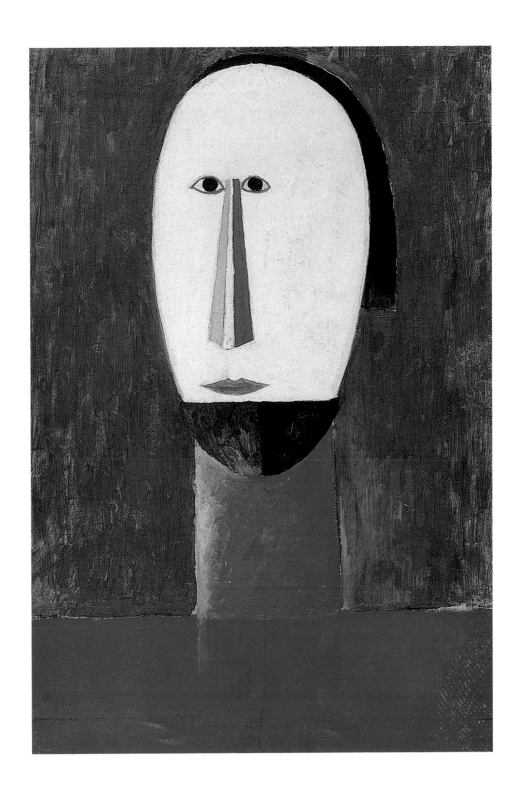

—a description reminiscent of the squat and thickset characters with their bald heads that Filonov painted before the Revolution such as *Workers* (1915–16, Russian Museum, St. Petersburg).

St. Petersburg boasted two major ethnographic repositories—the Alexander III Ethnographical Museum and the Academy of Sciences Museum of Ethnography and Anthropology. In contrast to the great European collections, the Russian museums did not possess a large African contingent, but, on the other hand, their Oceanic collections were superb, thanks in part to the findings of the great explorer and ethnographer Nikolai Miklukho-Maklai, who, in 1871, had set out on a grand voyage for New Guinea, the Pacific islands, Australia, and New Zealand. [37] The North American section of the museums was also very strong, containing Native American costumes that had been acquired by the Russian-American Company in Alaska. The unexpected appearance of a Native American wearing warrior attire and a luxurious feather headdress in Filonov's *Flight into Egypt* (1918, private collection)

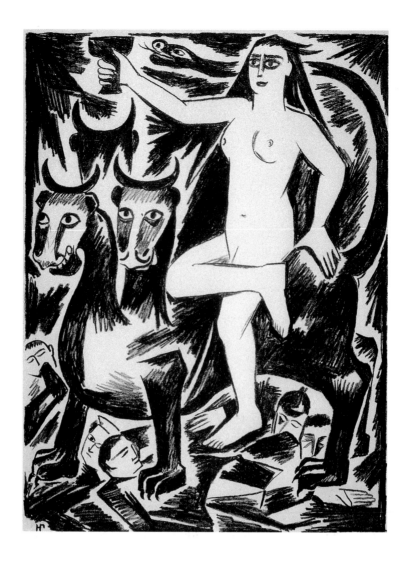

could be regarded as strong witness to Filonov's awareness and appreciation of ethnography in general and of the St. Petersburg museums and their collections in particular. No doubt, Filonov's interest in these things was reinforced by his period of study with the ethnographic artist and book illustrator Lev Dmitriyev-Kavkazsky in 1903–8 — who enjoyed wide acclaim for his renderings of the types and customs of Central Asia. [38] In the 1920s, too, Filonov continued to promote the importance of ethnography, elaborating a plan for the study of the popular arts in his projects for the Museum of Artistic Culture and the reformed Academy of Arts.

If a vital inspiration for Filonov's lapidary reduction of the human and animal body was the primitive wooden effigy (Russian or Scandinavian), a principal source for Goncharova — who started her career as a sculptress — was the ancient stone statue known as the *kamennaia baba*. At a stormy *diskussiya* in Moscow in 1912 she even declared that the genesis of Russian (as opposed to French) Cubism lay in the "stones of the Scythians" and the so called "stone maidens" (*kamennye baby*) [39] — and it is precisely a *kamennaya baba* that commands the viewer's attention in her *Still Life with Pineapple* (1908, Tretyakov Gallery, Moscow, also called *Still Life, Stone Maiden, Pineapple*). A symbol of fertility and potency, the *kamennaya baba* was a pagan megalith (male as well as female) erected near pre-historic tombs and tumuli, but often displaced by collectors in the nineteenth century (one of them still graces the grounds of the Abramtsevo estate). [40] Goncharova painted several other compositions with a *kamennaya baba* as the central subject, including *Pillars of Salt* (1908, Tretyakov Gallery, Moscow) and *Goddess of Fecundity* (1908, Tretyakov Gallery, Moscow), which, when exhibited at the Moscow Society of Free Aesthetics,

caused much righteous indignation and accusations of pornography: according to the newspaper *Golos Moskvy* (Voice of Moscow), Goncharova's idol was so indecent that even dissected bodies in a medical museum would have felt uneasy if confronted with such "disgusting depravation."[41] Still, if the *Goddess of Fecundity* was reminiscent of a *kamennaya baba*, it also came very close to Gauguin's *Blue Idol* of 1898 (then in the Shchukin collection, Moscow) and to the wooden sculpture *Oviri* (1894), which had been reproduced in various positions in *Zolotoe runo* (1909, no. 1). Obviously, in *Oviri* Goncharova identified the same heavy tri-dimensionality, the same tellurian and corporeal substance (symbolic of the very act of sculpting) that she recognized in the images of the *kamennaya baba*.

Whether for the Russian peasant or for the cosmopolitan scholar, these primal figures represented the female strength of fertility and procreation that J. J. Bachofen attributed to the matriarchal eras,[42] the same quality that, in its Amazonian phase, could also manifest itself as a wild and destructive force. Goncharova did not hesitate to interpret this condition, too, as is apparent in her lithographs of "women devils" for Alexei Kruchenykh's *Igra v adu* (Game in Hell) (Moscow, 1912), her wild women for his *Mirskontsa* (Worldbackwards) (Moscow, 1912), and her painting of the heavy and naked Apocalyptic *Woman on the Beast* (now in the Museum of Art, Kostroma) that formed part of *The Harvest* suite of 1911, which she lithographed for Konstantin Bolshakov's *Le Futur* (Moscow, 1913) and then for her album *Misticheskie obrazy voiny* (Mystical Images of the War) (Moscow, 1914).[43]

Misticheskie obrazy voiny was Goncharova's patriotic gesture to the First World War and, in its formal simplicity and traditional imagery, had much in common with the posters and *lubki* that Malevich, Lentulov, Vladimir Mayakovsky, Ilya Mashkov, et al. designed for the Modern Lubok corporation in Petrograd in 1914–15.[44] At first glance, it may seem strange that Goncharova would have defined her military images as "mystical," the more so since they are anything but incorporeal. However, in this cycle Goncharova is reinterpreting the perception of the Apocalypse by peasants, who, following a millennial and sectarian tradition, felt free to transpose the events of the World War into the conventional vocabulary of the biblical Apocalypse. So it is not fortuitous that, in several of the lithographic sheets such as *St. Michael the Archistrategus*, the warrior of the Lord and Herald of the Apocalypse, Goncharova produces a literal copy of the canonical icon — which, incidentally, was also included in the "Exhibition of Ancient Russian Art" of 1913. Another image in Goncharova's cycle for *Misticheskie obrazy voiny* deriving from the icon is that of St. George, which served as a source Filonov and Kandinsky.

But if for Kandinsky the Apocalyptic iconography served as a main path towards the disembodiment of form, especially in 1911–13,[45] for Goncharova it was the opposite — for it represented a return to the primitive, figurative image, solid and concrete, something that she emphasized in her set and costume designs for Sergei Diaghilev's Ballets Russes in Paris. Indeed, even her Rayonist experiments of 1912–13 still tended to refer to the recognizable world of objects, and they were rarely abstract in the way that Larionov's were.

A direct and special relationship seems to exist between the images created by Goncharova and Larionov and the physicality of the icon. But the artists of the avant-garde rediscovered and reassessed the icon not only as a coherent totality of formal properties, but also — and conversely — as an object

that held value precisely as the key component of an entire ritual or act. After all, an icon is unthinkable without its wooden board and, kissed by the faithful as they enter and exit the church, blessed by the priest, and perfumed by the incense, it plays an organic part in the Orthodox ceremony. This is not to say that the avant-garde artists were devout followers of the Church rite, for they had their own "tribal" deportments, gestures, and actions, and they used these, not the Orthodox Church, to advertise and reinforce their self-identity.

In his "autobiography of Futurism," the poet Benedikt Livshits remembers one such laical rite and its locus — the turbulent Burliuk family in the Ukraine, wherein visiting poets and painters were initiated and then, almost literally, devoured. [46] Relying on culinary metaphors, Livshits describes the fastness of the Hylaean steppes, the Rabelaisian eating and drinking, and the profuse creativity of the Burliuk brothers, Exter, and Khlebnikov. The more transgressional behavior patterns of the avant-gardists — such as the red wooden spoons that Malevich and Alexei Morgunov wore as they walked around downtown Moscow in February 1914 and the elaborate face-painting that Bolshakov, David Burliuk, Goncharova, Vasily Kamensky, Larionov, the Zdanevich brothers, and others undertook in 1913–14 — may also be regarded as elements of a new tribal ritual.

These outlandish facial designs, replete with pigs and vulgar innuendoes, remind us not only of the make-up used by clowns, but also of voodoo or shaman ritual. Perhaps recalling Khlebnikov's poem "The Shaman and Venus," Kruchenykh even tried to reenact the "sorcery of a shaman" as he accompanied his painted friends through the streets of Moscow and St. Petersburg, singing:

KhO-BO-RO

MO-ChO-RO

BO-RO-MO

ZhLICH! [47]

Like street graffiti, these patterns spilled over on to adjacent surfaces such as the hall of the first *Jack of Diamonds* exhibition of December 1910–January 1911, where artists had even sketched rude caricatures on the walls, the back wall of the Cabaret No. 13 (visible in the one surviving frame of the 1914 Futurist movie *Drama in Cabaret No. 13*), [48] or the dress that Sonia Delaunay designed for Vera Sudeikina in 1922 with *zaum* calligraphy by Zdanevich. [49] Here were material extensions into the public domain which, on the one hand, were casual and disparate and yet, on the other, were interconnected by the common denominator of performance space or theatrical arena.

The Futurists, Italian and Russian, were histrionic; the aesthetic of entertainment was crucial to their endeavor; and they made constant recourse to the low theater as a laboratory for artistic experiment: the circus, the martial arts, and the operetta (*Victory over the Sun* and *Vampuka*), the cabaret (the Stray Dog in St. Petersburg and the Fantastic Tavern in Tiflis), the café (the Café Kade in Moscow), ballroom dancing (especially the tango), the public debate, and the cinema were important conduits of Futurist activity. In a letter that Zdanevich wrote to his father in February 1914, for example, we read that Mikhail Le-Dantiu

> has devised a very curious thing, which is the first attempt to implement my doctrine
> that art must go out on to the street. Namely, he has signed a six month contract with

the Mirage Cinema (Officer St. [St. Petersburg]) according to which he, Mikhail Vasil'e-vich [Le-Dant'iu], obliges the Cinema to organize a permanent exhibition of paintings by artists of his faction in the auditorium. The paintings will change every fortnight and anyone purchasing a movie ticket will have the right to visit the show.[50]

Obviously, the sources of this kind of ritual were not the Church, the fashionable salon, or the mystical society, but, rather, the fairground with its *balagany*, its conjurors and quacks, the puppet theater, the cinema, the cabaret, the circus, and, for that matter, any kind of behavior that contradicted good taste and the norms of polite society. The wooden spoons, presumptuous top hats, and naughty graffiti that Larionov repeated in his pictures and face-painting are closely allied with that *other* world of vulgarity, gaudiness, and spontaneity generally identified with the "masses." Larionov made his gestures to topple the established edifice of "art," and the extravagant contents of his gestures—dirty drawings from barrack walls and barbershops, common streetwalkers now elevated into Venuses, and tricks and mystifications (such as his imagined trip to Turkey and fictional poets)[51]—served to expand and enrich the traditional syntax of the clown, the magician, and the charlatan.

The circus appealed to Larionov precisely because it enjoyed the license to upset, parody, and shortcut conventional genres and disciplines, and it was a spectacle that, like the avant-garde exhibition, could surprise and sadden, entertain and alienate, while relying on an eclectic arsenal of instruments, media, and narratives. The circus and similar forms of "magic" were especially popular in Russia at the end of the nineteenth century: the circus troupe of Ciniselli, the clowns Anatoly Durov and Ivan Kozlov, and the magician Leoni (pseudonym of V. Larionov, not a relative of Mikhail) were household names. Catering to an eager public, these celebrities concocted and proffered "illusions" (the Russian word for "conjurer" is "illiuzionist," and the early cinemas in Russia were also called "illiuziony"), illusions that became ever more complex and spellbinding as technological possibilities developed. The making of these "factories of dreams" paralleled the development of all manner of technological wizardries such as the telephone and the phonograph, inventions that found an immediate application in the fairgrounds and circuses of early twentieth-century Russia.

Levitation, beheading, trick photography, sawing ladies in half, face painting, and ventriloquism (transmuted by the Cubo-Futurists into their concept of verbal and visual *sdvig*, or displacement of words from their established sequence)—these are just some of the tricks that can be associated with the great Russian circuses and with the avant-garde, and a number of intriguing parallels can be traced. The lithograph of devils sawing a woman in half with which Malevich illustrated the second edition of *Igra v adu* (A Game in Hell) in 1914 brings to mind the traditional *lubok* on the same theme—and also the sensational acts of sawing by *illiuzionisty* in Moscow and St. Petersburg circuses; the weird clothes and painted faces of clowns return in the costumes and face painting of Burliuk, Goncharova, Kamensky, Larionov, Le-Dant'iu, and Zdanevich; the decapitations and displacements of heads implemented by Leoni and other magicians bring to mind Cubo-Futurist paintings such as Burliuk's *At the Barber's* (1912?, a transcription of Larionov's *Officer at the Barber* of 1909, which, in turn is a paraphrase of the famous eighteenth-century *lubok* of an *Old Believer Having His Beard Cut Off*); Leoni's prestidig-itations also remind us of the mysterious absences in some of Larionov's paintings, such as the two legs

missing from the chair in *Officer at the Barber*; the *lubok Farnos the Clown Riding a Pig* was the visual source for Tatlin's costume design for the pipe-player in the folk drama *The Emperor Maximilian and His Disobedient Son, Adolf* (1911, private collection), and, as if to animate the same picture, Durov would enter the circus arena riding a pig—which Larionov lets loose in his Neo-Primitivist paintings such as *Provincial Walk* (Tretyakov Gallery, Moscow); and perhaps the Kruchenykh miscellany *Porosiata* (Piglets) that Malevich illustrated in 1913 pays homage to the same source; similarly, Durov's top-hat and colored vests were copied readily by Burliuk, Kamensky, and Maiakovsky. There are many other pictorial and literary links between the avant-garde and the circus—Khlebnikov's laughter poem ("Incantation by Laughter") seems to have been inspired by Durov's regular public lecture "On Laughter;" Kamensky used to recite poetry while riding bareback in a circus; and even the serious Kandinsky praised clowns for their "intuitive movements" in his program for the Institute of Artistic Culture in 1920. [52]

Of course, it was not only icons, *lubki*, and circuses that inspired the Russian avant-garde, but also the everyday objects of the rural and urban environment, from tin trays and playing cards to store signboards and children's drawings. Tailors, bakers, butchers, haberdashers, and grocers used to commission signboard painters to paint the commercial logos and advertisements for their establishments—a man in a top hat for the tailor, a joint of beef for the butcher, an elaborate pretzel for the baker—and artists such as Goncharova, Larionov, Ilya Mashkov, and Shevchenko were captivated by the simplicity, forthrightness, and vitality of these signs that they both collected and paraphrased. [53] They regarded the sign-painter as an important member of the "primitive" community together with the child, the naif, and the Sunday painter and even contended that their favorite signboard painter, the Georgian Niko Pirosmanashvili, was the "Oriental" equivalent of Henri Rousseau le Douanier. [54] Moreover, alongside their own primitive paintings, such as *The Seasons* (Larionov) and *Morning in the Country after a Snowstorm* (Malevich), they included children's drawings (from Shevchenko's collection), local signboards (David Burliuk owned a vast collection), and twenty anonymous amateur paintings in the *Target* exhibition of 1913, as if to demonstrate that there was no essential difference between "high" and "low," mainstream and periphery, something implied in theses of the accompanying declaration of intent:

> 5) Aspiration towards the East and directing attention to national art;
>
> 6) Protest against the servile subordination to the West which returns our own art and
>
> the forms of the East back to us in a vulgarized manner. [55]

The Neo-Primitivist movement in Russia was short-lived, producing works of brilliance and originality at its climax in around 1910 and then entering a difficult phase of decline as it combined with more extreme and less tolerant styles. Once eager supporters of Neo-Primitivism like Malevich and Tatlin proceeded to explore other territories, in their case Suprematist painting and the abstract relief, other colleagues such as Lentulov and Shevchenko diluted the roughness and readiness of Neo-Primitivism with the smoother elegance of Cézanne and Sonia Delaunay; and, obviously, the permanent residence of Goncharova and Larionov in Europe and their full commitment to stage design after 1915 was a major loss to the Neo-Primitivist cause in Russia.

In some sense, the stage, specifically the ballet and the cabaret for which Goncharova and Larionov worked after their emigration, witnessed the end of Neo-Primitivism as a distinctive and dynamic movement. The theatrical application now tended to reinforce rather than develop the common denominator of signboards, *lubki*, and even icons as forms of entertainment and performative ritual, taming their raw energy and provocative resolutions for an audience that was anything but primitive. Certainly, Diaghilev's public was diverted by Goncharova's vigorous *Coq d'or* and Larionov's happy *Chout* as the stage turned into a buffonade liberating color, movement, dramatic gesture, and imagination, but by then Goncharova and Larionov were using formulae that they had already exploited several years before. On the other hand, with the demise of Imperial Russia in 1917 and the onslaught of the Russian diaspora in Berlin, Paris, and New York, Neo-Primitivism assumed a nostalgic and sentimental power that evoked a tinsel Russia of yesteryear with dashing peasants playing rousing balalaikas, quaint provincial streets with signboards askew swaying above the ample curves of languorous merchant's wives, and cozy medieval churches with brooding Madonnas and indulgent priests. Here was a Russia, primly primitive, which amused a displaced and saddened émigré population at the Blue Bird in Berlin, the Chauve-Souris in Paris, and the Russian Tea Room in New York, but which, by then, had very little in common with the Russian savages, either old or new.

NOTES TO THE TEXT

1 The subject has received limited attention in the form of publications and exhibitions. See, for example, G. Pospelov et al., *Primitiv i ego mesto v khudozhestvennoi kul'ture novogo i noveishego vremeni* (Moscow: Nauka, 1983); J. Petrowa and J. Poetter, eds., *Russische Avantgarde und Volkskunst.* Catalogue of exhibition at the Staatliche Kunsthalle, Baden-Baden, and State Russian Museum (St. Petersburg, 1993); K. Varnedoe and A. Gopnik, *High and Low. Modern Art and Popular Culture.* Catalogue of exhibition at the Museum of Modern Art (New York, 1991). Among recent sources of information on Russian naïve art, particular mention should be made of A. Lebedev, ed., *Primitiv v Rossii.* Catalogue of exhibition at the Tretyakov Gallery, Moscow (Moscow, 1995); and A. Lebedev: *Tshchaniem I userdiem* (Moscow, 1998).

2 David Burliuk praised Russia's radical artists for being the "new barbarians" in his article "Die 'Wilden' Russlands" in W. Kandinsky and F. Marc, eds., *Der Blaue Reiter* (Munich, 1912), 13–19.

3 In a lecture that he delivered in Moscow in March 1913, Ilya Zdanevich declared that a pair of boots was as beautiful as the Venus di Milo. See P. Hulten et al., *Iliazd.* Catalogue of exhibition at the Centre Georges Pompidou, Paris (Paris, 1978), 48.

4 I. Snegirev and F. Solntsev, *Pamiatniki moskovskoi drevnosti.* 8 vols. (Moscow, 1842–45).

5 *Russkaya starina* (St. Petersburg, 1870–1918).

6 On Abramtsevo, see N. Beloglazova, *Abramtsevo* (Moscow, 1981); V. Bakhrevsky, *Savva Mamontov* (Moscow, 2000); on Talashkino, see B. Rybchenko and A. Chaplin, *Talashkino* (Moscow, 1973); L. Zhuravleva, *Knyaginia Maria Tenisheva* (Smolensk, 1994). For general commentary on Neo-Nationalism

and the Arts and Crafts revival in Russia, see W. Salmond, *Arts and Crafts in Late Imperial Russia* (Cambridge, 1996).

7 On the *World of Art* movement, see J. Kennedy, *The "Mir iskusstva" Group and Russian Art* (New York: Garland, 1977); J. Bowlt, *The Silver Age: Russian Art of the Early Twentieth Century and the "World of Art" Group* (Newtonville, 1979); Y. Petrova et al., *"Mir iskusstva"* (St. Petersburg, 1998). Benois, in particular, appreciated the "primitive" arts. See his articles in the St. Petersburg newspaper *Rech'* [Discourse]: "Povorot k lubku" (1909, 18 March, 2), "Kul'tura nashikh detei" (1912, 2 November, 2), "Russkie ikony i zapad" (1913, 2 April, 2), "Ikony i novoe iskusstvo" (1913, 5 April, 2), and "O detskom tvorchestve" (1916, 27 May, 2).

8 Kandinsky took part in two ethnographic expeditions, publishing his observations as "O nakazaniyakh po resheniyam volostnykh sudov Moskovskoi gubernii" in *Trudy Etnograficheskago otdela Imperatorskago obshchestva liubitelei estestvoznaniya, antropologii i etnografii* (Moscow, 1889), vol. 61, no. 9, 13–19; and "Iz materialov po etnografii sysol'skikh vychegodskikh zyrian" in *Etnograficheskoe obozrenie* (Moscow, 1889), book 3, 102–10. For commentary, see P. Weiss, Kandinsky and Old Russia, (New Haven, 1995).

9 D. Rovinsky, *Russkie narodnye kartinki*. 5 vols. (St. Petersburg, 1881 and other editions). The *lubok* was a cheap print, often hand-colored and carrying topical commentary on social and moral issues.

10 V. Stasov, *Vostochnyi i slavianskii ornament* (St. Petersburg, 1887). The late nineteenth century saw an outburst of compendia concerned with Russian folklore and antiquities, e.g. N. Simakov, *Russkii ornament* (St. Petersburg, 1882); N. Sorokine, *Broderies-Tissus* (Paris, nd); S. Davydoff, *La Dentelle Russe* (Leipzig, 1895).

11 N. Goncharova, Preface to the catalog of her one-woman exhibition, i.e. *Vystavka kartin Natalii Sergeevny Goncharovoi, 1900–1913* (Moscow, 1913), 1.

12 Pioneering research in this area has been undertaken by Albert Kostenevich. See, for example, *Morozov and Shchukin. The Collectors.* Catalogue of exhibition at the Museum Folkwang, Hanover, and other cities, 1993–94; *Pol' Sezann i russkii avangard nachala XX goda.* Catalogue of exhibition at the State Hermitage Museum, St. Petersburg, and the Pushkin Museum of Fine Arts, Moscow, 1998; M. Bessonova et al., *Paul Gauguin e l'avanguardia russa.* Catalogue of exhibition at the Palazzo dei Diamanti, Ferrara, 1995.

13 V. Markov (Waldemars Matvejs), "Printsipy novogo iskusstva" in *Soiuz molodezhi* (St. Petersburg, 1912), no. 1, 8.

14 V. Rozanov, "Balet ruk. Zanimatel'nyi vecher" in *Sredi khudozhnikov* (St. Petersburg, 1914), 31–45, 51–61.

15 Markov, *Printsipy novogo iskusstva*, op. cit., 18.

16 A. Shevchenko, *Neo-primitivizm. Ego teoriia. Ego vozmozhnosti. Ego dostizheniia* (Moscow, 1913). Reprint: M. Larionov, N. Goncharova, A. Shevchenko: *Ob iskusstve*, (Leningrad, 1989), 61.

17 See V. Basilov, *Nomads of Eurasia.* Catalogue of exhibition at the Natural History Museum of Los Angeles County (Los Angeles, 1989).

18 Khlebnikov even entitled one of his poems "The Shaman and Venus" (published in 1913). The phonic effect of Filonov's long poem *Propoven' o prorosli mirovoi* (Petrograd, 1915) is that of a chant or incantation. Kandinsky seems also to have been interested in shamanism. See Weiss, op. cit., chapter 3.

19 V. Kandinsky, *Tekst khudozhnika* (Moscow, 1918), 28. The "red corner" [*krasnyi ugol*] was the traditional place of the icon in the Russian home. The word *krasnyi* also used to mean "beautiful."

20 See, for example, V. Stasov and D. Ginzburg, *Drevne-evreiskii ornament po rukopisiam* (St. Petersburg, 1886); D. Gunzburg and V. Stassof, *L'Ornement Hébreu* (Berlin, 1905). For commentary, see R. Apter-Gabriel, ed., *Tradition and Revolution. The Jewish Renaissance in Russian Avant-Garde Art 1912–1928*. Catalogue of exhibition at the Israel Museum (Jerusalem, 1987); and S. Goodman, ed., *Russian Jewish Artists in a Century of Change 1890–1990*. Catalogue of exhibition at the Jewish Museum (New York, 1995).

21 N. Altman, *Evreiskaia grafika* (Berlin, 1923).

22 See D. Nikiforov, *Sokrovishcha v Moskve* (Moscow, 1901); P. Muratov, *Vystavka drevnerusskogo iskusstva* (Moscow, 1913 (without plates); enlarged edition with plates (Moscow, 1913).

23 For a discussion of the rediscovery of the Russian icon in the early twentieth century, see G. Vzdornov, *Istoriya otkrytiya i izucheniya russkoi srednevekovoi zhivopisi XIX veka* (Mosow, 1986), esp. chapter 7; and Yu. Bobrov, *Istoriya restavratsii drevnerusskoi zhivopisi* (Leningrad, 1987).

24 See, for example, his review of the "Exhibition of Ancient Russian Art" in *Apollon* (St. Petersburg, 1913), no. 5, 39–42; also see his "Ellinizm i Vostok v ikonopisi. Po povodu sobraniia ikon I. S. Ostroukhova i S. P. Riabushinskogo," ibid., no. 3, 181–97; and "Zametki ob ikonakh iz sobraniia N. P. Likhacheva" in *Russkaya ikona* (St. Petersburg, 1914), no. 1, 21–47.

25 K. Malevich, "Suprematizm" in the catalogue of the "X State Exhibition: 'Non-Objective Creativity and Suprematism'" ("X Gosudarstvennaia vystavka "Bespredmetnoe tvorchestvo i suprematizm"") (Moscow, 1919). Reprinted in I. Matsa et al., *Sovetskoe iskusstvo za 15 let* (Moscow-Leningrad, 1933), 115.

26 The magazine *Makovets* (Moscow, 1922) played a special role in this promotion. See, for example, P. Florensky, "Khramovoe deistvo kak sintez iskusstv" in *Makovets*, no. 1, 28–32.

27 S. Scherbatov, "Russkie khudozhniki" in *Vozrozhdenie* (Paris, 1951), no. 18, 117.

28 B. Livshits, *Polutoroglazyi strelets* (Leningrad, 1933), 79.

29 Quoted from ibid., 83. Goncharova expressed her ideas about religious art in the form of a letter that she sent to various newspaper editors. For commentary, see T. Durfee, "Natalia Goncharova" in *Experiment* (Los Angeles, 1995), no. 1, 159–64.

30 K. Malevich, "Fragments from 'Chapters from an Artist's Autobiography'" (1933) in J. D'Andrea, ed., *Malevich*. Catalogue of exhibition at the National Gallery of Art, Washington, D.C., and other cities (Washington, D.C., 1990–91), 17. The connection between Malevich's painting and the iconic tradition was the subject of the exhibition "Kazimir Maleviich e le sacre icone russe" at the Palazzo Forti, Verona, 2000 (catalogue by Giorgio Cortenova and Yevgenia Petrova).

31 Shevchenko, op. cit., 56.

32 V. Meierkhol'd and V. Bebutov, "K postanovke 'Zor'" (1920). Quoted in D. Zolotnitsky, *Zori teatral'nogo Oktyabrya* (Leningrad, 1976), 103.

33 See, for example, M. Larionov and N. Goncharova, "Luchisty i budushchniki. Manifest" (1913). English translation in J. Bowlt, *Russian Art of the Avant-Garde. Theory and Criticism 1902–1934* (London, 1988), 87–91.

34 K. Balmont, "Chelovecheskaia povest' Kvichei-Maiev. (Iz teogonii narodov drevnei Meksiki)" in *Zolotoe runo* (Moscow, 1906), no. 1, 78–89, and no. 2, 45–57. Also see his "Strana krasnykh tsvetov (Meksika)" and "Kosmogoniia Maiev: Otryvki iz Sviashchennoi knigi Popol Vukh" in *Iskusstvo* (Moscow, 1905), no. 1, 22–41.

35 V. Markov, *Iskusstvo Ostrova Paskhi* (St. Petersburg, 1914); *Iskusstvo negrov* (Petrograd, 1919); C. Einstein, *Negerplastik* (Leipzig, 1915).

36 Quoted from I. Kozhevnikova, *Varvara Bubnova. Russkii khudozhnik v Yaponii* (Moscow, 1984), 44.

37 For information, see E. Webster, *The Moon Man: A Biography of Nikolai Miklouho-Maclay* (Berkeley, 1984).

38 See, for example, his illustrations to I. Bozherianov, *Voina russkogo naroda s Napoleonom 1812* (St. Petersburg, 1911).

39 N. Goncharova, "Letter to the Editor" (1912). Quoted in Durfee, "Natalia Goncharova", op. cit., 162.

40 For a photograph of the stone maiden at Abramtsevo, see Beloglazova, *Abramtsevo*, op. cit., unpaginated.

41 V. Giliarovsky, "Bratsy-estety" in *Golos Moskvy* (Moscow, 1910), no. 69, 3. Also see Larionov's response, "Gazetnye kritiki v roli politsii nravov" in *Zolotoe runo*, 1909/10, no. 11/12, 97–98. Valery Briusov described the polemic in his diaries, i.e. *Dnevniki 1891–1910* (Moscow, 1927), 142, 191–92.

42 J. Bachofen, *Das Mutterrecht. Eine Untersuchung über die Gynokratie der Alten Welt und ihrer religiosen und rechtichen Natur* (Stuttgart, 1861). Florensky also referred to Bachofen in his essay "Naplastovanie egeiskoi kul'tury" in *Bogoslovskii vestnik* (Moscow, 1913), vol. 2, no. 6, 346–89.

43 N. Goncharova, *Misticheskie obrazy voiny* (Moscow, 1914).

44 For information on Modern Lubok, see V. Denisov, *Voina i lubok* (Petrograd: Novyi zhurnal dlia vsekh, 1916).

45 For a discussion of this see, S. Ringbom, *The Sounding Cosmos. A Study in the Spiritualism of Kandinsky and the Genesis of Abstract Painting* (Abo, 1970).

46 B. Livshits, *Polutoroglazyi strelets*, op. cit., esp. chapter 1.

47 A. Kruchenykh, "Koldovstvo shamana" in Archive of Mikhail Matiushin, Pushkin House, St. Petersburg, call number: f. 656, l. 7.

48 For a reproduction of the frame, see M. Calvesi, *L'arte moderna* (Milan, 1967), vol. 5, no. 44, 314.

49 See. J. Bowlt, ed., *The Salon Album of Vera Sudeikin-Stravinsky* (Princeton, 1995), xxvii–xxx.

50 Letter from Ilya Zdanevich to Mikhail Zdanevich dated 5 February 1913. Archive of Ilya Zdanevich, State Russian Museum, St. Petersburg, call number: f. 177, ed. khr. 50, verso of sheets 2–3.

51 Larionov maintained that, after winning a grant to visit Turkey from the Moscow Institute of Painting, Sculpture and Architecture, he visited Tiraspol instead, where he painted "Turkish" types and

scenes. See A. Parton, *Mikhail Larionov and the Russian Avant-Garde* (Princeton, 1993), 40. Larionov also seems to have invented some of the poets such as Frank and Semenov who "contributed" to the miscellany that he produced in 1913, i.e. Oslinyi khvost I mishen' (Moscow).

52 V. Kandinsky, "Programma Instituta khudozhestvennoi kul'tury" (1920). English translation in P. Vergo and K. Lindsay, *Kandinsky. Complete Writings on Art* (Boston, 1982), vol. 1, 455–72, esp. 467.

53 For information on the signboard and the artists of the avant-garde, see A. Povelikhina and E. Kovtun, *Russian Painted Shop Signs and Avant-Garde Artists* (Leningrad, 1991). For a general discussion of late nineteenth- and early twentieth-century urban folklore, including signboards, see Ya. Rivosh, *Vremia i veshchi* (Moscow, 1990).

54 For information on Pirosmanashvili, see, for example, K. Zdanevich, *Pirosmanashvili* (Tbilisi, 1965); G. Buachidze, *Pirosmani ili progulka olenia* (Tbilisi, 1981); and E. Kuznetsov, *Niko Pirosmani* (Leningrad, 1983).

55 M. Larionov, "Predislovie" in *Mishen'*. Catalogue of exhibition at the Art Salon (Moscow, 1913), 6.

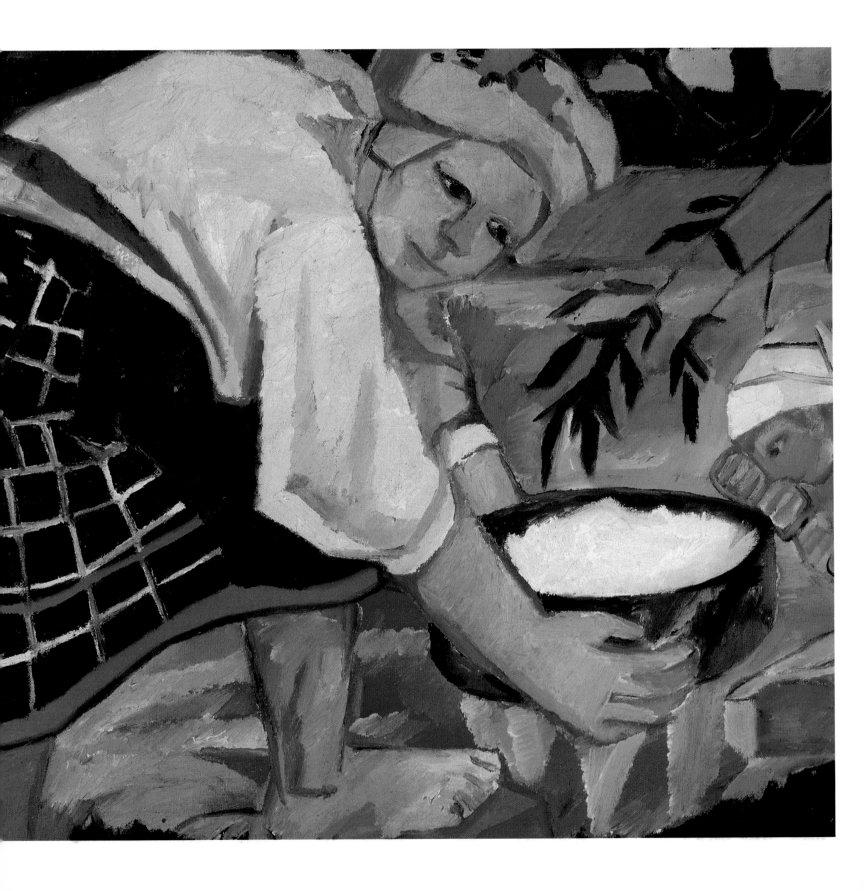

THE CREATORS OF NEO-PRIMITIVISM IN THEIR OWN WORDS

Elena Basner

"I was troubled by the separation of one form of art from another, [fine art] from folk and children's art, from [ethnography]; [the creation of] rigid borders between such kindred, it seemed to me, often identical phenomena, which, in a word, were interconnected by such synthetic relations."[1]

These words, written by Wassily Kandinsky, might serve as the key to better understanding the mutual influence of different, seemingly antithetical types of art — of innovative and traditional, rational and intuitive, "high" and "low." A great number of statements in theoretical articles, polemical interjections at public debates, manifestos, and letters demonstrate that these interrelationships were of central concern both to artists entering their formative period during the early twentieth century and to their contemporary critics.

The artist and critic Alexander Benois belonged to an earlier generation than the members of the avant-garde discussed here, and their ideas — and even more so, the forms that these ideas sometimes took — were deeply foreign to him. Nevertheless, it is precisely with his article — whose title, "A Turn Towards *Lubok*," is itself significant — that we must begin this look at Neo-Primitivism. A perceptive, and more importantly, sympathetic scholar of the contemporary artistic process, Benois could not fail to see in the rising tide of Primitivism the future of a powerful movement. A penetrating critic, he could not fail to understand "that this is a systemic phenomena; this is not an offhand joke by some clever people, but a symptom with deep roots, [and] an irrepressible destiny. This is not an accident, but a law, whose explanation lies, on the one hand, in the necessary reaction against a narrow over-refinement of modern culture, and, on the other, in inspired intuition, which forces the artist to seek a spiritual rehabilitation in a kind of nakedness of feeling, a kind of embrace of materiality — the rough earth, some kind of purposeful savageness. There has been too much candy — hence the yearning for black bread."[2]

A few years after the appearance of Benois's essay, the scandalous success of the *Jack of Diamonds* exhibition, and the even more provocatively titled *Donkey's Tail* show, the image of artists seeking "a spiritual rehabilitation" was most fully and accurately summarized by Alexander Shevchenko in his brochure *Neo-Primitivism: Its Theory, Its Possibilities, Its Achievements* (1913). (It should also be noted that the quotation in the title of this article comes from Shevchenko's brochure).

In this tract, Shevchenko wrote: "We desire a quest for new paths in our art, yet we by no means reject the old. And among the earlier forms, we have the highest regard for primitive art — the magic

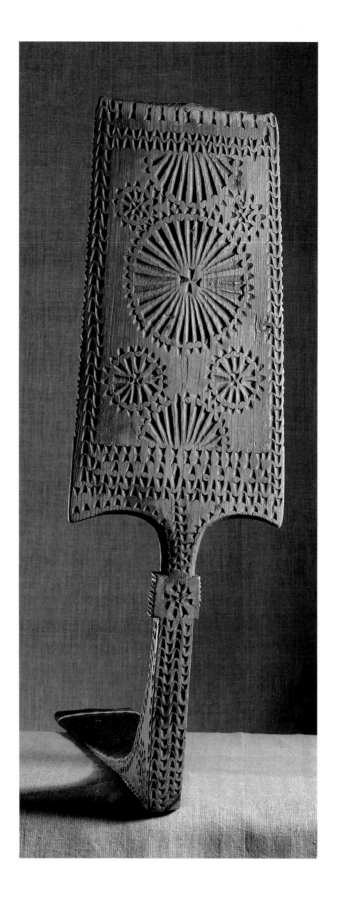

fairy tale of the old East. The simple, guileless beauty of *lubok*, the austerity of the primitive, the mechanical precision of construction, nobility of style, and fine color, all brought together by the creative hand of the master artist—that is our password and our slogan…

"We take *lubok*, the primitive, and the icon as the point of departure for our Art, for in them we find the sharpest and most direct perception of life; moreover, a purely aesthetic perception."[3]

The term "Neo-Primitivism" was coined by Shevchenko, who endowed it with the connotations it retains: "The word 'Neo-Primitivism' indicates both our starting point and, by its prefix 'Neo,' evokes the links to the artistic movements of our own day."[4]

The fact that the term was not immediately accepted for all art based on folk and archaic traditions can be seen from the lecture delivered by the poet Sergei Bobrov at the Pan-Russian Congress of Artists, which was held in St. Petersburg in late 1911 and early 1912. Bobrov spoke on behalf of the *Donkey's Tail* group, which was headed by Mikhail Larionov and included Shevchenko among its members, but his presentations focused on European painting in general. Noting "the great artistry of Cézanne and Gauguin," he suggested "calling these masters and their followers 'Purists,' for… they succeeded in hitting on true, unadulterated, and pure art."[5]

Bobrov contrasted "Purism" with "Realism" (dismissing the latter as a "course in elementary ethics") by noting that the former recognized and used primitive art: "The Realists…were creators by accident. Purism explored creativity self-consciously. It began to study the art of savages, of [ancient] peoples, of archaic painters—among whom mimetic forms are almost never used—and it came to the conclusion that their art had greater beauty, and more of that inner power that gives value to art, than

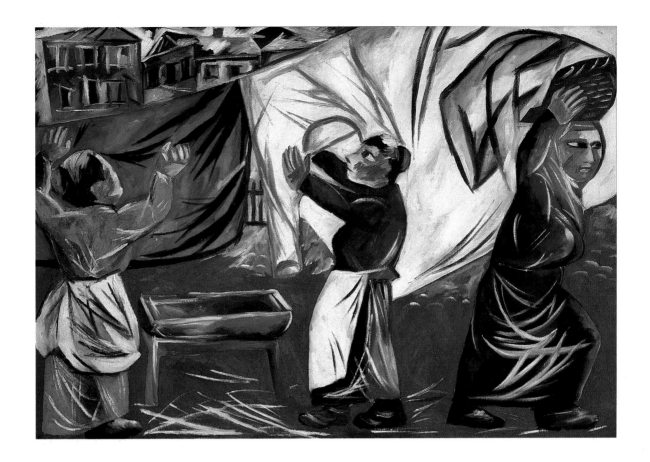

those objects that are closer to nature. And this school followed these guileless masters, these anony-mous geniuses."[6]

Referring to Russian Purists, among whom he included above all Natalia Goncharova, Bobrov stressed that they finally "stopped learning from France." By overcoming the French, the Russian Purists began to see how much there was in their motherland that was still untouched and undevel-oped: "Our amazing icons — these crowning laurels of Christian religious art — our old *lubok*, northern embroideries, steles, bas-reliefs on communal wafers and crosses, and our old signboards.

There is so much new and untouched here. Today, it seems, artists have come to love antiquities and to study them, yet for some reason they go no further than a cheap and vulgar stylization, not under-standing or perceiving the tremendous artistic value of these guileless masterpieces. By contrast, Russian Purists, having noted all of these achievements, have embraced them, and have penetrated into their very souls. Henceforth, our national antiquities, our archaic traditions will lead us towards unexplored horizons."[7]

Speaking at the same congress, the artist Nikolai Kulbin likewise discussed the beneficial influence of Naïve art (in which he included folk art) on contemporary artistic trends. Although in his own art Kulbin adhered to Neo-Impressionism and Fauvism, he served as a passionate propagandist of the new art by organizing numerous debates and exhibitions. He particularly stressed the importance of an unspoiled artistic world-view, which was untouched by civilization and professional study: "besides the art created by man the artist…there is in nature also the art of animals, of primitive man, of children, and, finally, the art of an entire people acting as one. And, in these kinds of art, in the great unconscious art achieved for the most part through intuition, we see the same features that are char-acteristic of the new art. In ordinary folk sculpture, we encounter art that exhibits the newest tech-

niques, and at the same time is endowed with such an undeniable and resounding beauty that we can acknowledge it absolutely and without reservation. [8]

The idea that a similarity of form and a spiritual kinship connected the makers of folk art and the members of the newest artistic movements was likewise expressed by Natalia Goncharova. Speaking at the famous *Jack of Diamonds* debate held at the Polytechnical Museum in the spring of 1912, Goncharova declared, "Cubism is a good thing, although not entirely new. Scythian steles, the Russian painted dolls sold at fairs, are all made in a Cubist style. These are all works of sculpture, but in France as well, the images of Gothic sculpture were the starting point for Cubism." [9]

A year later, in the foreword to the catalogue of his *Exhibition of Icon-Painting Originals and Lubok*, Mikhail Larionov compared the techniques used in folk prints, in which the object is freely positioned in various planes and from various points of view, to the representational principles of composition discovered by Pablo Picasso and Georges Braque. [10]

Natalia Goncharova and Mikhail Larionov, for both of whom folk art was perhaps the greatest, most living and inexhaustible source of personal inspiration, spoke with concern about the need to protect old monuments as examples of artistic traditions. In December 1911, Goncharova wrote in the *Against the Current* newspaper: "…the meaning of these creations for the future of Russian art is immeasurable. Great and serious fine art cannot become truly national. By denying the achievements of the past, Russian art is hacking away at its roots. I am not saying that foreign influence is harmful or useless. But you need to mix the alien [tradition] with your own. Only thus can you create the necessary surge to push art forward." [11]

David Burliuk, a tireless advocate of the new art and the "father of Russian Futurism," wrote about his love for folk art by describing it as "that which, it seems, is presently most important and necessary for the well-being of Russian culture." He continued, "…How can we not value or even notice the treasury of our national spirit…the coffer of our folk painting, which is disappearing before our eyes without study, classification, or preservation. The Russian 'contemporary *lubok*,' folk icon painting (that is hand-made icons)—the pride of Russian art—our outstanding signboards (which constitute innumerable masterpieces in the provinces and the most obscure back-alleys)." [12]

"The artist Mansouroff, who knew Larionov in Paris, recounted Larionov's and Kandinsky's hunt for *lubok* among the Moscow vendors: 'Most often he and Kandinsky wandered among the bazaars in search of peasant-made *lubok*. There you are, it was not Cézanne, but Prince Bova and Tsar Saltan, accompanied by angels and archangels, all covered with a layer of transparent dye, that became the source of all sources." [13]

In the 1920s, Kazimir Malevich confessed to his students his interest in folk art, and especially in painted signboards: "We would go around the bazaars to look at the signboards, and learn from them, and then look at the people around us and see in them the same feelings and faces…. The signboard painters masterfully depicted these sensations and countenances." [14]

The words of Bobrov and Kulbin at the Pan-Russian Congress of Artists, the passionate speeches and publications of Goncharova and Larionov, and the recollections of Malevich were doubtless an expression of ideas that shaped the thoughts and mental dispositions of the artistic circles of the early

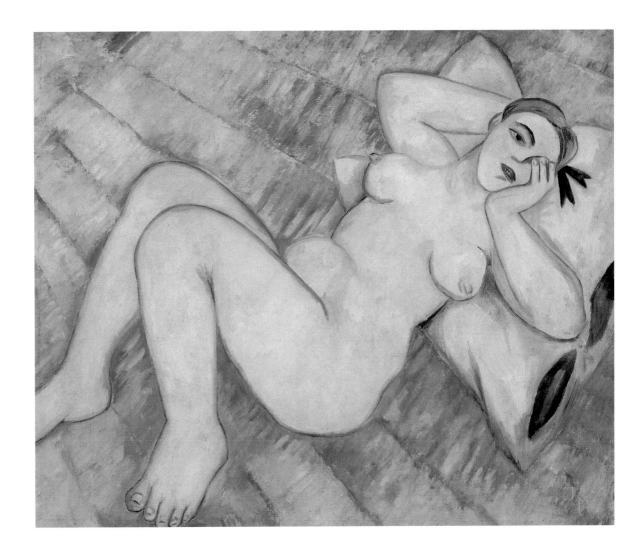

1910s. These ideas took their most developed form in the works of Voldemars Matvejs, one of the most perceptive ideologues of the new art. [15]

Matvejs declared himself to be against the concept of "Eurocentrism" and insisted on the undeniable value of oriental art. He was thus instrumental in creating the "myth of the East," which was influencing the art of many contemporary painters, poets, and playwrights: "If we survey the panorama of all world art, we will notice two distinct and diametrically opposite poles, two principal movements that are at odds with each other. These two worlds are constructiveness and non-constructiveness. The first can be seen most clearly in Greece, the second in the East.

"…Ancient peoples and the peoples of the East did not have our scientific reasoning. They were children for whom feeling and imagination dominated logic. They were simple, unspoiled children who penetrated into the world of beauty through intuition, and who could not be bribed by realism or by scientific studies of nature. Contemporary Europe does not understand the beauty of the unreasoned or the illogical. Our artistic tastes, brought up on rigid rules, cannot let go of the existing world view; they cannot reject "this world" and surrender to the world of feelings, love and dreams, to pass through anarchism, which ridicules established rules, and to slip into the non-constructive world." [16]

Voldemars Matvejs's main theoretical positions were further developed in the 1920s by Nikolai Punin, who had great respect for his predecessor. The main principle of many of his articles remained the significance of primitive art for world culture:

"Primitive art is...the stimulus for a new renaissance of European art, or at least for its renewal. It has broken the closed circle of century-old traditions that have dominated bourgeois art, and it has injected into these traditions forces of entirely different cultural worlds; it has weakened the inner contradictions of European artistic culture introduced by artistic idealism.

"In a formal sense, primitive art has liberated painting from the conventions that limited it since the Renaissance, and thereby brought the fixed-range of 'Renaissance forms' closer to folk art; the influence of folk pictures, peasant toys, and decorative painting on contemporary art has frequently been noted; finally, primitive art has given the contemporary artist that life-affirming power and mighty expressiveness of the artistic language that characterizes the art of our time and that differentiates it from the somewhat tepid and overrefined art of the late eighteenth and early nineteenth centuries." [17]

The aforementioned "myth of the East" became one of the leitmotifs of the Russian Neo-Primitivist movement. Alexander Shevchenko wrote in his manifesto: "The word 'primitive' points directly to eastern origins, for in our time it is understood to signify a myriad of eastern arts: Japanese, Chinese, Korean, Indo-Persian, etc." In our school, this word indicates a style of painting (not the subject matter), a manner of execution that relies on eastern traditions of painting, an internal and spiritual closeness with the East." [18]

In the foreword to the catalogue of her one-woman show in 1913, Natalia Goncharova wrote: "...my path [leads] to the original source of all art, to the East. I am rediscovering the path to the East, and I am certain that many will follow me. Where else but from the East do all the western masters whom we have studied for so long derive their inspiration? And yet we have failed to learn the essential: not to imitate senselessly and not to search for one's individuality, but to create artistic works with the knowledge that the source from which the West draws is the East and ourselves." [19]

From this well-known and often cited passage it is clear just how broadly Natalia Goncharova and the artists of her circle interpreted the concept of the East, projecting it onto folk art, icon painting, and their own art: "For me the East is the art of new forms: broadening and complicating the problem of color. It will help me to express modernity better and more vividly, to bring out its living beauty. The purpose of my nationalist aspirations and interest in the East is not to simplify the tasks of art, but, on

the contrary, to make it all-embracing and global. And if I extol the art of my own country, it is because I believe that it should and deserves to occupy a more honored place than it has until now." [20]

The spirit of "orientophilia" is also present in the writings of Mikhail Larionov and his supporters in the foreword to the *Target* exhibition and in the manifesto *Rayonists and Futurists*: "We seek the East and draw attention to national art. We protest against the slavish obedience to the West, which returns to us our own and Eastern forms flattened and debased." [21]

"Long live the wonderful East! We unite for joint work with modern eastern artists. Long live nationality! We go hand in hand with the signboard painters." [22]

One of the most talented and original followers of Mikhail Larionov was Mikhail Le-Dantiu. In a defining, theoretical article in 1914, Le-Dantiu examined the question of artistic mastery by returning the reader to the mutual influence of folk and professional art:

"One must seek all the valuables created by genuine artists over this period, one must study *lubok*, signboards, embroidery, handicrafts, etc. This is where the real inheritance of Russian art can be found in all of its independence, defining traits, and advantages. Turning to modern study of this material, one can discover in it inexhaustible possibilities for future artistic development." [23]

A special declarative pathos permeated not only the public comments of Larionov's group, but was characteristic even of their private letters. A typical example is the letter written by Ilya Zdanevich to

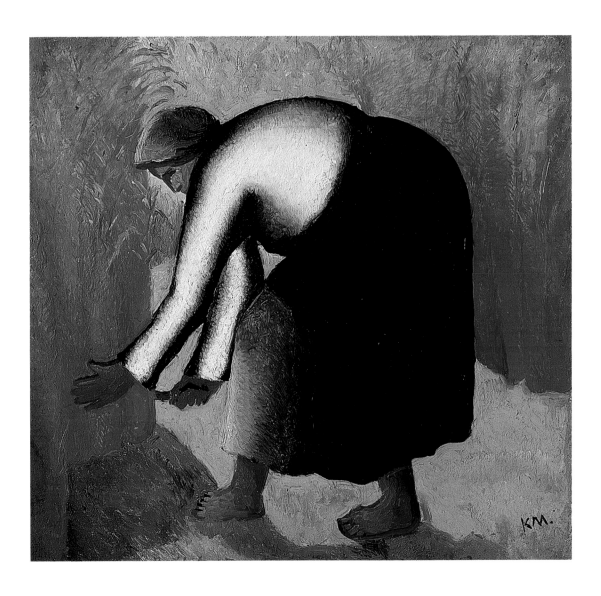

Natalia Goncharova in December 1914, which is now in the manuscript department of the Russian Museum. It so expressively and vividly conveys their style of socializing that it is worth reproducing in full:

"Dear Natalia Sergeyevna, I have learned that you are going abroad to work. From the bottom of my heart I congratulate you. The mighty river of art will now flow from the East to the West and the barbarians are again coming to conquer. How wonderful it is that instead of Léon Bakst, Russia's ambassador will be you, who is true to the East. The flutes and the peacocks cry together at dawn as our armies begin the march. Remaining behind, I greet them and watch from the rooftop as they fade in the distance. But do not forget to return. Although I know that the camp of the enemy cannot lure you. Do not remain in the country of the defeated and of the people of the West. For if you do, the East will stop sending its rays towards you. Our time has come, tomorrow is now today. Man the planes, ready the artillery! You and your art, arising in the East, I greet you. Well, do not let them forget the East! Please accept my regards, Ilya Zdanevich." [24]

The selected statements of the various artists quoted in this article—who examine such complex themes as the search for national sources and their efforts to connect to centuries-old artistic traditions—reflect just how important it was for them to express these questions not only in terms of art, but also in words. Although the history of Russian Primitivism and its offshoots cannot be confined to the names and issues addressed here, even this superficial attempt to examine this turbulent period "from within," from the perspective of the participants, offers a fascinating insight into the complexity and importance of this theme.

NOTES TO THE TEXT

1 W. Kandinsky, "Der blaue Reiter (Ruckblick)", *Der blaue Reiter. Documente einer geistigen Bewegung* (Leipzig, 1986), 161.

2 A. Benois, "Povorot k lubku", *Rech'*, 18 (31) March 1909, no. 75.

3 A. Shevchenko, *Neo-primitivizm. Ego teoriya. Ego vozmozhnosti. Ego dostizheniya* (Moscow, 1913), 9–10.

4 Ibid., p. 13.

5 S. I. Bobrov (*Donkey's Tail*), "Osnovy novoi russkoi zhivopisi (Zasedanie 31 dekabrya 1911)", *Trudy Vserossiiskogo s'ezda khudozhnikov v Petrograde. Dekabr' 1911–yanvar' 1912*, vol. 1 (Petrograd, 1914), 41–42; see also the original text of Sergei Bobrov's speech in A. D. Sarabianov, N. A. Guryanova, Neizvestnyi russkii avangard (Moscow, 1992), 325–26.

6 Ibid., p. 42.

7 Ibid., p. 43.

8 N. I. Kulbin, "Garmoniya, dissonans i tesnye sochetaniya v iskusstve i zhizni", *Trudy Vserossiiskogo s'ezda khudozhnikov v Petrograde. Dekabr' 1911–yanvar' 1912*, vol. 1 (Petrograd, 1914), 46–57.

9 "Pis'mo Natalii Goncharovoi", *Protiv techeniya*, 3 (16) March 1912.

10 *Vystavka ikonopisnykh podlinnikov i lubkov, organizovannaya M. F. Larionovym* (Moscow, 1913), 8.

11 *Protiv techeniya*, No. 15, 24 December (6 January) 1911, 2.

12 A. Povelikhina, Y. Kovtun, *Russkaya zhivopisnaya vyveska i khudozhniki avangarda* (Leningrad, 1991), 186.

13 *Russian Avant-Garde: The Uncompleted Chapters* (St. Petersburg, 1999), 36.

14 Anna Leporskaya's diary entry for 20 October 1926 (private collection, St. Petersburg).

15 Voldemars Matvejs (1877–1914): Studied at the Imperial Academy of Arts in St. Petersburg. Member of the *Union of Youth*, contributed to its exhibitions. Researched ethnography and studied African culture (summer 1913), leading to the posthumous publication of his book *The Art of the Negroes* (1919).

16 V. Matvejs, "Printsipy novogo iskusstva", *Obschestvo khudozhnikov Soyuz molodezhi*, No. 1 (St. Petersburg, April 1912), 8–10.

17 N. Punin, "Iskusstvo primitiva i sovremennyi risunok", *Iskusstvo narodnostei Sibiri* (Leningrad, 1930), 16.

18 Shevchenko, *Neo-primitivizm*, 16.

19 *Vystavka kartin Natalii Sergeyevny Goncharovoi. 1900–1913* (Moscow, 1913), 1.

20 Ibid., 4.

21 *Katalog vystavki kartin gruppy khudozhnikov "Mishen'"* (Moscow, 1913), foreword by Mikhail Larionov, 3; see also the original text in G. G. Pospelov, *Bubnovyi valet. Primitiv i gorodskoi fol'klor v moskovskoi zhivopisi 1910-kh godov* (Moscow, 1990), 248–49.

22 *Oslinyi khvost i Mishen'*, (Moscow, 1913), 9; see also the original text in A. D. Sarabianov, N. A. Guryanova, *Neizvestnyi russkii avangard* (Moscow, 1992), 326–27.

23 A. D. Sarabianov, N. A. Guryanova, *Neizvestnyi russkii avangard* (Moscow, 1992), 331.

24 Letter from Ilya Zdanevich to Natalia Goncharova dated 6 December 1914, *Russian Avant-Garde: The Uncompleted Chapters* (St. Petersburg, 1999), 27.

GLOBALIZATION WITH A RUSSIAN EDGE: RUSSIAN AVANT-GARDISTS AND PEASANT VILLAGE CULTURE

S. Frederick Starr

A revealing test of the richness and vitality of any art movement is the number of times it can be "rediscovered." By this measure, Russian avant-garde painting of the period 1908–25 sets some kind of record. American abstract expressionist painters were among the first to rediscover the movement in the 1950s, albeit at second hand, through those Russians who ended up at the German Bauhaus. These Americans grudgingly admitted that the turn-of-the-century Russians were their own aesthetic precursors. Then Camilla Gray rediscovered the Russian avant-garde in 1962 with the publication of her *The Great Experiment*. For Gray, the Russians had created a laboratory for innovation, and their work constituted the "forgotten thread" of Russian culture. During the 1970s, a fresh rediscovery focused on the avant-garde's post-revolutionary "constructivist" phase. Those in Russia and the West who dreamed of a renewed Soviet Union freed from Stalinism idealized those painters and architects — albeit a minority — who had cast their lot with Lenin's revolution. By the late 1970s and 1980s, painters like Malevich, Rodchenko, Popova, and Larionov were being rediscovered yet again, this time as the long-forgotten but still living roots from which a new, independent, and individualistic art might spring.

And now once more we are rediscovering Russia's avant-garde painters of the period 1908–25. This time they are not aesthetes carving a path to abstract expressionism, cold experimentalists, harbingers of a new left-wing art, or patron saints of a new individualism. Rather, they are the "New Barbarians" who revived a bureaucratized and soulless Russian art by infusing it with the boundless vitality and raw animal spirits of Russian folk art.

There is good reason for this. With the collapse of the USSR, both the Communist ideology and the patronage structure deriving from it came to an end. After such a trauma, how will Russian culture move forward? Two paths lie open. First, one can plunge into the cosmopolitan world of art as it is lived in Paris, London, New York, or Tokyo, not only participating in it, but helping to shape it. Or, second, one can withdraw from the international whirl, dig into the soil of Russian aesthetic life, find whatever roots are still green, and nurture them back into full bloom.

Each path reflects a specific approach to Russian politics and life as a whole. The former, as framed here, is a caricature of the globalist approach. Russia becomes a part of the global monoculture, a contributor, to be sure, but fully assimilated into the larger whole. The latter approach is populist, romantic, and nationalistic, in that it holds out the possibility of a specifically Russian path in art and culture. Never mind that all kinds of mixtures of the two are possible and perhaps even inevitable. For many Russians today, this is an issue on which one must make a choice.

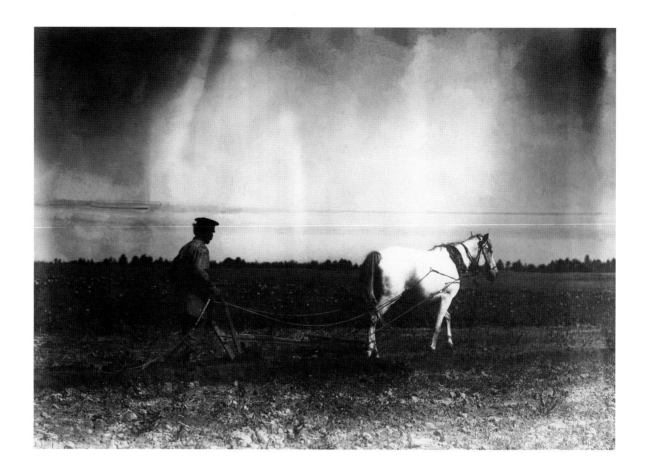

Avant-garde artists of the first quarter of the twentieth century are directly relevant to this debate. Far more than any Russian practitioners of "high art" before them, they immersed themselves in the world of peasant arts and crafts. They were in full rebellion against those artists of the older generation who had once raised the revolutionary banner of realism, only to become thoroughly assimilated into the very establishment against which they railed. The upstarts had nothing but contempt for the old realists' tendency to preach through their art. Who cares if Academy member X championed peasant land reform or if Academy member Y favored a more aggressive foreign policy against the Ottoman Turks or Central Asian emirs? Their paintings are stilted and generic, lacking any hint of a specifically Russian voice.

But where was a new approach to be found? The budding primitivists said "Just look around you." Peasant Russia in 1900 was flooding to the cities, bringing to staid Moscow and St. Petersburg hard-drinking rustics with rough habits. But with them also came the echo of country songs, village dancing, religious rituals, and sophisticated crafts. Or one could read the monographs of a whole school of ethnographers who, throughout the late nineteenth century, had been collecting information on these traditional arts. Or, again, one might visit the artists' colonies run by such wealthy Russians as financier Savva Mamontov or Princess Tenisheva, where a new generation of artists had for years been collecting and finding inspiration in village handicrafts and peasant manufactures.

Back in the 1860s, the older generation of Russian artists and musicians had also made its rebellion in the name of Russia's heritage. Its commitment to it is manifest in Rimsky-Korsakov's or Tchaikovsky's ample use of Russian melodies or Vasily Perov's or Illarion Pryanishnikov's paintings of deep rural subjects. But if the older generation was content to describe peasant life from the outside, the young rebels wanted to capture its very essence in a direct and tactile way. Only through such a

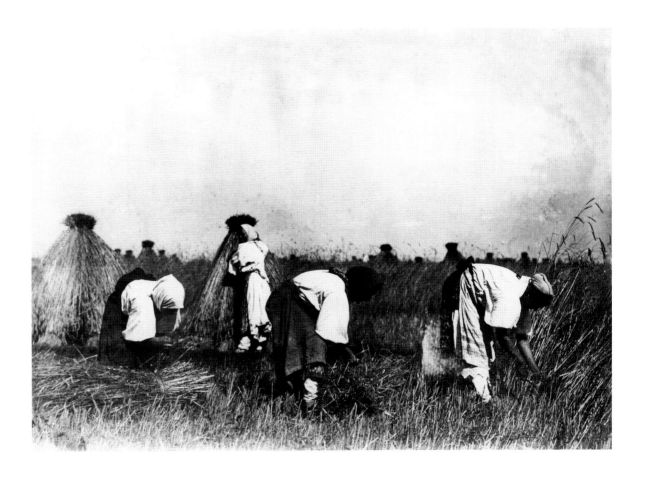

process can the artist convey the raw vigor, spontaneity, and animal energy that is the heart and soul of folk culture. This is what young Stravinsky set out to do in *Petrushka* and what every painter in this exhibition achieved in the works shown here.

There is a sad irony in the artistic discovery of Russia's peasant and lower-class life during the decades before the First World War. The age had been ushered in by terrible rural famines, which in the 1890s and again in the first years of the new century decimated the peasant population and disrupted its ancient ways. Peasant life was in a state of collapse at the very time peasant primitivism arose as a movement in Russian art. Huge factories on the outskirts of Moscow scooped up young peasants fleeing the countryside and chained them to a bleak and colorless existence. One wonders if the primitivists' use of bold primary colors deriving from the folk palette was done with any realization that the world they so admired was ceasing to be, to be replaced by urban smoke and industrial gloom?

There is a further paradox of this movement, which stressed the "made in Russia" theme. To industrialize itself, Russia had sold hundreds of millions of dollars' worth of bonds abroad, mainly in France. By World War I, the largest outstanding debt on earth was that owed by Russia to France. Russian-owned factories were booming, but foreign firms like Singer Sewing Machine and International Harvester were coming to dominate Russia's economy. By implication, Russian primitivism in the arts seems to oppose, or at least regret, all this. As it extolled the vigor and vitality of Russia's indigenous folk culture, however, was it looking forwards or backwards?

There is scant reason to believe that such political and social concerns entered the conscious minds of most Russian primitivist artists. Their more immediate goal was to capture the sheer energy, vitality, raucous spontaneity, and erotic power of folk culture. With the exception of the aristocratic Natalia

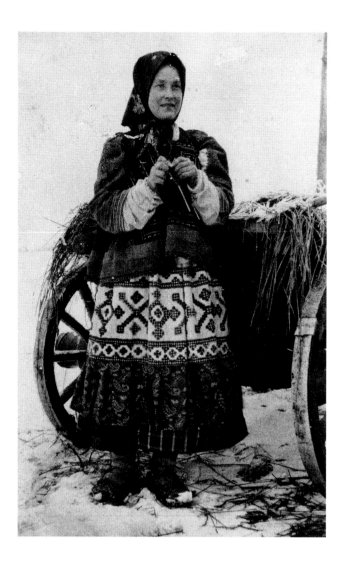

Goncharova, most of the new artists came from modest and unpolished backgrounds. Thus, when Mikhail Larionov painted card players in a bar or soldiers dancing, he is giving voice to a kind of sour grapes: "See, these people whose boots would track mud across the carpet of your salon have something you'll never possess."

As one views the folk prototypes and the avant-garde paintings evoking them, one inevitably asks, "What at bottom is the relationship between them?" A generation ago, Soviet critics were convinced that the folk art "inspired" the primitivists, and that the avant-gardists' works were "based upon" or even "derived from" folk models. Today, we can readily discern a completely different relationship between them. It cannot be denied that the avant-gardists mined the visual archives of Russia. There is no other explanation, for example, for the emergence of brilliant greens and oranges in the works of Goncharova or Popova. Yet time and time again, the modern painters did not "draw on" or "apply" the folk motifs so much as *transform* them. This meant employing them in a totally new medium and setting, and assigning them completely new meanings in a visual language with virtually no ties to the received traditions of Russia.

If the vocabulary of the new visual language often derived from folk prototypes, the syntax and grammar was pan-European and completely contemporary in scope. This is not surprising. The Russians' plunge into the world of primitive art is comparable to Picasso's interest in African masks. Their fascination with the bold and exotic palette of folk culture recalls Cézanne's visual discoveries in the South Seas. Russians' exploration of peasant crafts and design exactly parallels the arts and crafts movement in England, Germany, and above all Scandinavia, notably Finland. Their turn to the elemental and the erotic brings to mind the artists of the Viennese Secession, not to mention a whole school of European philosophers beginning with Nietzsche. Because they were full and integral participants in European culture as a whole, Russian artists were Fauves almost before there were Fauves, and Futurists before there were Futurists.

What, if any, were the differences between the Russian and European champions of folkishness and the village crafts tradition? In Germany and the Anglo-Saxon countries, the movement led to a revival of many handicrafts. The Kunstgewerbeschulen in Austria and the Deutscher Werkbund in Germany are only the two most well known of many European examples of the merger between tra-

*Russian peasants in
traditional folk costumes.
Early 20th century*

ditional crafts and modern production.
Russian populism, as reflected in the
Socialist Revolutionary Party, was by
1917 the most powerful single political
movement in the country. Yet in a coun-
try driving single-mindedly towards
modern industrialism, popular crafts
appeared at best as a curiosity, far
removed from the mainstream of devel-
opment.

Primitivism was everywhere merely
one brief stop along an intensive contin-
uum. Russia's artists transcended the
folkish moment with lightning speed
and never looked back. The early turn to
abstraction by several former primi-
tivists and the astonishing turn to meta-
physical abstraction by Malevich and his
fellow Suprematists has no ready paral-
lel in the West.

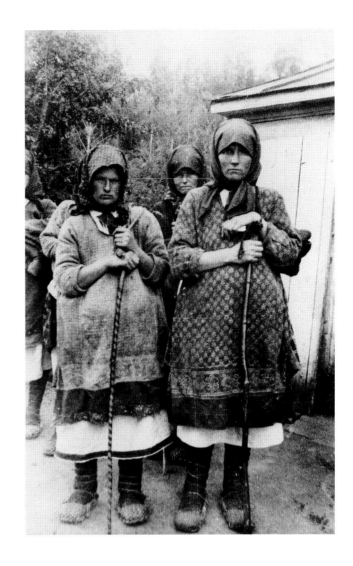

Russia's "New Barbarians" were a product of the rather hermetic world of the Russian intelligentsia
during the last two decades of the Romanov dynasty. In the end, they came up against the genuine bar-
barians in Russian politics, the Bolshevik Party founded by Vladimir Ilich Lenin. Politically, the
painters ranged across the spectrum. While some supported populism or constitutional democracy,
most were disengaged politically. If a single ideology prevailed among them, it was anarchism, not of
the bomb-throwing variety but of that refined version espoused by Prince Kropotkin, that held that
there was little need for government in a society guided by traditions of cooperation and communal
self-government.

No wonder, then, that most of the former primitivists welcomed the fall of the Romanov dynasty
in February 1917. They saw in this first revolution the end of bureaucratic formalism and the possibil-
ity of a new form of rule in which society would govern itself, simply and directly, beginning from the
ground up rather than from the top down. Within eight months, however, Lenin's Bolsheviks had
picked up power from the collapsing government of Alexander Kerensky. Some of the primitivists
immediately fled abroad, to Berlin or Paris. Others stayed in Russia, to be stifled as soon as the
Bolsheviks gained real control over the apparatus of communications and culture.

Bolshevism was above all a movement of urban intellectuals bent on destroying the former middle
class in the name of the urban workers. In a two-stage campaign beginning in 1918 and culminating in
the forced collectivization of the peasantry in 1928–31, they utterly destroyed what remained of
Russia's rural heritage. Stated differently, they brutally industrialized the countryside and in the

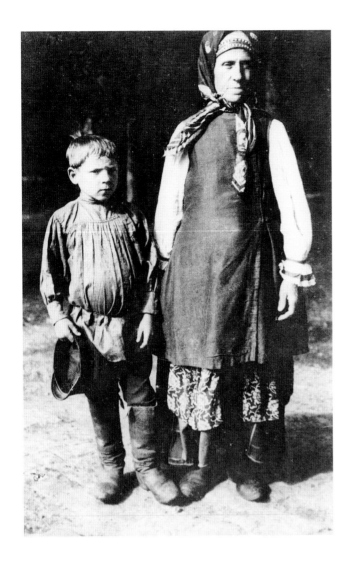

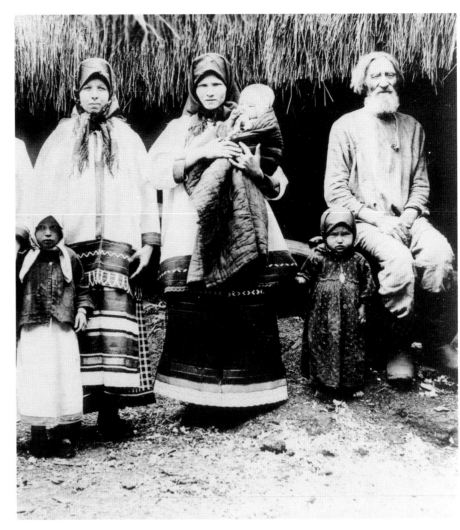

Russian peasants in traditional folk costumes. Early 20th century

process obliterated what little was left of the authentic rural culture from which Russia's "New Barbarian" artists had once gained inspiration.

Which brings us to the present and back once more to the question of globalization. By what path will Russia move forward? During the 1990s, many commentators, both in Russia and abroad, assumed that with the end of the USSR Russia would advance in a "normal" manner, by developing institutions and values similar to those prevailing in western Europe and North America. In spite of many failings, much has been achieved. But it is also painfully evident that it is neither possible nor desirable simply to implant unfamiliar institutions or values in another country. Can Russia, then, build on its traditional practices and indigenous values? The issue is complex and turns on a host of economic, sociological, political, and psychological factors. In that context, it is absurd to suggest that the story of a small group of avant-garde artists almost a century ago is of more than anecdotal importance to the question at hand. Nonetheless, two points concerning the "New Barbarians" are directly relevant.

First, the peasant world from which Russia's primitivists drew was vanishing before their eyes and eventually died over the course of three quarters of a century of Bolshevik rule. The greatest tragedy of Russia's Soviet era is that it was so destructive of Russian culture and values as they had developed over a thousand years. Stated differently, there are very few living roots, little of the riches of a noble traditional culture, that have survived in Russia and upon which Russia can build today.

Second, and more to the point, the primitivists' self-appointed mission was not to copy, build on, or mechanically derive something new from Russia's traditional folk culture. True, they loved it, took

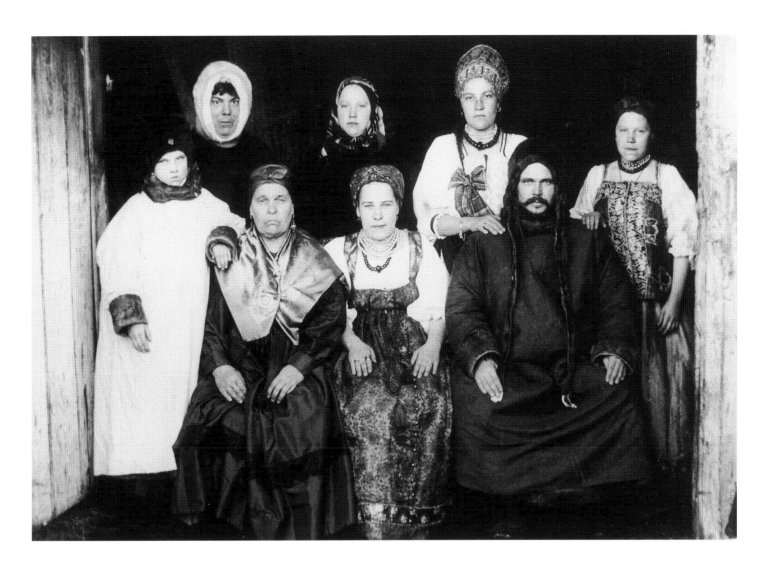

Russian peasants from Archangel Province in traditional folk costumes. Early 20th century

inspiration from it, and occasionally quoted discrete elements of it in their paintings. But they were more interested in the internal essence of Russian peasant and folk life than in its exterior forms. They located that essence in the communal harmony, exuberance, spiritual depth, and brilliant vitality of Russia's peasant heritage.

Rather than simply *adopting* these features for their paintings, however, the "New Barbarians" *adapted* them, mixing them freely with motifs and modes of expression from their contemporary world, both Russian and European.

In the process of effecting this transformation, Russia's "New Barbarians" turned something that had been beautiful yet backward-looking, provincial, and narrowly national into an art that is forward-looking, cosmopolitan, and, yes, global in its appeal.

If this modest history from the world of art is relevant to the debate over Russia's direction forward, the country is not faced with an either/or choice between globalism and localism. Instead, following the example of the "New Barbarians," Russia can find a path to a new global life by affirming yet transforming whatever part of its legacy has survived from the past.

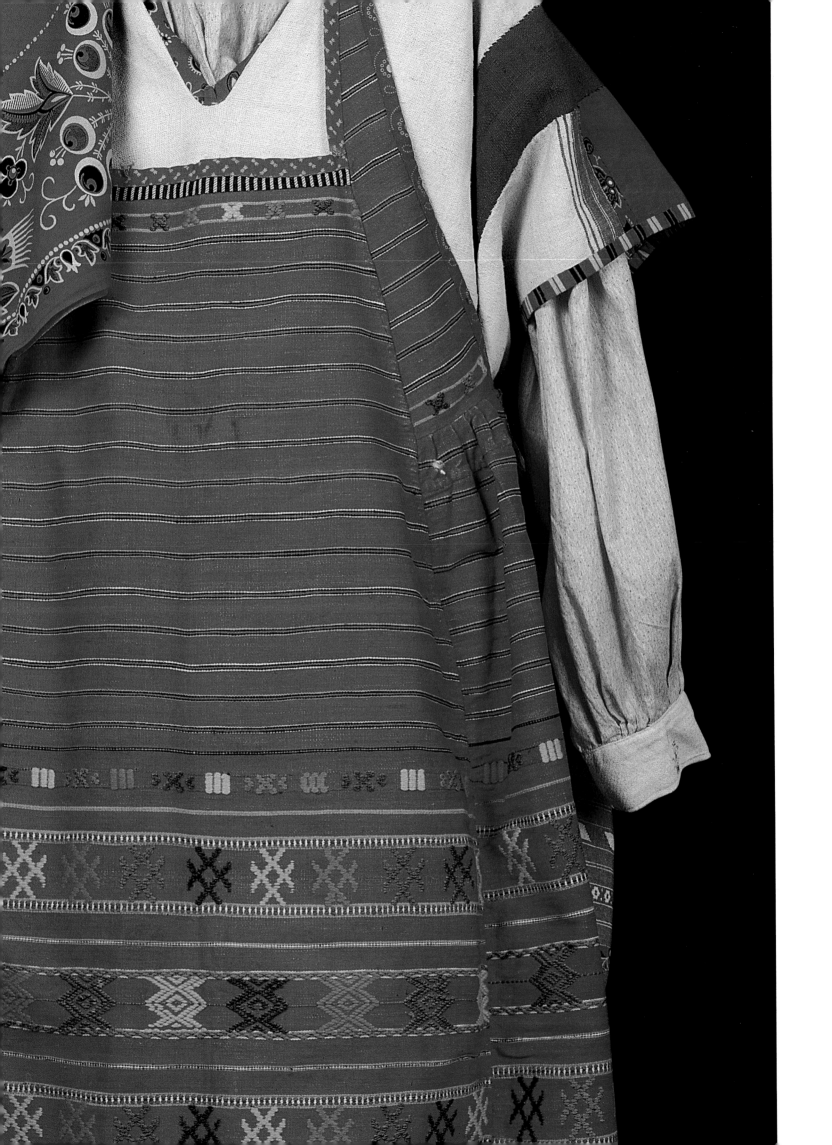

FOLK ART
AND THE ARTISTS
OF THE RUSSIAN
AVANT-GARDE

Irina Boguslavskaya

Throughout the second half of the nineteenth and the early twentieth century, Russian artists in one way or another turned to folk culture, first to its verbal forms through folklore and then to decorative folk art.[1] It was a period of universal interest in national cultural history — Old Russian and folk art — and the appearance of the first collections, publications, and exhibitions acquainting the public with the various forms of folk creativity.

Russia was swept by a movement of support for traditional cottage industries. In large cities and major provincial towns, handicraft museums were created with the support of the *zemstvo* councils (local government bodies established in the central provinces of Russia after the emancipation of the serfs in 1864). Different classes of Russian society — members of the progressive intelligentsia, art patrons, *zemstvo* officials, society ladies, civil servants — contributed to the movement in various ways. The socio-economic and historico-cultural reasons for the trend range from the spread of capitalism to the Russian countryside and the necessity of giving additional earnings to regions with insufficient arable land to the direct influence of the ideas of *narodnichestvo* (populism), a wave of interest in national culture and history and the rendering of practical assistance to craftsmen.

This period saw the formation of the outstanding collections of folk art by Princess Maria Tenisheva, Natalia Shabelskaya, and such artists as Ivan Bilibin, Alexander Benois, Dmitry Dmitriyev-Orenburgsky, and Vasily Mathé.[2] In 1885, Elena Polenova and Elizaveta Mamontova opened the country's first ever museum of folk art in Abramtsevo, a village lying thirty miles to the north-east of Moscow.[3]

Collecting activities spurred visits to the countryside, and artists began to travel across the Russian provinces in search of works of folk art. Wassily Kandinsky made an expedition to the Komi (Zyryan) lands of northern Russia in 1889.[4] The artist was particularly enchanted by the inhabitants' carved wooden huts with their brightly colored interiors. All his life, he retained vivid memories of the works of Russian folk artisans.

Artists of various movements and creative aspirations sought and found personal and professional inspiration in folk sources. Folk art offered some artists themes and subjects; for others, it provided a stylistic basis. This erasure of the traditional boundaries separating "high" and "low" art forms was typical of the Russian avant-garde; the oeuvres of this group of artists also contain many examples of both close adherences to the original sources and works revealing a less direct influence.

Wassily Kandinsky consciously avoided all explicit references to other art forms. The artist spurned acknowledgement of external influence in his work, and his paintings make no overt use of folk art.

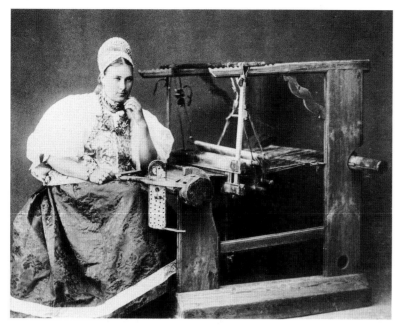 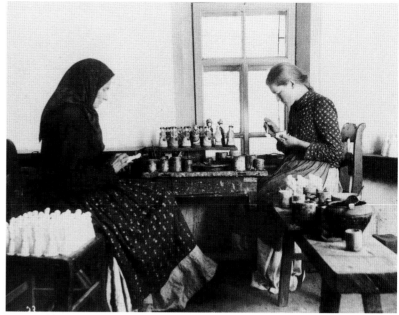

Unlike Kandinsky, Kazimir Malevich deliberately and consciously drew upon the folk tradition. His interest in icon painting and Russian and Ukrainian peasant art is well documented. Malevich was not only inspired by the general principles of folk art, but he also made use of specific folk art forms and techniques. The artist's love of national costumes is reflected in many aspects of his oeuvre — the pure and vivid tones; the predominance of red, white, green, and yellow (particularly in the *Peasant* cycle); the inner harmony, rhythmic repetition, and the geometric forms that pay tribute to the ornamental designs seen in traditional embroideries and fabrics. Malevich also reinterpreted carved roadside crosses and Ukrainian rag dolls with crosses for faces in the paintings of his *Peasant* cycle.

The works of Mikhail Larionov and Natalia Goncharova reflect their own unique understanding of folk art. Perceiving the works of folk craftsmen in purely emotional terms, they discerned various features corresponding to their own creative aspirations. Larionov and Goncharova's concept of "folk art" embraced a wide variety of phenomena, ranging from traditional crafts to signboards and the popular prints of various nations and peoples. They were interested less in the distinctive traits of specific works or centers and more in what they believed to be typical of folk art in general.

Notwithstanding the great diversity of manners and styles falling under the common heading of the avant-garde, these artists were inspired by a number of common features of Russian folk art — the sincere, spontaneous, and often naïve expression of feelings; an uninhibited approach towards artistic expressiveness, capable of turning any image, motif, or composition into purely decorative forms; the general mood of optimism and bright, vivid tones; simplistic forms; the representation of figures as social "types", rather than individuals; and the masterful economy of line and color to capture the essence of the original.

In his brochure *Neo-Primitivism: Its Theory, Its Possibilities, Its Achievements*, Alexander Shevchenko lists what attracted the artists to works of folk art: "Its sharp and spontaneous perception of life…. its simple and balanced style, spontaneous and artistically correct feeling for life, the distinct and austere drawing, harmonious compositions, simplification of form with complication of its concept, artistic, rather than scientific perspective, the rhythms of the movements and colour as such."[5]

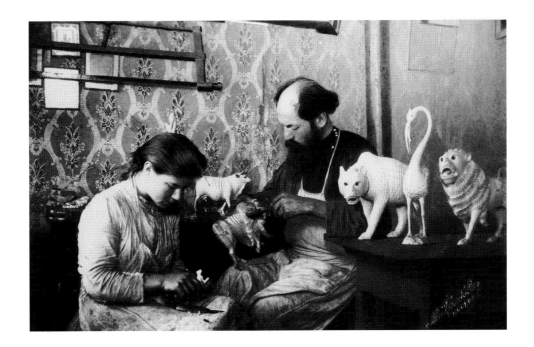

Making traditional wooden dolls in Bogorodsk, Moscow Province. Early 20th century

The Russian avant-garde implemented the fundamental principles of folk art long before they attracted the attention of scholars. Employing their indigenous forms in original ways, the avant-garde artists thus affirmed the inexhaustible wealth and enduring aesthetic merits of Russian folk art.

NOTES TO THE TEXT

1 V. I. Plotnikov, *Fol'klor i russkoe izobrazitel'noe iskusstvo vtoroi poloviny XIX veka* (Leningrad, 1987).

2 *Istoriko-etnograficheskii muzei knyagini M. K. Tenishevoi. Obschii katalog* (Smolensk, 1909); *Katalog vystavki VIII Arkheologicheskogo s'ezda* (Moscow, 1890), section 1 (Natalia Shabelskaya collection); I. Y. Bilibin, *"Narodnoe tvorchestvo russkogo Severa,"* Mir iskusstva, 1904, No. 11; *Igrushka, ee istoriya i znachenie* (Moscow, 1912).

3 N. Beloglazova, *V. Polenov i E. Polenova v Abramtseve* (Leningrad, 1980), 42.

4 V. V. Kandinskii, *Moscow* (Moscow, 1989), 10.

5 *M. Larionov, N. Goncharova, A. Shevchenko ob iskusstve* (Leningrad, 1989), 56, 57, 63, 64.

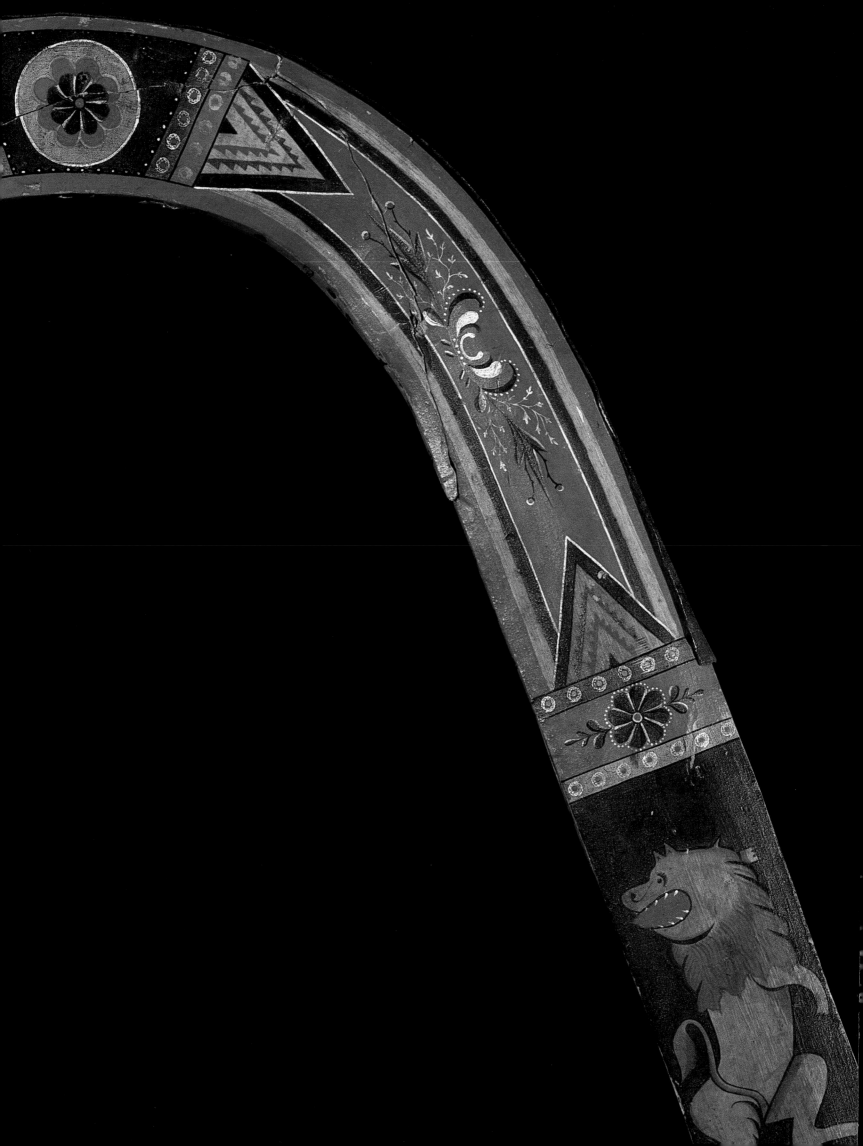

CATALOGUE
of the Exhibition

Ivan **L**arionov
Landscape with Tree
and House. 1899
Gouache on canvas. 57 x 75 cm
Ж-8795

Ivan **L**arionov
Landscape with Tree
and Hill. 1899
Gouache on canvas. 54 x 76 cm
Ж-8796

Ivan Larionov was much influenced
by his elder brother Mikhail Larionov.
Never having received a special art
education, he retained many genuine
features of Naïve art in his paintings.
Ivan Larionov's works were highly
rated in the circle of his elder brother,
who wrote in his *Rayonists and Fut-
urists* manifesto: "Simple and chaste
people are closer to us than the artis-
tic trash that sticks to the new art like
flies to honey." (*E. B.*)

Ivan **L**arionov
Landscape with Tree
and House. 1899
Ж-8795

Ivan **L**arionov
Landscape with Tree
and Hill. 1899
Ж-8796

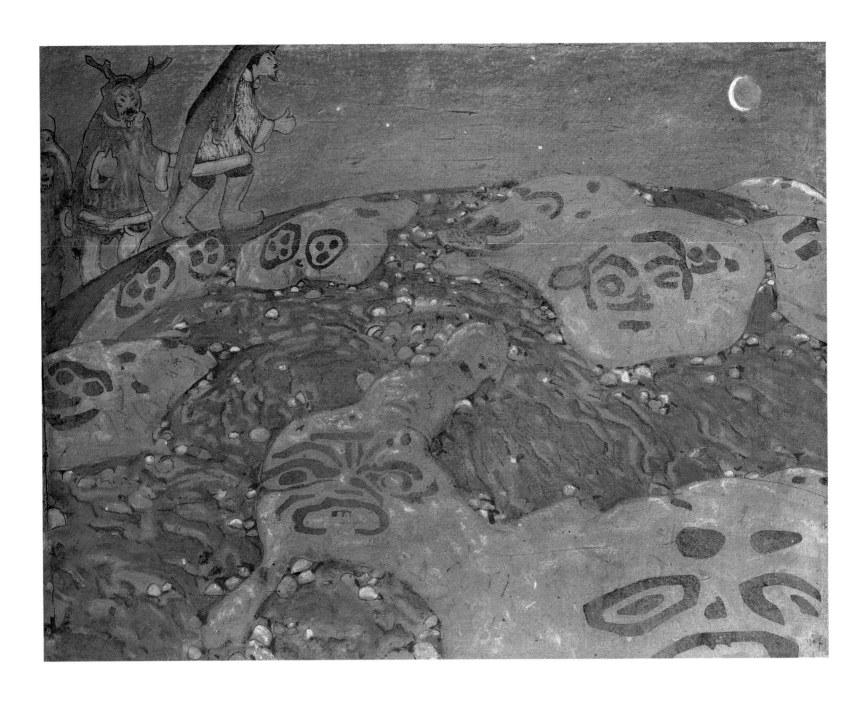

Nicholas **R**oerich
Earthly Curse. 1907
Tempera on cardboard. 49 x 63 cm
Ж-1966

In the 1900s, Nicholas Roerich created a series of paintings in which he attempted to give visual expression to his own understanding of the days of yore. Both as an artist and a scholar, Roerich studied pagan monuments and the anonymous creativity of cultures which had long since vanished from the face of the earth. The master's oeuvre combines figments of the imagination and real impressions from archaeological excavations. Roerich confessed his love of the "profound and captivating northern sagas, the blustery northern winds, the eternal green hills and the silent circles of grey stones." Roerich often depicted northern landscapes, the sites of ancient camps and stones with petroglyphs. His animated and exalted images are almost anthropomorphic. One can almost picture the people of the past coming to these sacred stones at night, performing their secret rituals by the light of the crescent-shaped moon. (*G. K.*)

Nicholas **R**oerich
Idols. Modello. 1901
Gouache on cardboard. 49 x 56 cm
Ж-1961

Nicholas Roerich was a member of the Russian Archaeological Society and took part in many of their excavations. Endowed with great creative fantasy, the artist created stirring pictures of the past based on archaeological discoveries. Roerich's imagination was particularly drawn to ancient idols. Animals were once offered in sacrifice to the wooden effigies of these pagan gods and the places where they stood were regarded as sacred. *Idols* was painted in Paris, at the studio of Fernand Cormon, who said of Roerich: "He feels the character of his country. He has a special point of view." (*G. K.*)

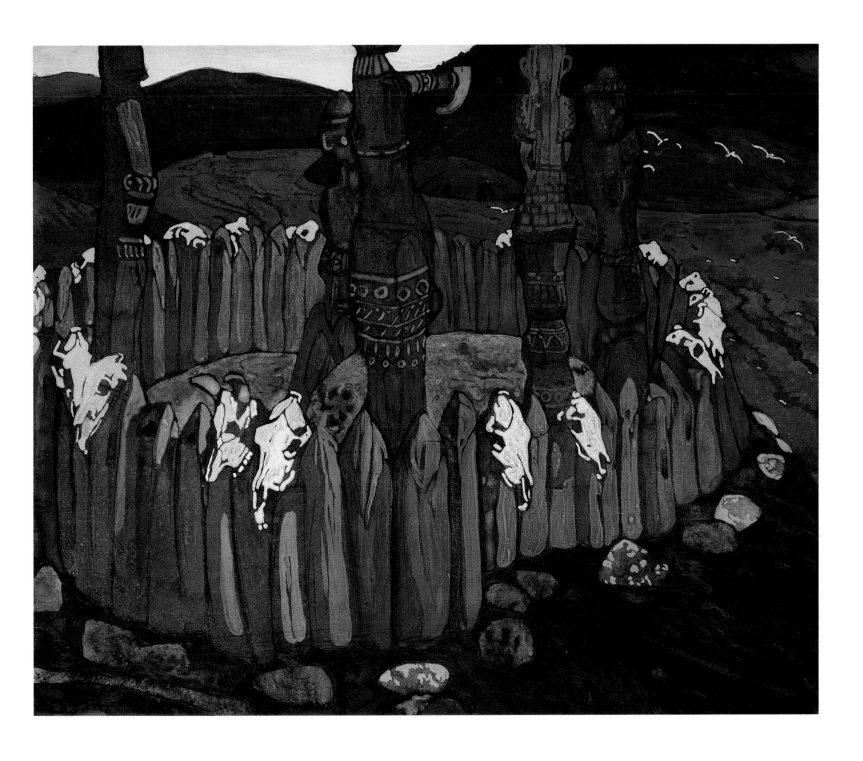

ПѢСНЯ.

Небрани меня родная.	Что такъ рвется ретивое	Въ ясный день и темны ночи	Кудри молодца и взгляды
Что я такъ люблю его.	И терзаюся тоской	И во снѣ и на яву	Сердце бѣдное зажгли
Скучно скучно дорогая,	Все оно во мнѣ изныло.	Слезы мнѣ туманятъ очи	Зжалься зжалься же родная
Жить одной мнѣ безнего	Все горю я какъ вогнѣ	Все летелабъ я къ нему	Нерестань меня бранить
Я незнаю что такое	Все немило все пастыло	Мнѣ ненужны все наряды	Знать судьба моя такая
Въ другъ случилося сомной;	И страдаю я понемъ	Ленты камни и парчи.	Что должна его любить.

Song. 1884
Lithograph. Image: 22.8 x 34.6;
sheet: 35 x 44.3 cm
Гр.луб-1478

Wassily **K**andinsky
Red Church. Circa 1901
Oil on plywood. 28 x 19.2 cm
ЖБ-1163

Wassily Kandinsky's landscape reflects the naturalistic tendencies of his early oeuvre. The painterly structure betrays such various influences as the Union of Russian Artists, French Fauvism and German Expressionism. Kandinsky's aspiration towards generalisation, the active tones and the contrasting combinations pave the way for the artist's future quests. Intensified by its contrast to the surrounding green, the orange-red colour of the church is virtually "liberated" from its object. This search for independence through colour betrays Kandinsky's future painterly experiments. (O. S.)

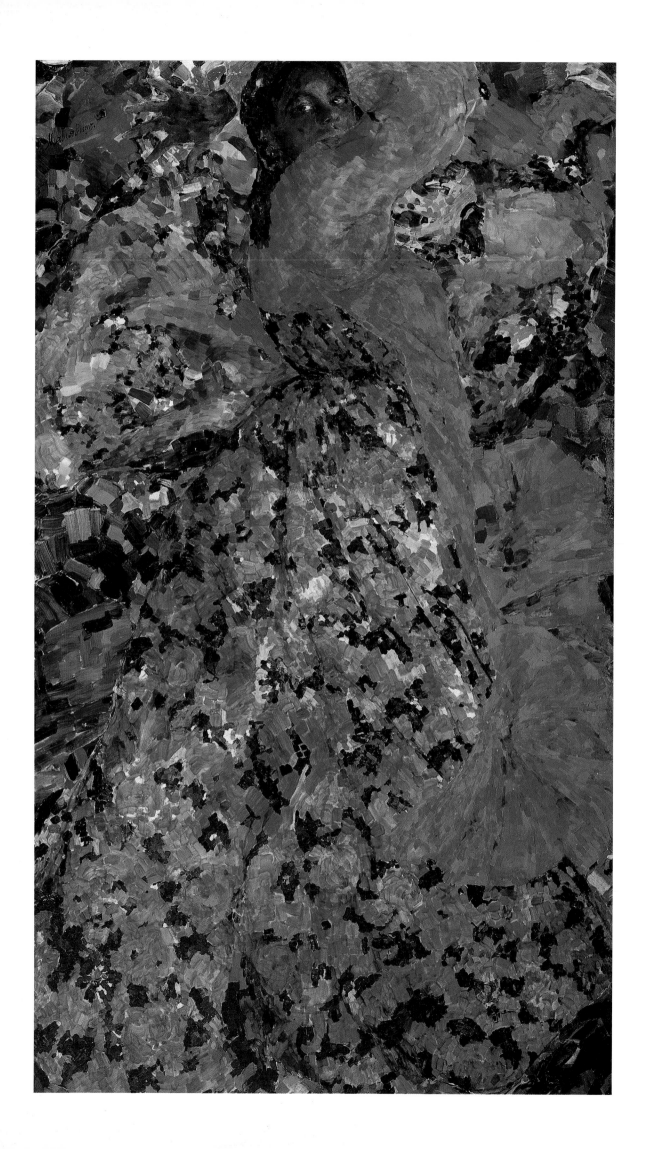

Philipp **M**alyavin
Dancing Peasant Woman.
Late 1900s
Oil on canvas. 210 x 125 cm
Ж-1913

The concept of the latent power of
the Russian people was firmly estab-
lished in the minds of many Russian
artists, particularly Malyavin, who
came from the peasant class. The
artist's quests for a national character
are reflected in his images of peasant
women, in which the general "type"
takes precedence over the specific
individual. *Dancing Peasant Woman* is
engulfed in fiery color. The figure is
full of energy; her bright attire swirls
in the air. The passionate dancing and
innate fortitude of the Russian peas-
antry are personified in this innova-
tive work, which utilizes pictorial con-
ventions found in the folklore tradi-
tion. (*V. K.*)

Distaff. Late 19th or early
20th century
Master V. A. Tretyakov, Zavorye,
Totma district, Vologda Province
Fretwork and paint on wood
87 x 22 x 40 cm
Д-2734

Each locality had its own distinct
forms of distaff and decorative fret-
work, paintwork, and design. Distaffs
were often carved from a single piece
of wood. North Russian distaffs had a
large spindle and were ornamented
with a row of festoons at the top and
wattles at the bottom. The surface of
the spindle and the stand were cov-
ered in thick, trifluted fretwork in the
form of circles, vortex-shaped roset-
tes, diamonds, and squares. The carv-
ed patterns were painted and sup-
plemented with floral designs. Dis-
taffs from northern Russia were often
remarkable works of art in their own
right. (*I. B.*)

Spin, My Spinner. 1892

V. Vasilyev Chrome Lithograph Studio

Lithograph. Image: 19.5 x 32.5; sheet: 35.5 x 43.5

Гр.луб-3394

Philipp Malyavin

Verka. 1913

Oil on canvas. 106 x 84 cm

Ж-1912

The son of a peasant who first studied art at an icon-painting studio and then under Ilya Repin, Philipp Malyavin lauded peasant Russia in his memorable and original canvases. His finest works were painted in the village of Axinino near Ryazan. The artist's models were local peasant girls like Verka, with her dark-complexion, icon-like face and the open gaze of her dark eyes. In his quest for a national type, Malyavin retains all the features of a portrait; such features were then lost in the impetuous and sweeping strokes of the artist's later paintings, leaving only a general impression of the Russian peasant girl. (*V. K.*)

Дозволено Цензурой Москва, 9 МАРТА 1892 года.

Хромо-Литографія В. Васильева, Пятницкая улица, близь Серпуховскихъ воротъ, собств. домъ.

Пряди моя пряха.
 Пряди не лѣнися.
Я бы рада прялa.
 Да меня въ гости звали:
Звали, зазывали
Къ сосѣду во бесѣду
 У сосѣда будетъ

Мой милый пригожій.
 Мой милы хорошій,
Бѣлой, кудреватый.
 Холостъ, неженатый.
Вотъ ѣдетъ мой милый.
 На ворономъ конѣ,
Въ бѣломъ балахонѣ;

Шапочка съ углами,
 Головка съ кудрями.
Къ двору подъѣзжаетъ.
 Дѣвица встрѣчаетъ,
За ручки хватаетъ,
 За столикъ сажаетъ

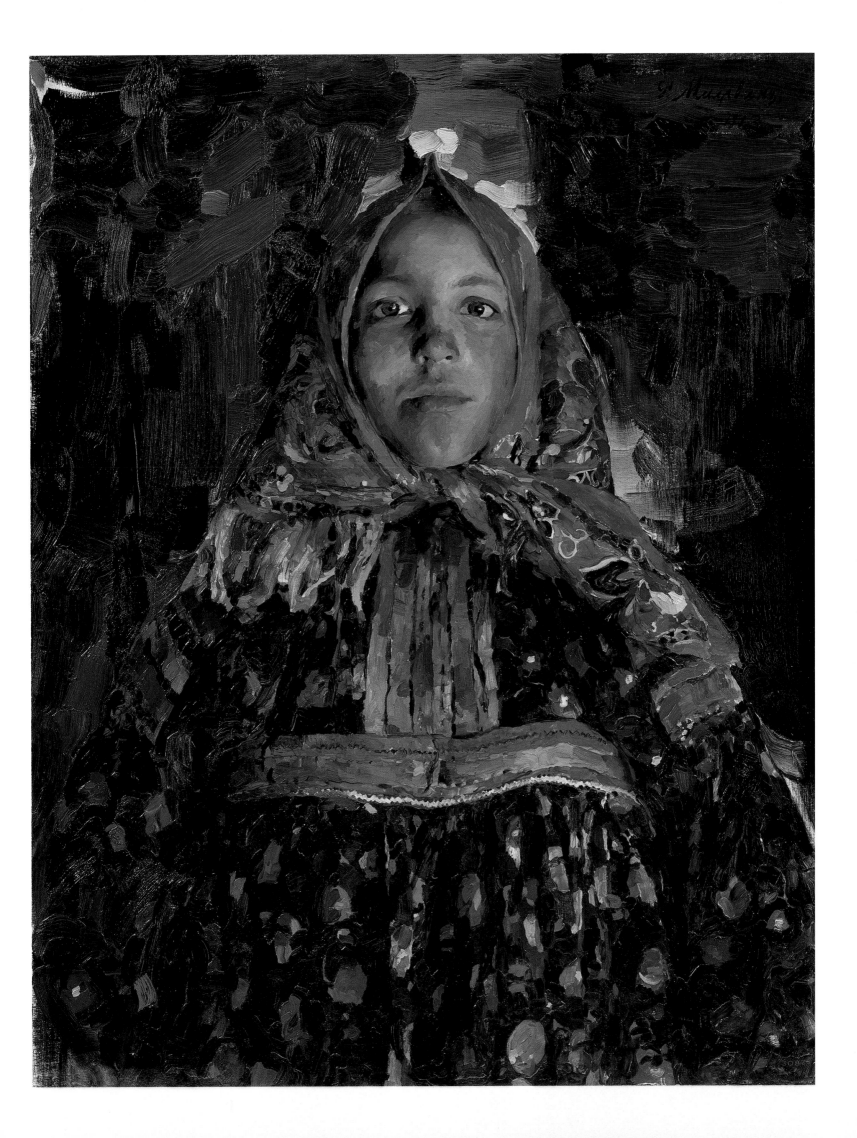

Box. Late 19th century
Mezen district, Archangel Province
Bast and paint on wood.
46 x 40 x 27.5 cm
P-2288

Natalia **G**oncharova
Bleaching Linen. 1908
Oil on canvas. 115 x 103.5 cm
ЖБ-1596

Bleaching Linen is one of Goncharo-va's mature or "classical" Neo-Primi-tive works. The artist was obviously referring to paintings from this stage of her career when she listed the influences on her oeuvre as "Scythian stone stele and Russian painted wooden dolls sold at country fairs" in a letter to a Russian newspaper in March 1912. In her desire to rework traditional handicrafts, Goncharova went one stage further than her avant-garde colleagues. Rather than simply imitating the appearance of Russian folk art, she attempts to re-create the impersonality and spiritual intensity of an artisan mode of pro-duction. (*E. B.*)

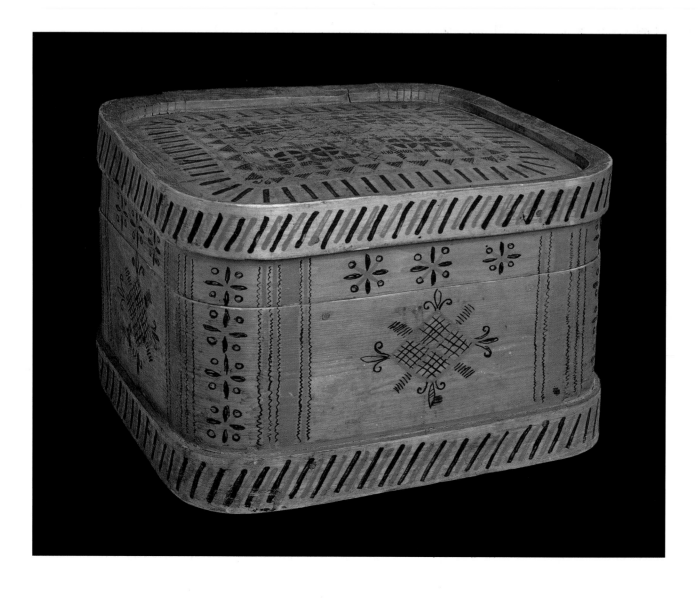

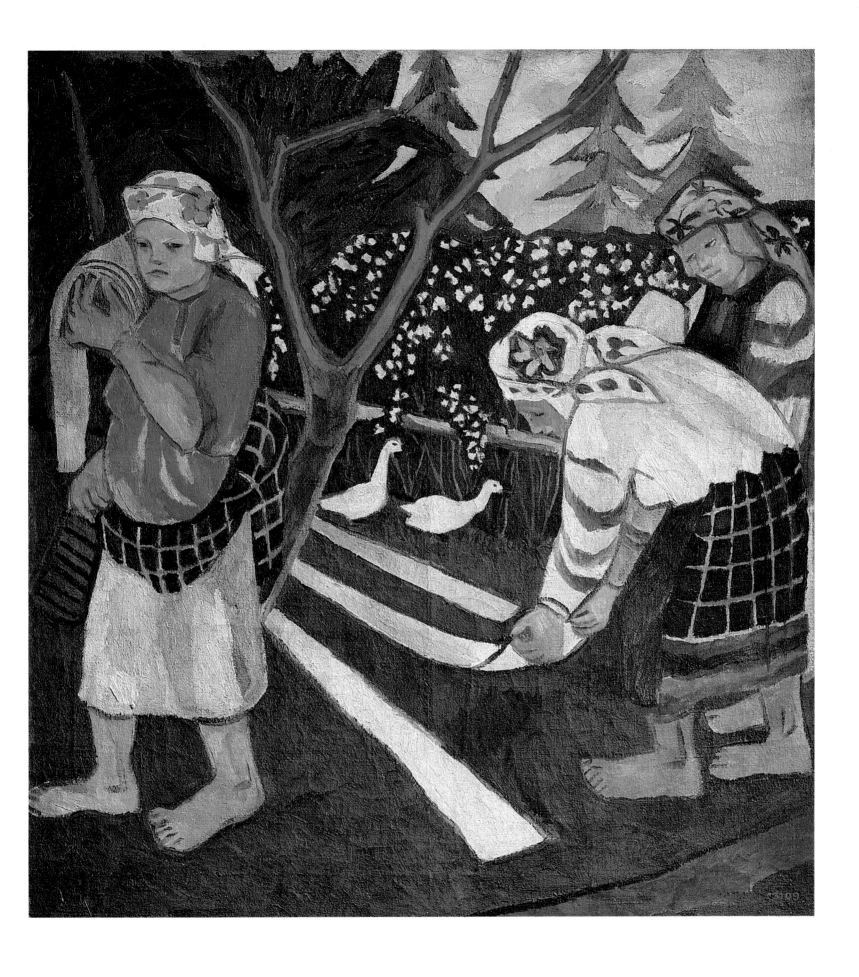

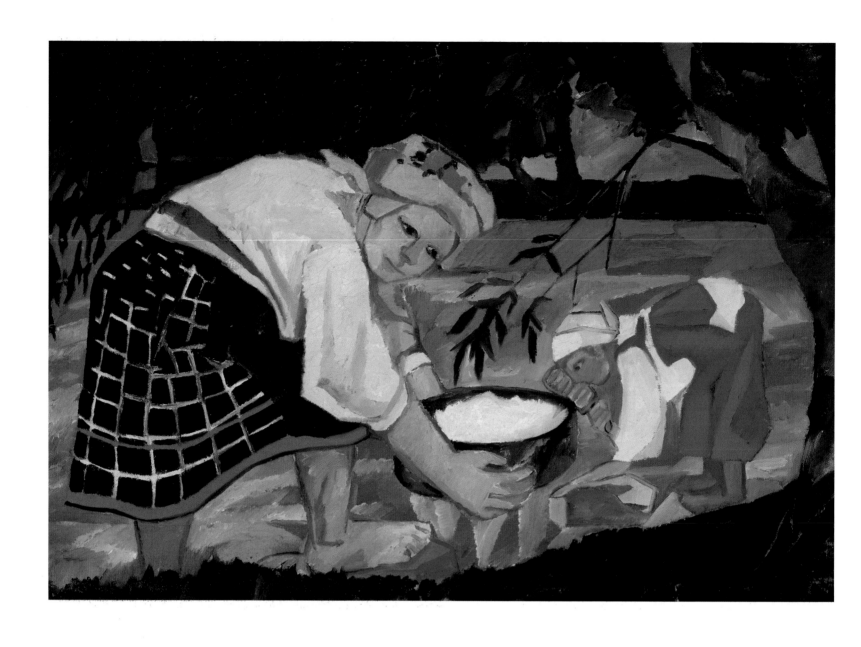

Natalia **G**oncharova
Peasant Women. 1910
Oil on canvas. 73 x 103 cm
Ж-9741

Goncharova's Neo-Primitivist period spanned the years 1907 to 1911. This phase of her oeuvre took the form of works on themes from peasant life. Like Mikhail Larionov, Goncharova introduced narrative elements into her paintings, although unlike her future husband's genre works, her canvases contain neither humor nor irony. Depicting scenes from everyday life — picking fruit, bleaching linen, shearing sheep, washing clothes — the artist filled her works with profound and symbolic meaning. The figures appear to be frozen, which elevates their everyday activity into timeless ritual. The subject is cleansed of genre detail and the gestures seem to have deeper significance. (*E. B.*)

Five-Piece Female Festive Costume. Early 20th century
Master U. F. Antoshechkina (1883–?),
Kasimov district, Ryazan Province

Blouse
Chintz and linen. 115 x 147 cm
T-3381

Skirt
Linen and wool. 68 x 76 cm
T-3382

Top
Linen, paper, and wool. 71.5 x 84.5 cm
T-3383

Apron
Linen, paper, and wool. 81.5 x 90 cm
T-3384

Headscarf
Chintz. 102 x 91 cm
H-1983

The composition, cut, and decoration of Russian folk costumes vary greatly from region to region. The costume from Ryazan Province consists of several objects cut in a distinct manner and decorated with patterned weaving and a chintz headscarf. The top and apron are worn over the light blouse, which sets off the heavy linen skirt. This original set of clothing incorporates a wealth of different details, materials, and decorative devices. (*I. B.*)

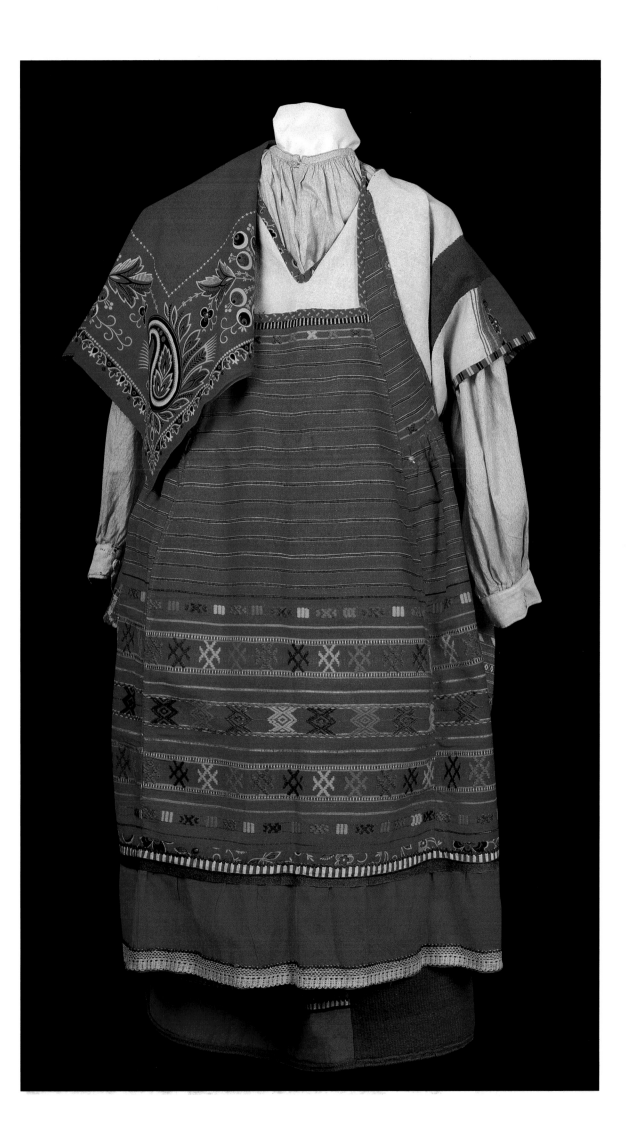

Children's Distaff. 1920s
Master V. I. Tretyakov
Lower Toima, Solvychegodsk
district, Vologda Province
Fretwork and paint on wood.
65.5 x 17.5 x 42 cm
P-2973

Natalia **G**oncharova
Peasants. From the *Picking Grapes*
nine-part polyptych. 1911
Oil on canvas. 131 x 100.5 cm
ЖБ-1592

In 1911, Goncharova painted two mo-
numental nine-part compositions—
Picking Grapes and *Reaping*. Only four
fragments of *Picking Grapes* have sur-
vived — *Dancing Peasants* (private
collection, Paris), *Feasting Peasants*
(Tretyakov Gallery, Moscow), *Peasant
Women Carrying Grapes* (Tretyakov
Gallery, Moscow), and *Peasants* (Rus-
sian Museum, St. Petersburg). These
four canvases are united by their
common monumental and emotion-
al power, underlining the religious
and epic concept of the composition,
which is linked to Gospel motifs. (*E. B.*)

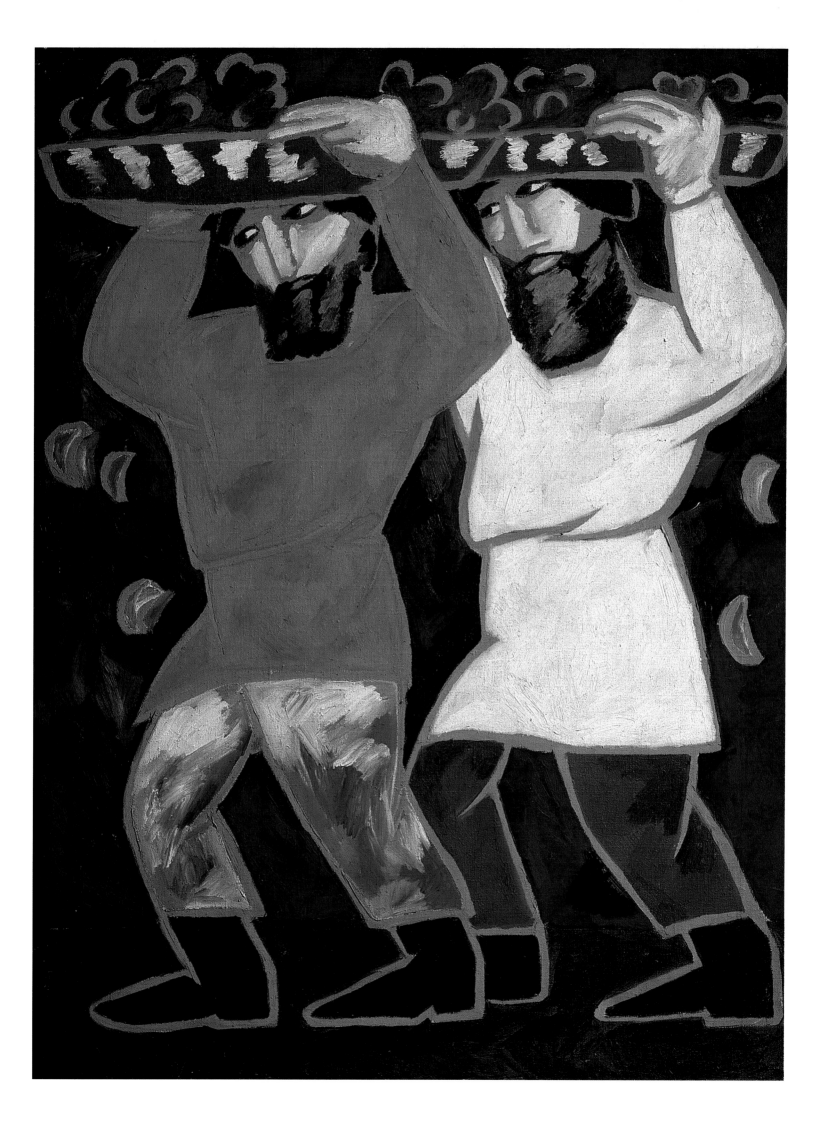

Distaff. Late 19th century
Lake Kena, Kargopole district,
Olonets Province
Fretwork and paint on wood.
97.5 x 22 x 70 cm
Д-2071

The distaff is an important object in the Russian peasant environment, uniting various aspects of folk life. It is an instrument of labor, helping women of all ages to spin threads. It is also a ritual decoration adorning social gatherings, a traditional wedding present from a father to his daughter, and a symbolic farewell gift when leaving one family to join a new one. Distaffs are sticks traditionally used to hold fibers for spinning. They consist of three parts — the seat on which the spinner sits, a vertical stand, and the spindle. A common feature of village get-togethers, distaffs were treasured and handed down from generation to generation. There was one in every peasant house. (*I. B.*)

Natalia **G**oncharova
Winter. 1911
Oil on canvas. 118 x 99 cm
ЖБ-1599

Russian poetess Marina Tsvetayeva defined the essence of Natalia Goncharova's creative mentality as "the four seasons in labor, the four seasons in joy." The cycle of nature, with its period of "death" in winter and subsequent "resurrection" with the onset of spring, was a motif frequently encountered in the artist's paintings and drawings. The cold and austere black and white tones and sharp lines of *Winter* liken it to Goncharova's graphic art, particularly her illustrations to *Spring after Death*, a collection of poems written by Tikhon Churilin. The artist's contemporaries also noted the similarities between these paintings and Japanese prints. Like many artists of her generation, Goncharova was interested in Asian art and the architectural fretwork (distaffs and gingerbread boards) of the Russian folk craftsmen. (*E. B.*)

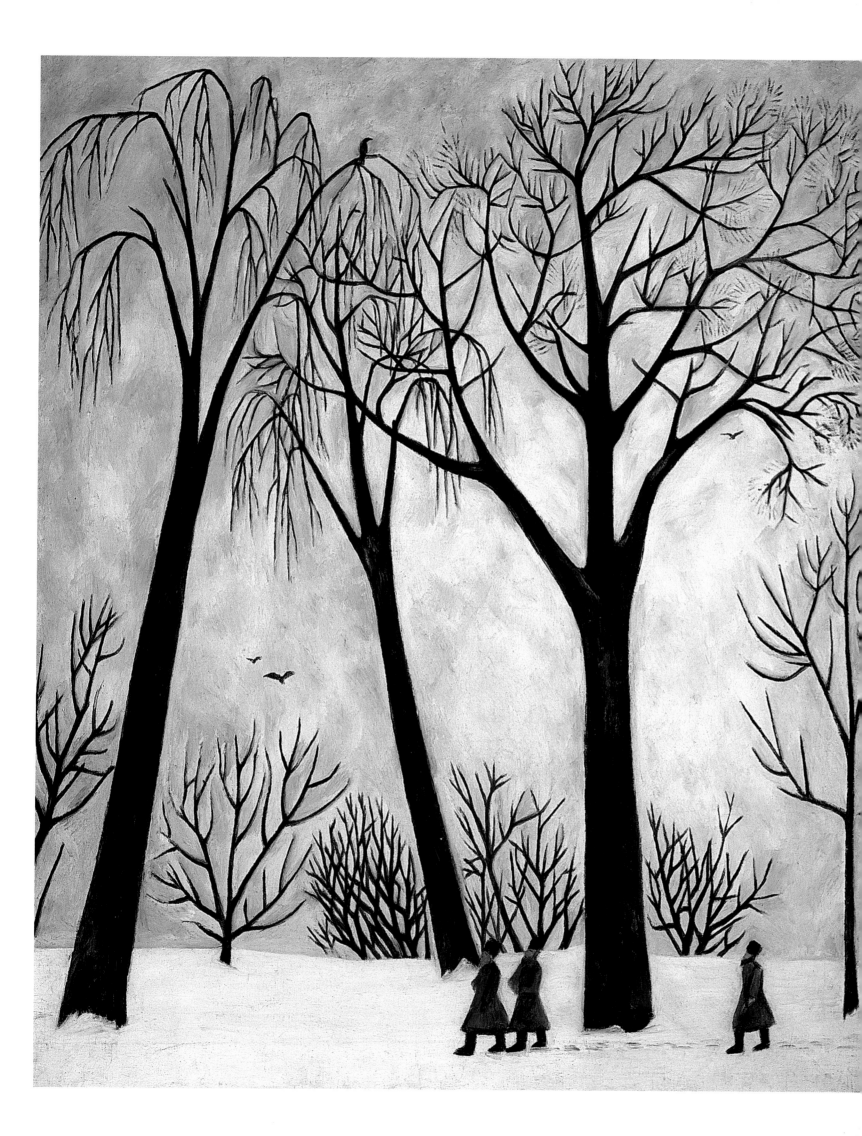

Natalia **G**oncharova
The Evangelists. Tetraptych. 1911
Oil on canvas. 204 x 58 cm (each)

Blue Evangelist
ЖБ-8183

Red Evangelist
ЖБ-8184

Gray Evangelist
ЖБ-8185

Green Evangelist
ЖБ-8186

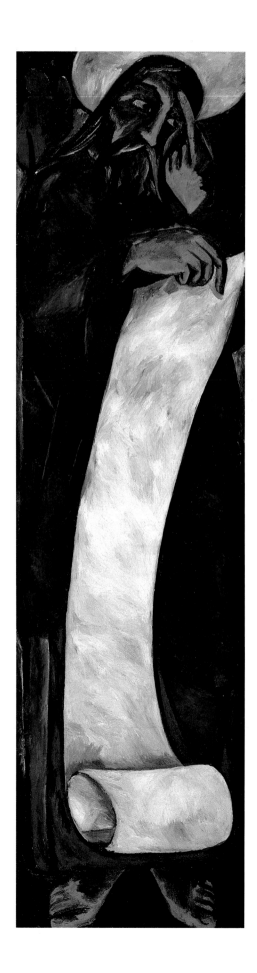
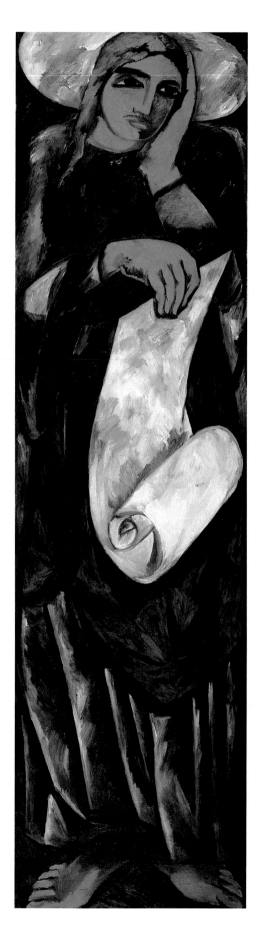

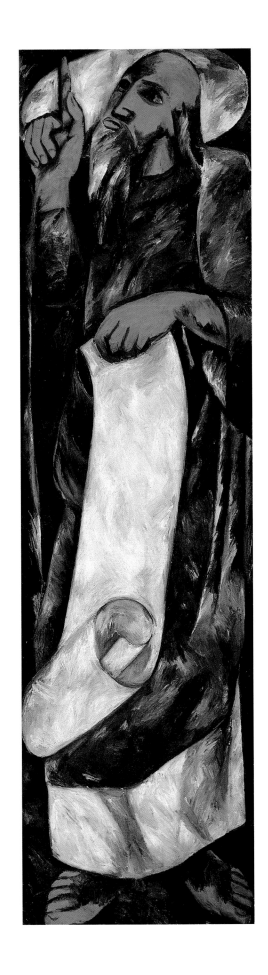
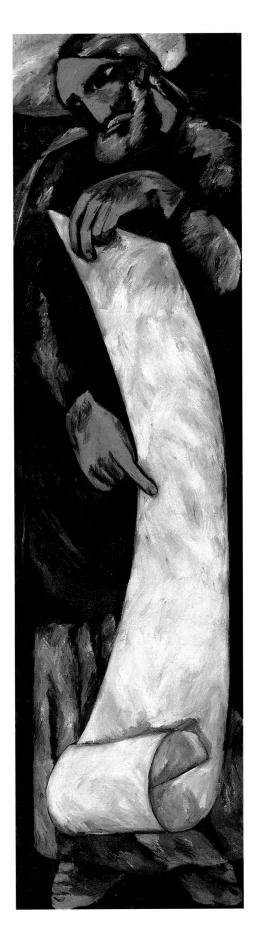

Goncharova was one of the few masters of the Russian avant-garde to pay tribute to religious subjects in her mature oeuvre. The artist wrote in 1912: "Religious art and patriotic art have always been the most majestic and perfect forms of art. This is largely because such art is not theoretical, but traditional." Contemporaries regarded Goncharova's *Evangelists* as one of her finest creations. This four-part panel reflects the artist's interest in the fine traditions of Old Russian monumental painting and grotesque sculpture, with its expressive rhythms of alternating poses and gestures. Although analogies with Albrecht Dürer's *Four Apostles* (Alte Pinakothek, Munich) inevitably arise, Goncharova's *Evangelists* were painted by a modern artist endowed with a special feeling for expression and decoration. The *Evangelists* were twice confiscated by the censor, who accused Goncharova of "anti-religious blasphemy." (*E. B.*)

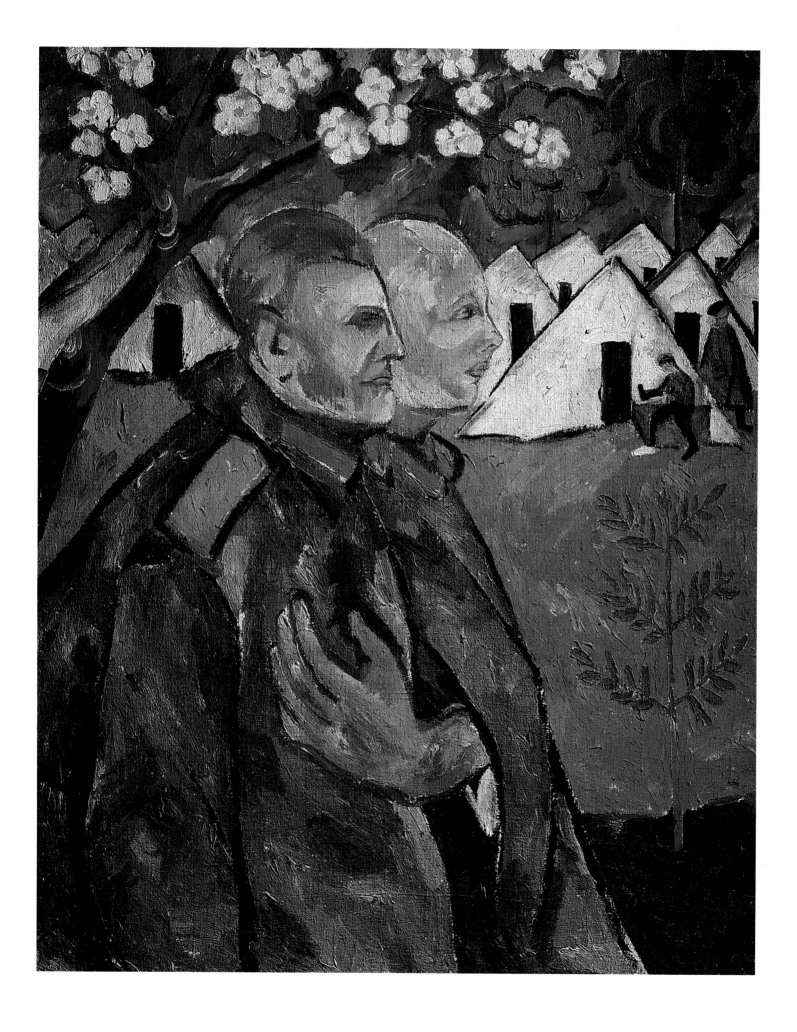

Natalia Goncharova
Portrait of Mikhail Larionov
and His Platoon Commander.
1911
Oil on canvas. 119 x 97 cm
ЖБ-1593

Larionov served in the Russian Army in the spring of 1911. This period in his life is reflected in both his own oeuvre and the works of Goncharova. This painting recalls Larionov's own soldier series, however, it typifies Goncharova's unique personal style, as can be seen in her sensitive juxtaposition of the coarse male figures and the tender blossoms on the branch. (*E. B.*)

Hussar. Toy
First half of the 19th century
Sergiev Posad, Moscow Province
Fretwork and paint on wood.
28 x 8.5 x 3.5 cm
Д-29

Sergiev Posad and the village of Bogorodskoe near Moscow are traditional centers of wooden toy production in Russia. Many artists at the turn of the twentieth century avidly collected the works of the craftsmen of these localities. (*I. B.*)

Decorative Design from
a Peasant House. 1876
Master I. Trofimov, Zaovrazhnaya,
Kargopole district, Olonets Province
Paint on wood. 78 x 66 x 2 cm
P-2581

Mikhail **L**arionov
Portrait of Arthur Fon Vizen.
Mid-1900s
Oil on canvas. 88 x 71 cm
ЖБ-8244

Larionov first met Arthur Fon Vizen at
the Moscow School of Painting,
Sculpture, and Architecture. The two
students also contributed to the *Link*
and *Golden Fleece* shows and the first
Jack of Diamonds exhibition. The por-
trait is painted in a free and sketch-
like manner, with broad and impetu-
ous brush strokes. Judging by the bru-
shes clenched in the sitter's hand and
the look of tenacity on his face, Fon
Vizen was himself engaged in paint-
ing a portrait of Mikhail Larionov
(which has probably not survived). (*E.P.*)

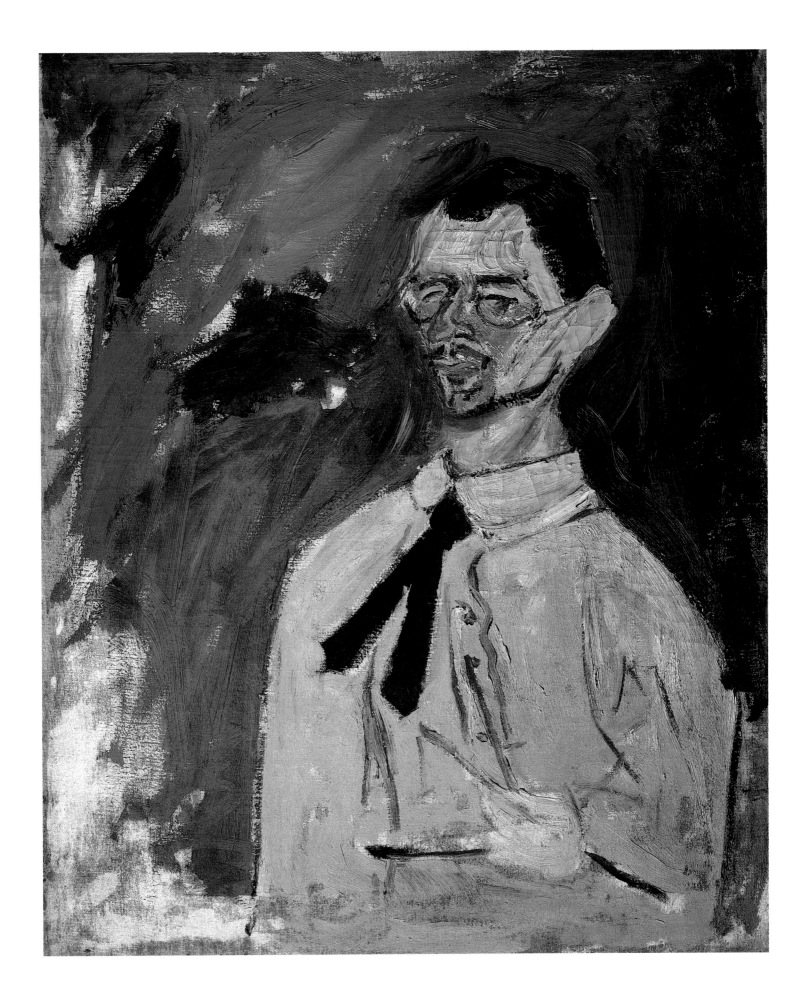

Mikhail **L**arionov
Turkey Hen. Mid-1900s
Oil on canvas. 61 x 71 cm
Ж-9005

Turkey Hen is part of a large series of canvases depicting poultry painted by the artist at his family estate in Tiraspole, where he paid regular visits in the summer months. Here, Larionov is as influenced by Impressionism as he is by the provincial signboards that fascinated the artist and became one of the principal sources of his Neo-Primitivism. (*E. P.*)

Distaff. Early 20th century
Master E. Kopiegorsky,
Rubchevskaya, Totma district,
Vologda Province
Fretwork and paint on wood
100 x 22 x 66 cm
Д-2696

Distaff. 1879
Vorobyovo, Kargopole district,
Olonets Province
Fretwork and trifluted paint
on wood. 92 x 25 x 54 cm
Д-2175

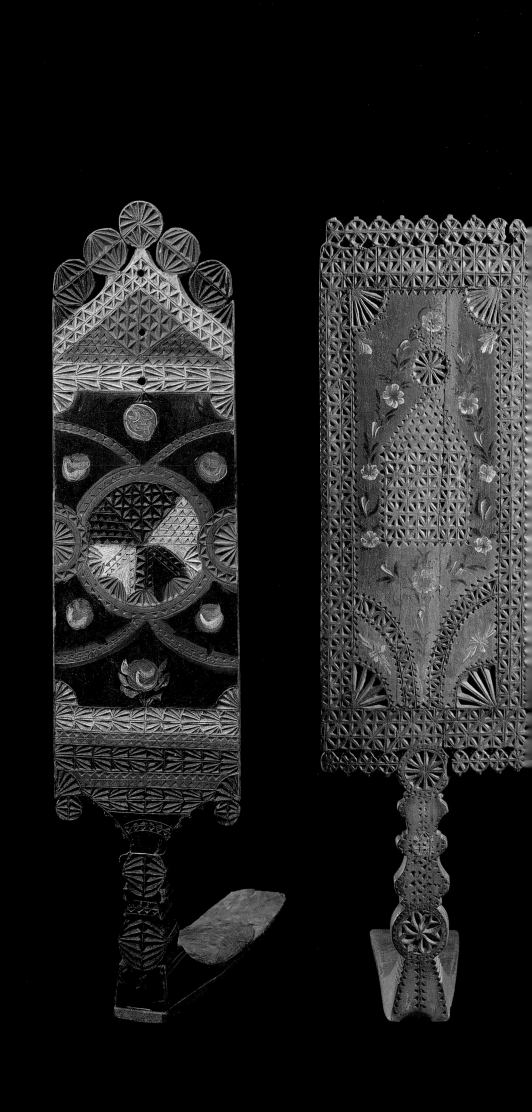

Mikhail **L**arionov
Barber. 1907
Oil on canvas. 77.5 x 59.5 cm
ЖБ-1366

Larionov's *Barbers* series (1907–9) reflects his fascination with the art of urban folklore, which seemed to him refreshingly free of any schooling. Lightly parodying the urban signboard, this genre painting depicts a scene in a barber's shop. Larionov simplifies the subject and pictorial structure, embodying the concept of Everythingism. One of the many avant-garde concepts of the early twentieth century, Everythingism, or *vsyochestvo*, proposed the eclectic blending of linguistic and pictorial elements drawn from a diverse range of sources, from children's drawings and graffiti to canonical images, in a single work of art. (*T. C.*)

Mikhail **L**arionov
Cupid Laying a Wreath.
Illustration to Alexei Kruchenykh's
Pomade (Kuzmin and Dolinsky,
Moscow, 1913)
Color lithograph. Image: 8 x 6.8 cm;
sheet: 8.8 x 7.1 cm
Гр-42219

Mikhail **L**arionov
"Ha[p]py Autumn". 1912
Oil on canvas. 53.5 x 44.5 cm
ЖБ-1576

In 1912, paralleling his work on his Rayonist compositions, Larionov painted several pictures in the spirit of "Infantile Primitivism." Among them, and affiliated with the *Seasons* cycle, is the canvas *"Ha[p]py Autumn."* The artist was captivated by children's drawings and collected them throughout his lifetime. A spontaneous naïvety, borrowed by the artist from these same drawings, is reflected here in the expressive "simplicity" of the color and the "clumsy" ungrammatical inscriptions. At the same time, the pictorial equivalence made between the marks used by the artist to signify facial features and the individual letters making up the words anticipates Larionov's later work on Futurist books, where he achieved a similar union of word and image. (*E. B.*)

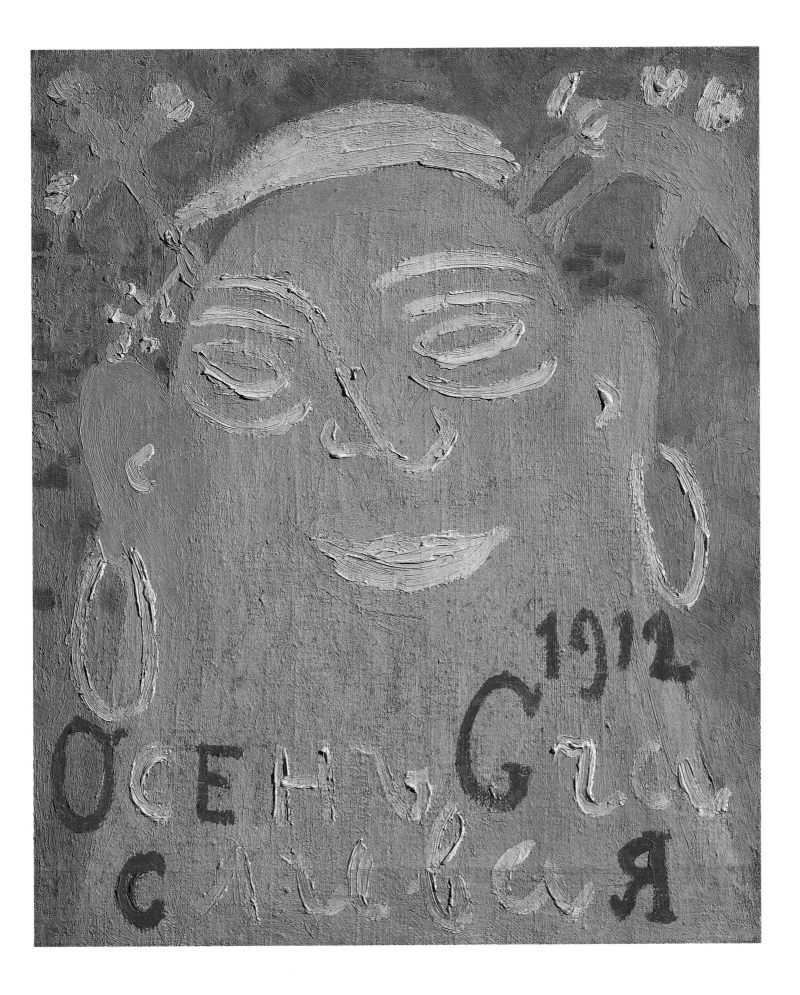

Mikhail **L**arionov
Katsap Venus. From
*16 Dessins M-e N. Gontcharoff
et M. Larionoff.* 1913
Lithograph. 13.7 x 18.4 cm
Гр-41591

Mikhail **L**arionov
Venus. 1912
Oil on canvas. 68 x 85.5 cm
ЖБ-1528

Larionov painted *Venus* in 1912, when he was also working on lithographic books, applying deliberately archaic, "homemade" stylistic devices and addressing the expressive possibilities of handwriting. Like his paintings of this period — the unfinished *Venus* series and the *Seasons* cycle — the artist creates something akin to an instantaneous stroke of the pen. Larionov considered such diverse things as the art of ancient cultures, children's drawings, and graffiti to be classifiable as folk art. Rebelling against "Greco-Roman sanctimoniousness," he painted his very own series of *Venuses*. While this particular *Venus* lies in a classical pose, the element of *amour* introduces a note of parody. Other associations, however, link the work to primeval images. The painting represents a simplified and generalized drawing; it is virtually a symbol. This *Venus* seems to have the innocence of an adolescent's caricature, but also conveys an adult's understanding of the object of representation. (*T. C.*)

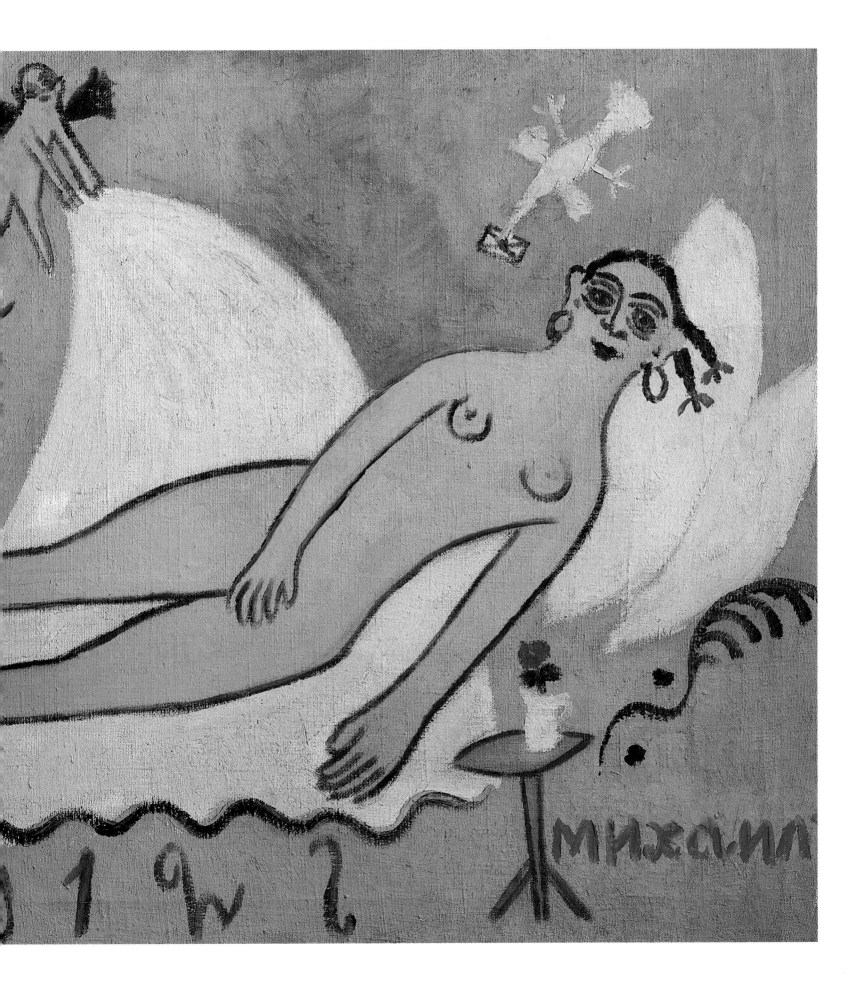

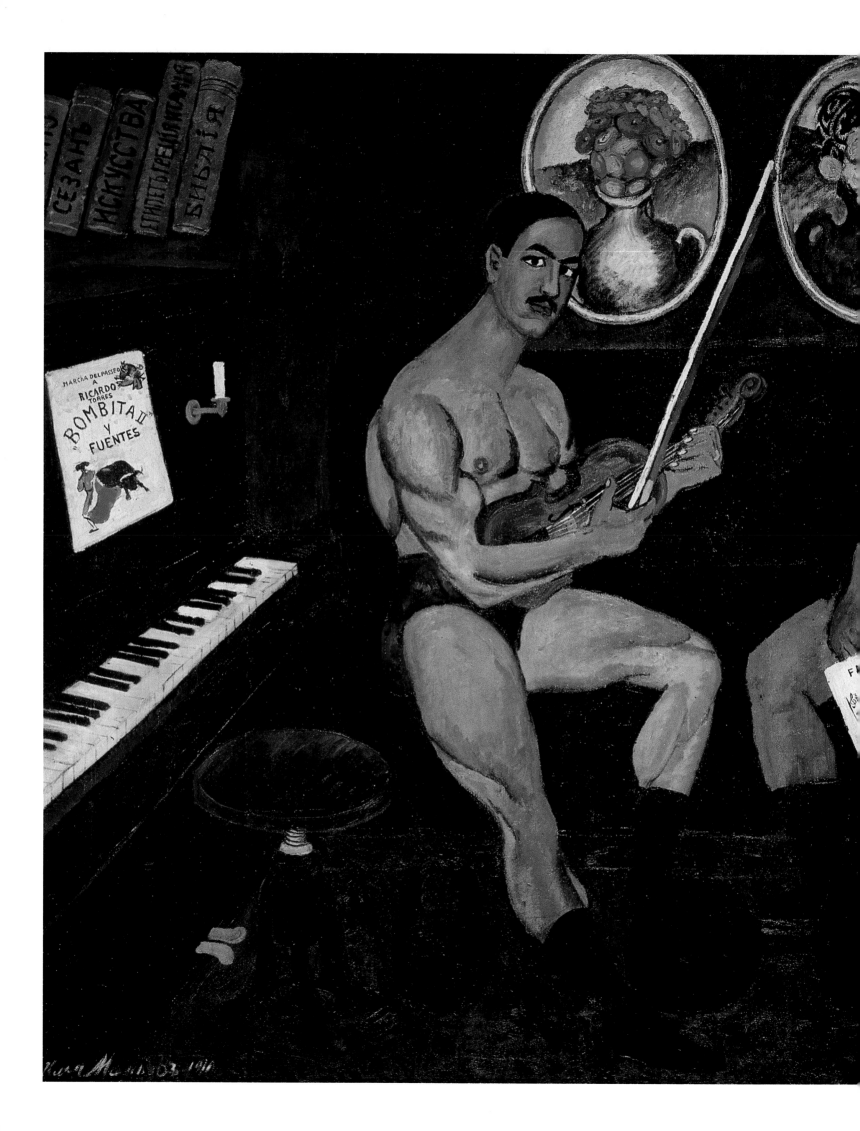

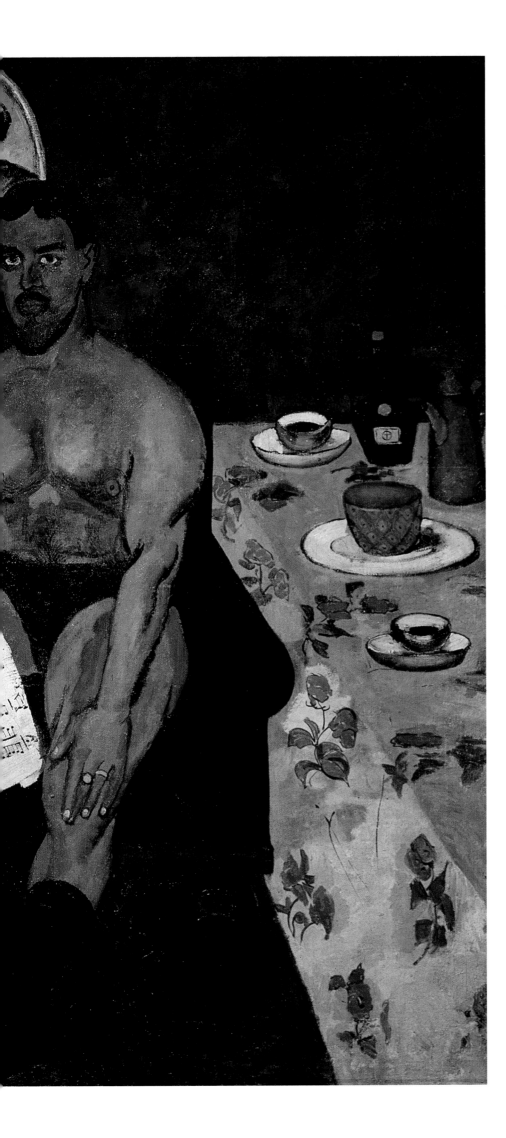

Ilya Mashkov
Self-Portrait with Pyotr
Konchalovsky. 1910
Oil on canvas. 208 x 270 cm
Ж-11323

Mashkov's *Self-Portrait with Pyotr Konchalovsky* was destined to become the manifesto for the first *Jack of Diamonds* exhibition in Moscow and a landmark work in the early history of the Russian avant-garde movement. The painting records the atmosphere of the exhibition, with its fairground bravado and its jocular and provocative playing with the public. Mashkov effects an ironic game with the genre of the official portrait, filling the entire canvas with a whole host of "eloquent" details (the enormous volumes on Cézanne, the art of Egypt, Greece, and Italy, and a Bible, the dumb-bells lying conspicuously on the floor, the sheet music for Spanish romances and fandangos, and a bottle of wine on the table), which are intended to offer the public an insight into the diverse interests of the artists. Critics often noted the "vulgar" tone of the painting and its invocation of the aesthetics of early cinematography. The oval frames on the wall originally contained portraits of the artists' wives; at the last moment, on the eve of the opening, the women demanded that Mashkov paint bouquets of flowers in their place. (*E. B.*)

Ilya Mashkov
Portrait of a Boy in
a Flowered Shirt. 1909
Oil on canvas. 119.5 x 80 cm
ЖБ-1499

The nature of Mashkov's talent—its creative sweep, energy, character, and sensuousness—distinguished the artist from fellow members of the *Jack of Diamonds*. Such early paintings as *Portrait of a Boy in a Flowered Shirt* reflect the various influences on Mashkov's oeuvre. He was influenced by modern French painting, particularly Fauvism. However, he was also profoundly invested in folk art, as is apparent in his frequent use of the graphic, decorative elements found on traditional tea trays, which, in this example, can be seen in the background as well as in the overall palette. His interest in signboards and fairground photography is also reflected in the positioning of the model and the subject's deliberately serious and attentive gaze, fastened directly on the viewer. (*E. B.*)

Kovsh. 1868
Yudino, Vetlyug district,
Kostroma Province
Hollowing, fretwork, and paint
on wood. 24 x 68 x 41 cm
P-3849

The kovsh, or scoop, doubled as a table decoration and as a vessel for beer and other beverages during traditional get-togethers and national festivals in Russia. This particular work was hollowed out of a tree stump and decorated with large flowers. The inscription along the side with the name of the artist and the date is unusual in Russian folk art. (*I. B.*)

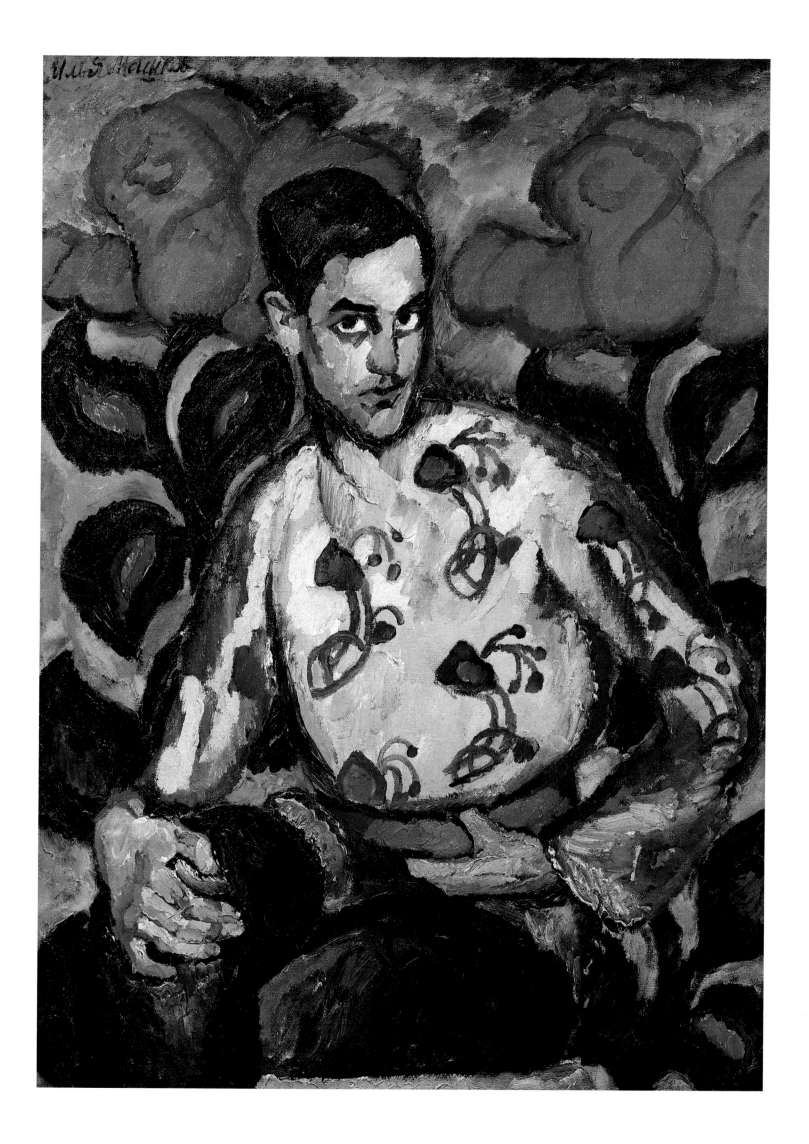

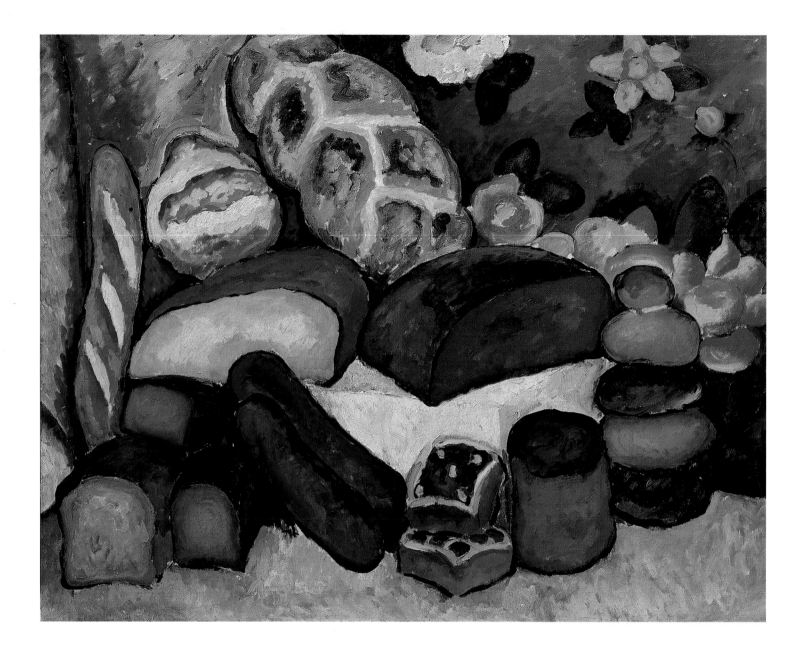

Ilya Mashkov
Still Life with Loaves. 1912
Oil on canvas. 105 x 133 cm
ЖБ-1725

Mashkov was a leading member of the Jack of Diamonds, a group of artists who attempted an original fusion of the devices of Paul Cézanne and the traditions of Russian folk art. This still life is one of Mashkov's most famous paintings. Inspired by the provincial signboard, with its static quality, the painting conveys wealth and plenty. The artist was drawn to the geometry suggested by the appearance of the loaves stacked up in piles. Transforming this motif from everyday life, Mashkov plays up the diverse possibilities offered by such conventional still-life subjects. As one art critic aptly noted, despite the feast of different textures and forms, "Mashkov's still life smells more of turpentine, paint, and varnish than icing." (E. B.)

Bread, Vegetables, and Groceries. Signboard. 1910s
Oil on iron. 124 x 98 cm
P-1594

Signboards are not, strictly speaking, works of folk art. They are the individual creations of urban painters, whose scope was regulated by their guilds and the official censor, rather than the creative traditions of folk art. Their painterly merits were nevertheless an important influence on the artists of the Russian avant-garde, who highly rated the originality of signboards. (I. B.)

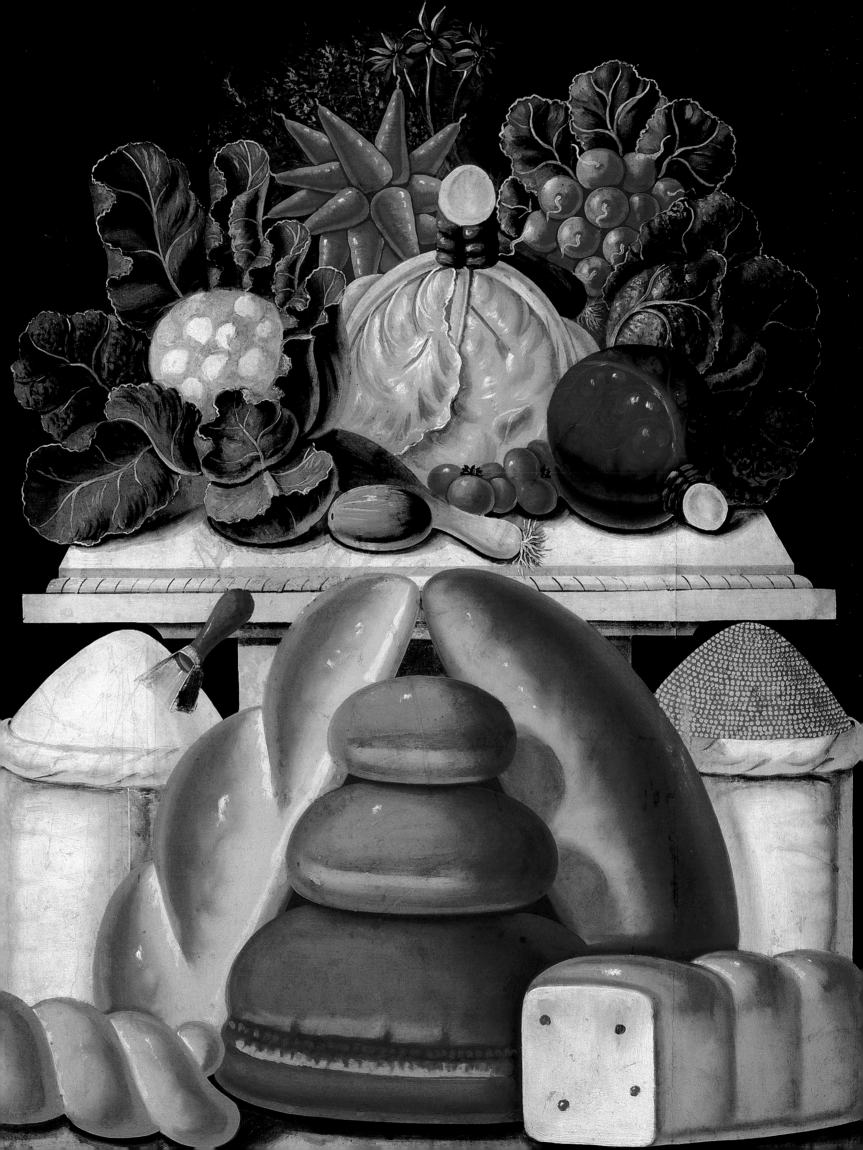

Barrel. Second half
of the 19th century
Vyatka Province
Paint on birchbark.
21 x 14 cm (diameter)
P-1522

The barrel was made from birchbark
and resembles a small wooden pail
with a lid. It was used to store grain
and flour, to carry food to people
working in the fields, or to soak
cloudberries and cranberries for win-
ter. Each locality had its own unique
style of decorating barrels with carv-
ings and paintings of birds, floral
designs, and genre scenes. (*I. B.*)

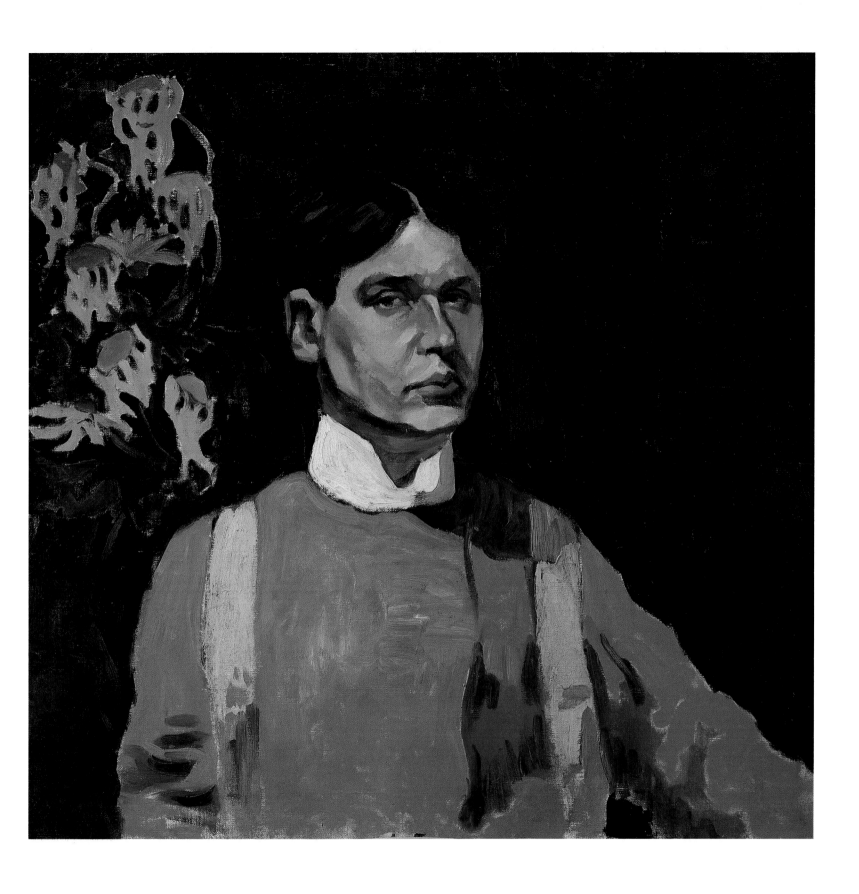

Aristarkh **L**entulov
Self-Portrait. 1913
Oil on canvas. 83 x 83 cm
Ж-8240

Sometimes known as *Self-Portrait in Red*, this is one of Lentulov's early works. Painted during his quest for his own personal style, *Self-Portrait* anticipates the expressive use of color that later became one of the distinguishing features of his work. The artist himself regarded *Self-Portrait* as one of his first important paintings. (*E. B.*)

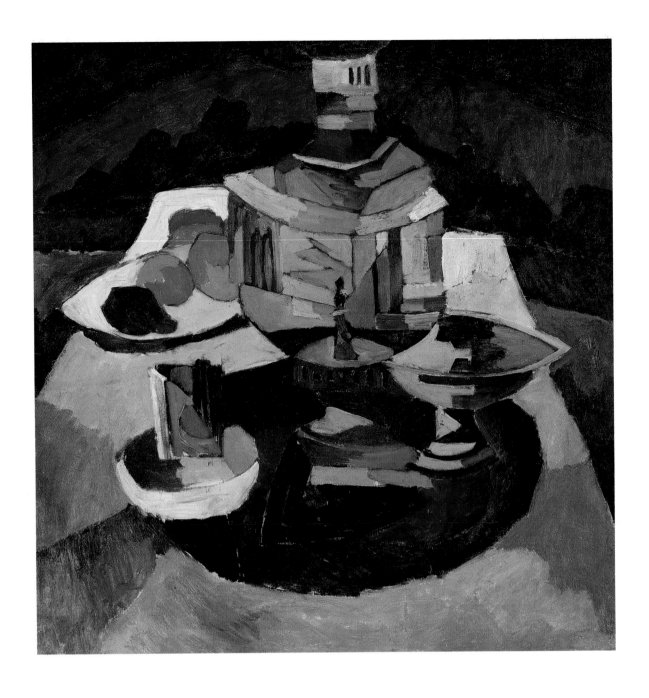

Aristarkh **L**entulov
Still Life with Samovar. 1913
Oil on cardboard. 102 x 100 cm
Ж-8707

Lentulov painted this work soon after
his return to Russia from Paris, where
he became acquainted with modern
French art. Working in Henri Le Fau-
connier's studio, Lentulov was un-
doubtedly influenced by the works of
the French Cubists. While this particu-
lar painting avoids their largely mo-
nochrome color schemes, the geo-
metric contours and restrained tones
still indicate the artist's familiarity with
the work of Pablo Picasso, Georges
Braque, and André Derain. It is clear,
however, that Lentulov was equally
influenced by the traditions of Russian
folk art. The artist was particularly
drawn to the bright and expressive
imagery of the *lubok* print. (*O. S.*)

Aristarkh **L**entulov
Churches. New Jerusalem. 1917
Oil on cardboard. 100 x 100 cm
ЖБ-1489

Churches. New Jerusalem was one of a
series of works inspired by the New
Jerusalem Monastery outside Mos-
cow. A typical example of Lentulov's
approach, it combines rich colors with
dynamic and "vortex" forms. The artist
smashes the Old Russian architecture
into bright fragments decoratively
similar to a mosaic panel; every brush
stroke reads like a piece of colored
glass. Velimir Khlebnikov noted the
rebellious and revolutionary spirit of
Lentulov's art: "Steeples with high
apertures bowed, like a man fractured
by a stick suddenly stooping and
clutching at his stomach or an ear of
corn broken in several places…. The
storm passed through his painting;
one day it will pass through life and
will smash many steeples." (*E. B.*)

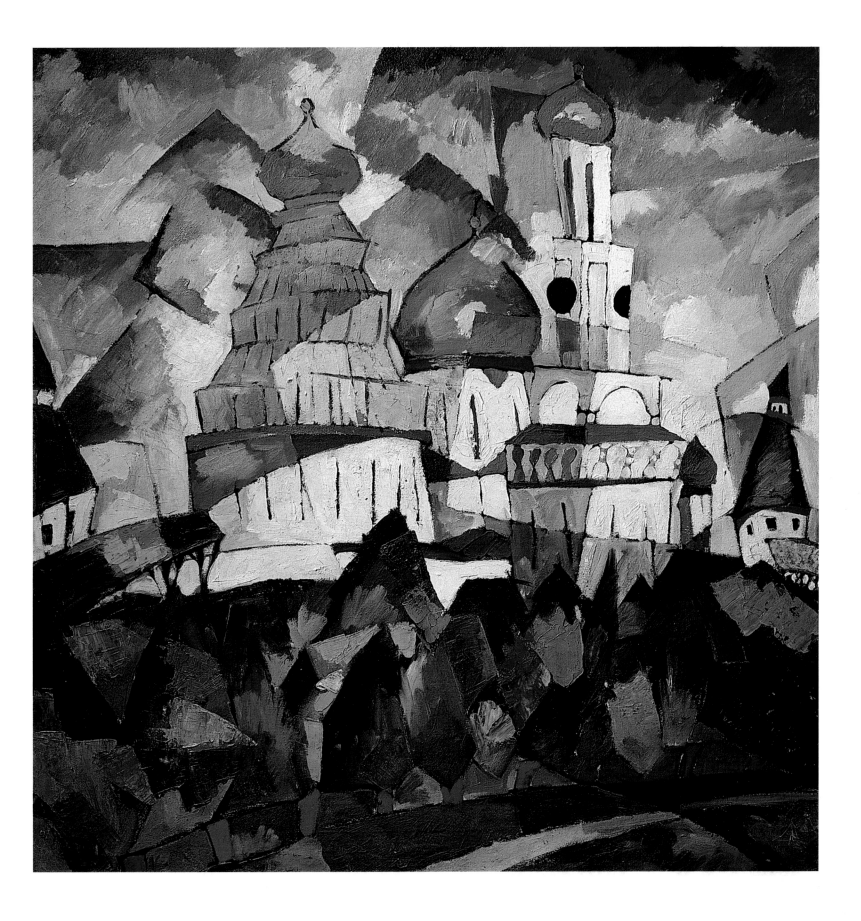

Pyotr **K**onchalovsky
Still Life with Samovar. 1917
Oil on canvas. 121 x 109 cm
ЖБ-1191

Konchalovsky's paintings are classic examples of the Cézanneism practiced by the members of the Jack of Diamonds and their interest in urban folk art. One Russian critic stated that Konchalovsky's works owe "as much to signboards and *lubok*, as they do to Cézanne." Like the art of several other members of the *Jack of Diamonds*, Konchalovsky's oeuvre represented the more moderate wing of the Russian avant-garde, oriented toward representational description and traditional painting values rather than outright abstraction. (*E. B.*)

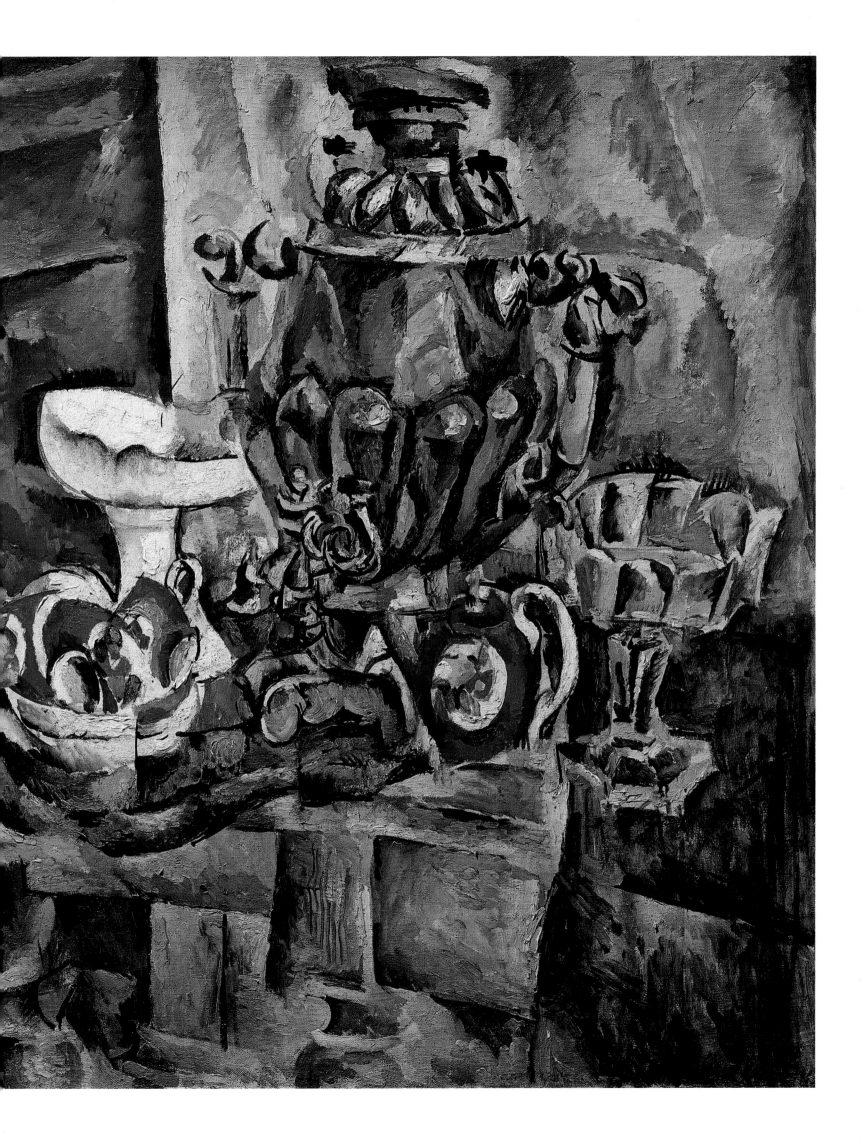

Distaff Seat
Second half of the 19th century
Gorodets district, Nizhny Novgorod
Province
Fretwork and paint on wood.
62 x 18.5 x 19 cm
P-1414

Distaff Seat
Second half of the 19th century
Gorodets district, Nizhny Novgorod
Province
Fretwork and paint on wood.
64 x 17 x 27 cm
P-1413

Distaff Seat
Second half of the 19th century
Gorodets district, Nizhny Novgorod
Province
Fretwork and paint on wood.
56 x 18 x 19 cm
P-1412

The masters of the Gorodets region
of the Volga decorated not the spin-
dle, as in other localities, but the seat,
onto which the comb was inserted.
After finishing her work, the spinner
would hang the seat up on the wall
of the hut like a picture. The Gorodets
designs became widespread after the
1870s, when they began to acquire an
original style and character of their
own, depicting figurative scenes of
ladies and cavaliers dressed in the
attire of the local merchant and mid-
dle classes. (*I. B.*)

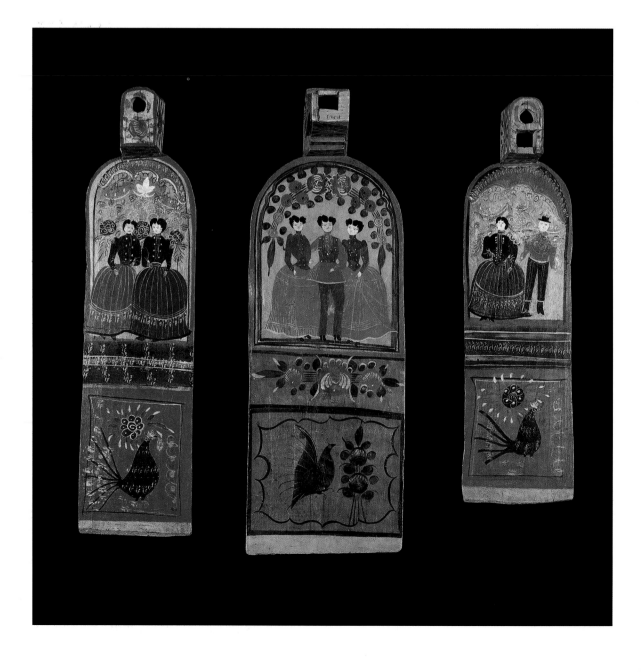

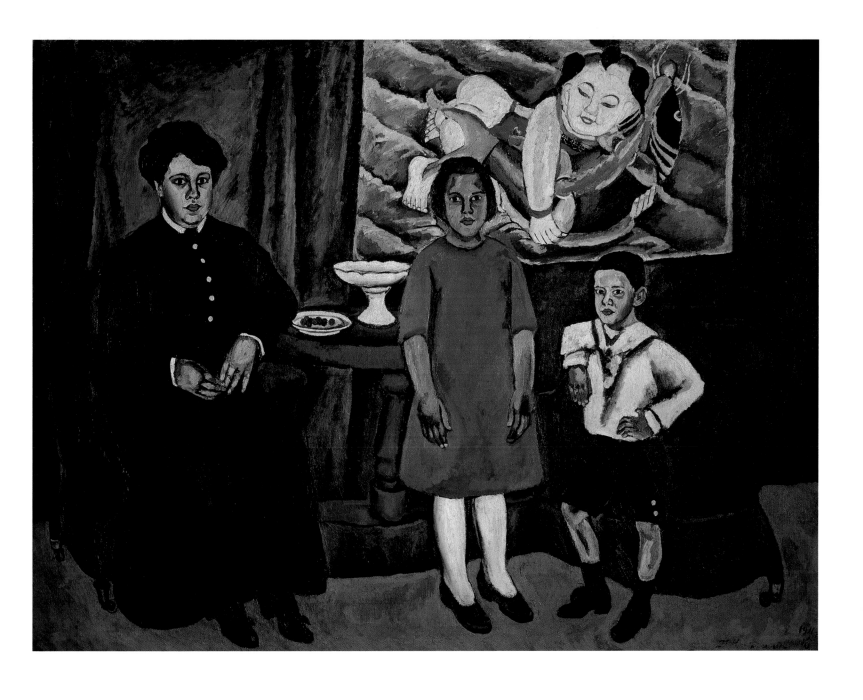

Pyotr **K**onchalovsky
Family Portrait. 1911
Oil on canvas. 179 x 239 cm
Ж-10121

Portrayed are the artist's wife Olga Vasilyevna Konchalovskaya (née Surikova) (1878–1958), daughter Natalia (1903–1988; writer), and son Mikhail (1906–2000; artist). Konchalovsky painted this portrait soon after his return from Spain, a country that strongly influenced his art. He himself wrote about the impact of his experiences in Spain on the portrait: "For me, Spain was a poem of black and white.… The entire time I lived there, I was haunted by the thought of mastering the art of simplified synthetic color. I fulfilled this aim in a portrait of my wife and children painted in 1911. This portrait is dominated by two colors — black and white. No matter how strong the reds and greens are, they play a strictly subordinate role; their task is merely to underline the resonance of the two main tonal notes of the portrait. The Chinese picture in the background serves to accompany these main tones." The closest visual source for this primitive version of the grotesque, however, is the fairground photograph, always popular with the Jack of Diamonds group. (E. B.)

Tray. 19th century
Godin brothers workshop,
Moscow Province
Oil on iron. 45 x 61 cm
P-1556

The boom in hotel and inn construction increased the demand for trays in the nineteenth century. Trays were used both to carry objects and to decorate interiors. Numerous workshops in St. Petersburg and outside Moscow painted skillful still lifes and bright bouquets of flowers on trays. (*I. B.*)

Ilya Mashkov
Still Life with Berries
and Red Tray. 1910–11
Oil on canvas. 132 x 140 cm
ЖБ-1733

As in many of the artist's other works,
Mashkov immerses the viewer in the
elements of pure painting. The deep
and rich tones of the depicted ob-
jects merge with the bright and
sometimes deliberately "tasteless"
background to form a unified plane
of vivid hue. (*E. B.*)

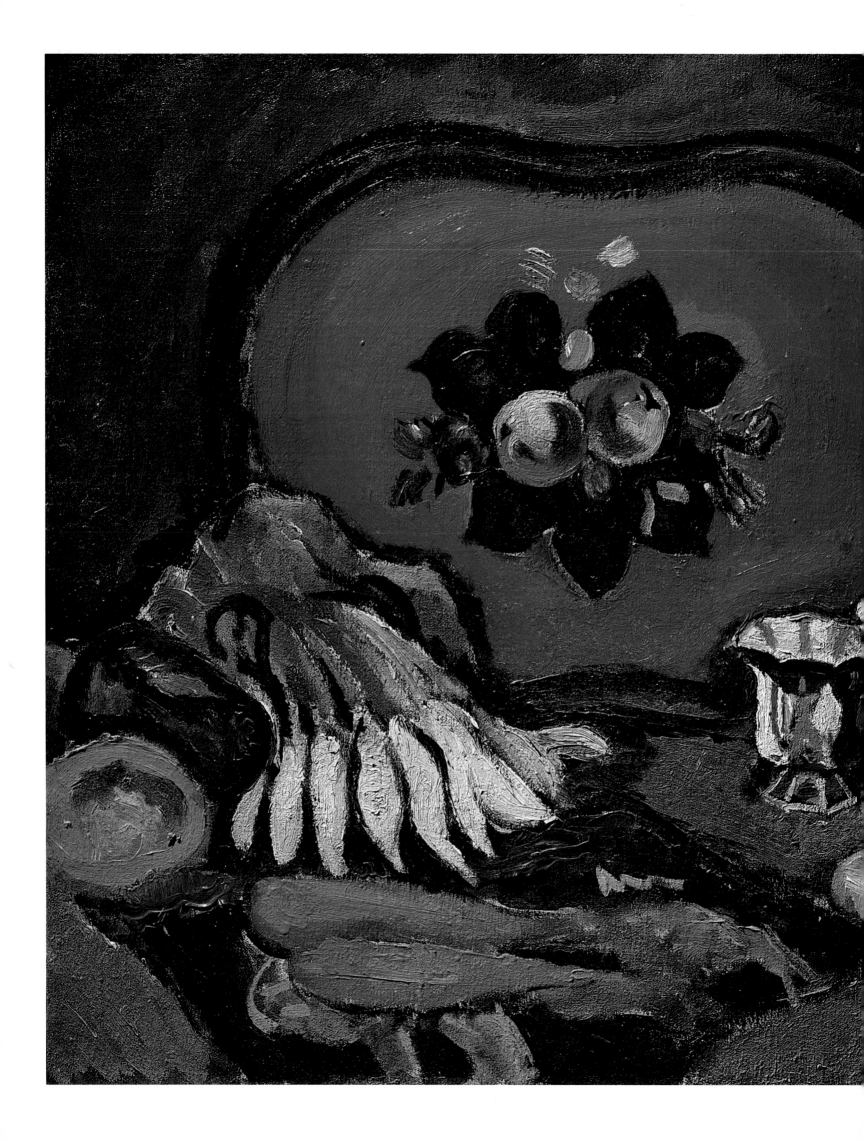

Pyotr **K**onchalovsky
Still Life with Tray and
Vegetables. 1910
Oil on canvas. 73 x 92 cm
Ж-2363

See p. 112.

Josif **S**hkolnik
Still Life with Vases
and Tray. Early 1910s
Oil on canvas. 65 x 79 cm
ЖБ-1623

Inspired by the works of folk crafts-
men (painted toys, embroideries, clay
and ceramic household objects), Shkol-
nik created landscapes and still lifes in
his own highly original style. The bril-
liant hues and economy of form of
Shkolnik's art provided the ideal vehi-
cle for his expansive creativity, lend-
ing his small pictures at once an oth-
erworldly aura and a believable mate-
riality. (E. P.)

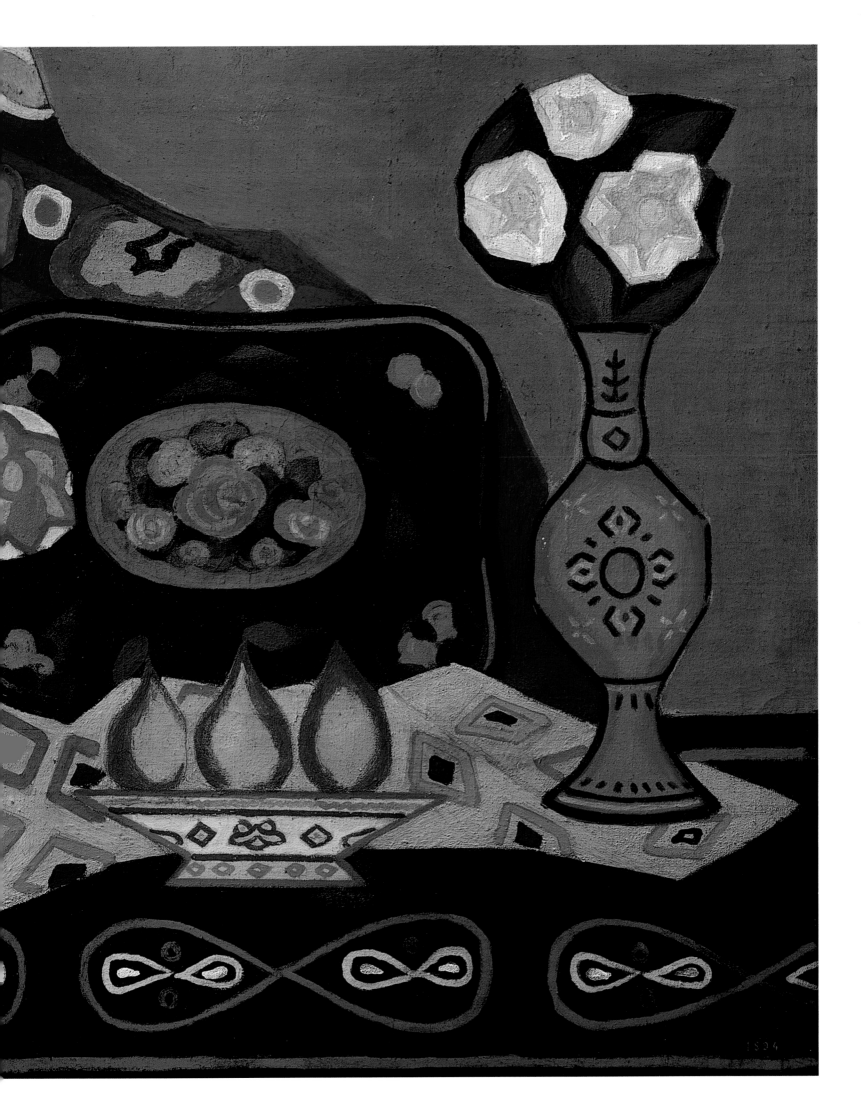

Toys. Late 19th – early 20th century
Master A. A. Mezrina (1853–1938),
Dymkovo, Vyatka Province
Molded and painted clay

Rider on a Goat. Toy.
14 x 10.9 x 9 cm
Г-58

Boatman. Toy. 9 x 12 x 10 cm
Г-109

Nanny and Child. Toy.
12.7 x 7 x 6.7 cm
Г-67

Nanny and Child. Toy.
12 x 7 x 6.5 cm
Г-64

Rider. Whistle. 12.1 x 9 x 6 cm
Г-52

Dymkovo in the Vyatka Province of central European Russia was a leading center of clay toy manufacture in the nineteenth century. Every spring, on the banks of the River Vyatka, Dymkovo hosted the annual *svisto-plyaska* festival of dancing and whistling, requiring figures and whistles molded from clay. Earthenware figurines of country squires, riders, nannies, animals, and birds were covered in a prime coating made from chalk dissolved in milk, then decorated with bright paints, in imitation of the newly fashionable porcelain statuettes. This folk handicraft still exists to this day, continuing the artistic traditions of the local art. (*I. B.*)

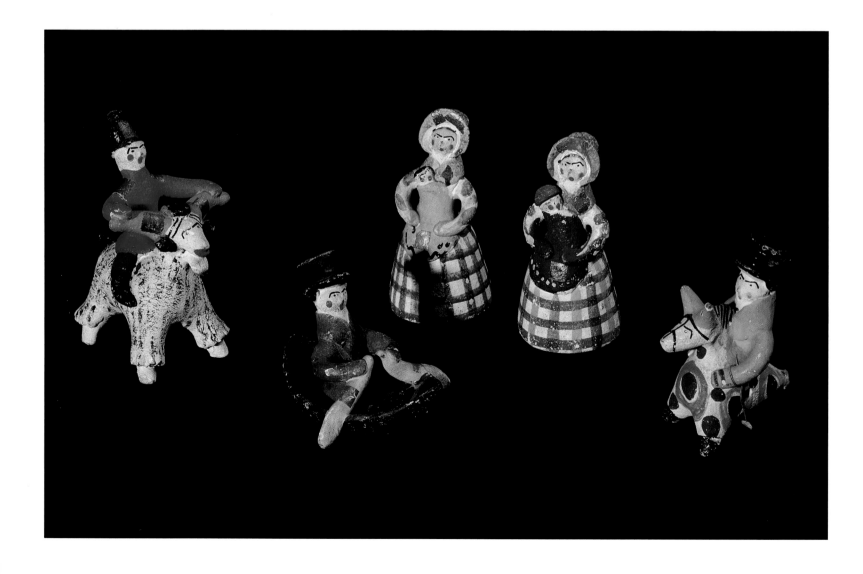

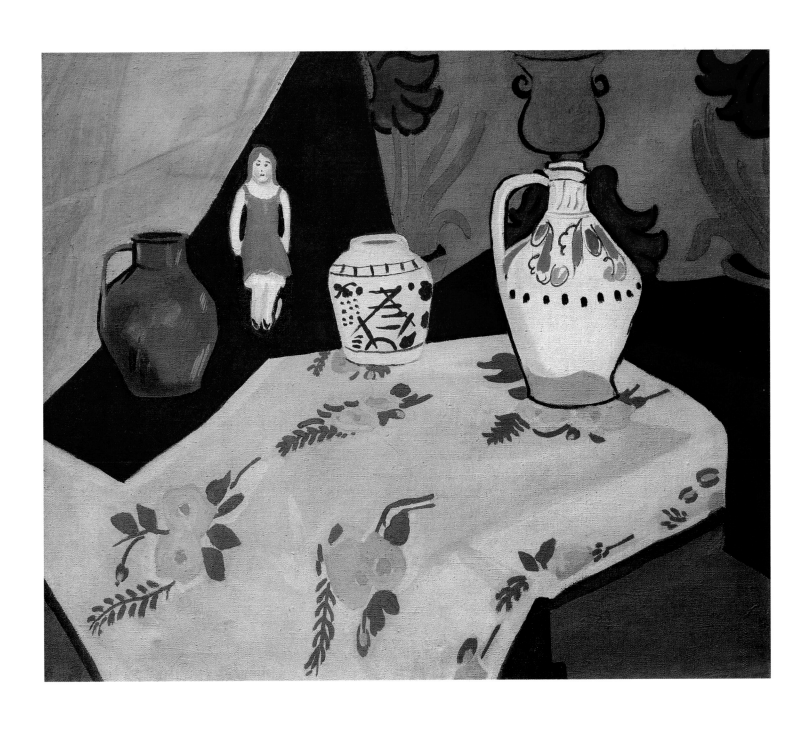

Josif **S**hkolnik
Still Life with Yellow
Tablecloth. Early 1910s
Size paint on canvas. 75 x 88.5 cm
ЖБ-1681

See p. 120

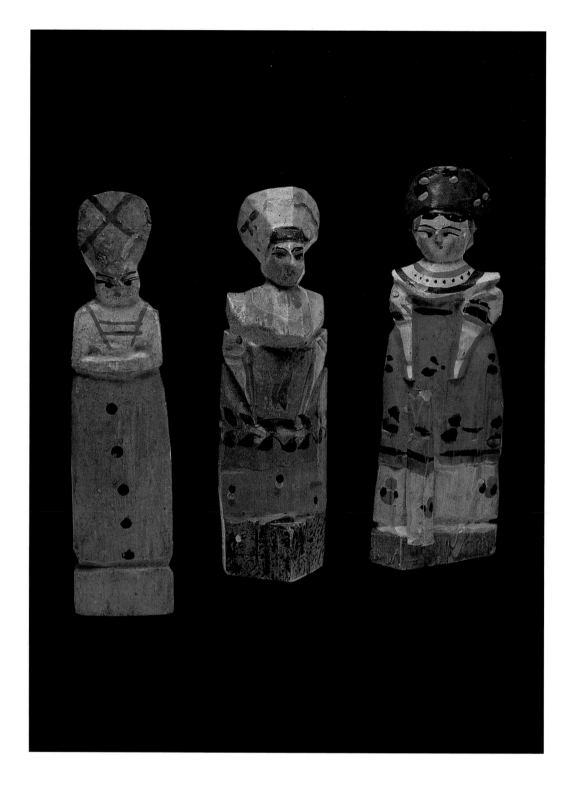

Lady of the Manor. Doll
19th century
Sergiev Posad, Moscow Province
Fretwork and paint on wood
17 x 6.5 x 3.2 cm
Д-66

Doll. Mid-19th century
Sergiev Posad, Moscow Province
Fretwork and paint on wood
17.2 x 5.9 x 1.6 cm
Д-2682

Lady of the Manor. Doll
First half of the 19th century
Sergiev Posad, Moscow Province
Fretwork and paint on wood
17.8 x 5.5 x 2.2 cm
Д-38

Josif **S**hkolnik
The Provinces. Early 1910s
Size paint on canvas. 75 x 80 cm
ЖБ-1682

See p. 120

Josif **S**hkolnik

Landscape. 1919 (?)
Tempera on canvas on
cardboard. 50 x 69 cm
ЖС-67

This painting depicts a small corner of
a ghostly and enigmatic, exotic town.
Its unusual motif might have come
straight out of the Arabian Nights.
The sense of hush and tranquility
typical of Shkolnik's pictures in gen-
eral adds a special sense of mystery
to the landscape, reflected in the
tense mauve-blue tones and the
uneasy contrasts of red and black
and blue and yellow. The decorative
nature of the picture reflects the
influence of folk art, which interested
Shkolnik and many other artists of his
circle, and the orientalism that was
such an important aspect of Russian
art in the early 1910s. (*E. B.*)

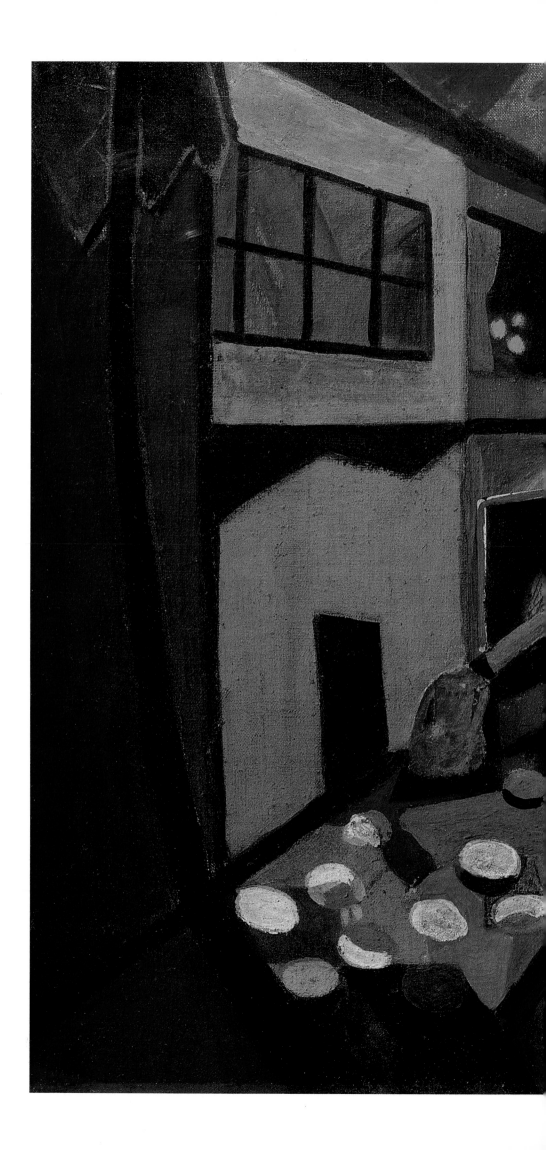

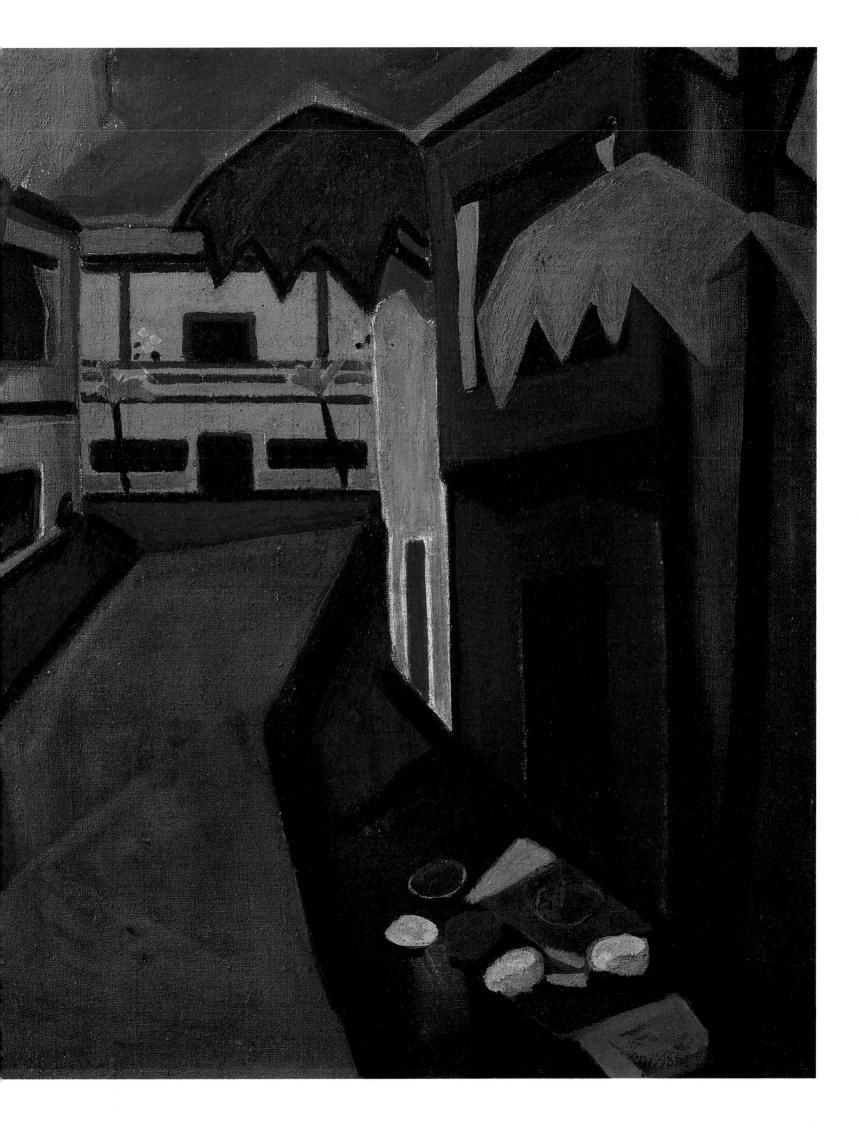

Lady of the Manor
Doll. 19th century
Sergiev Posad, Moscow Province
Fretwork on wood. 21.6 x 6.5 x 3.8 cm
Д-2864

The Bogorodskoe carvers created limewood figurines based on provincial life, playing up the natural color and texture of the wood. The masters of Sergiev Posad carved figures of ladies of the manor, hussars, and nannies with children from small logs and splinters, painting their facial features and attire on top of a thin prime coating. The expressive forms and brushwork identified each figure with a specific class of Russian society. (*I. B.*)

Olga **R**ozanova
Red House. 1910
Oil on canvas. 85 x 98 cm
ЖБ-1481

An artist who, tragically, died young, Rozanova was one of the most talented members of the Russian avantgarde. Like the majority of her contemporaries, for a time her work was engaged with the tenets of Neo-Primitivism. Rozanova was inspired by Russian provincial life, icons, folk prints (*lubok*), toys, and traditional fretwork. (*E. P.*)

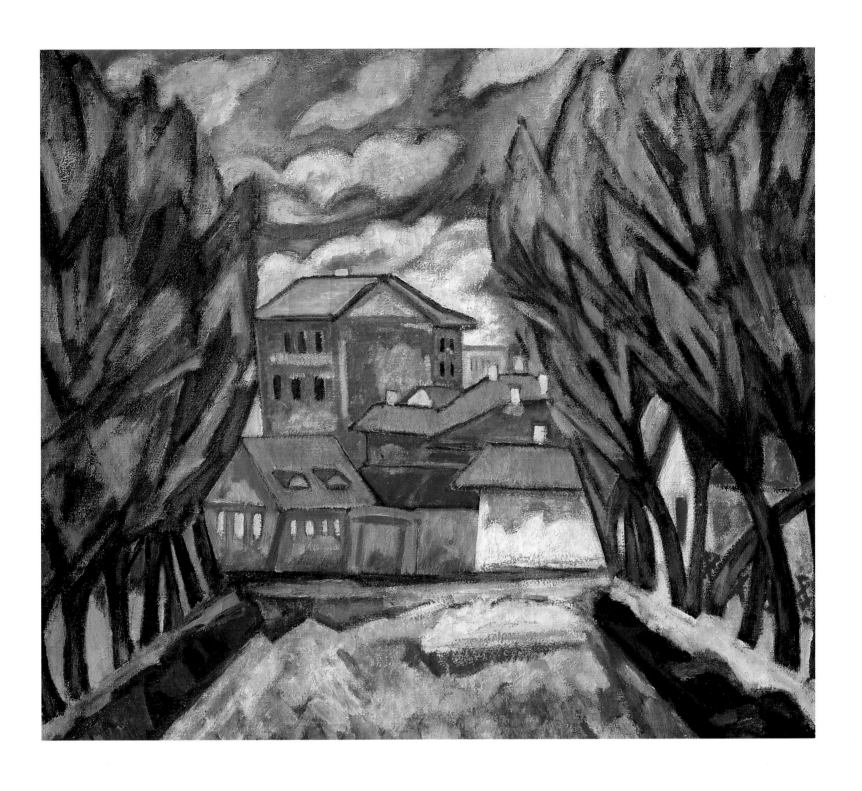

Doll. 19th century
Gorokhovets district,
Vladimir Province
Fretwork and paint on wood
20.7 x 7 x 2.5 cm
Д-373

Carriage. 19th century
Kirillovo district, Novgorod Province
Fretwork and paint on wood
12.1 x 13.8 x 12 cm
Д-384

Toys are a special form of Russian folk
art. They were made from various
materials, though mostly from wood
and clay. Carpenters carved toys from
logs when out hunting in northern
Russia, creating generalized images
of horses, women, and other figures.
(I. B.)

Olga **R**ozanova
Cityscape. 1910
Oil on canvas. 62 x 53 cm
ЖБ-1637

See p. 128

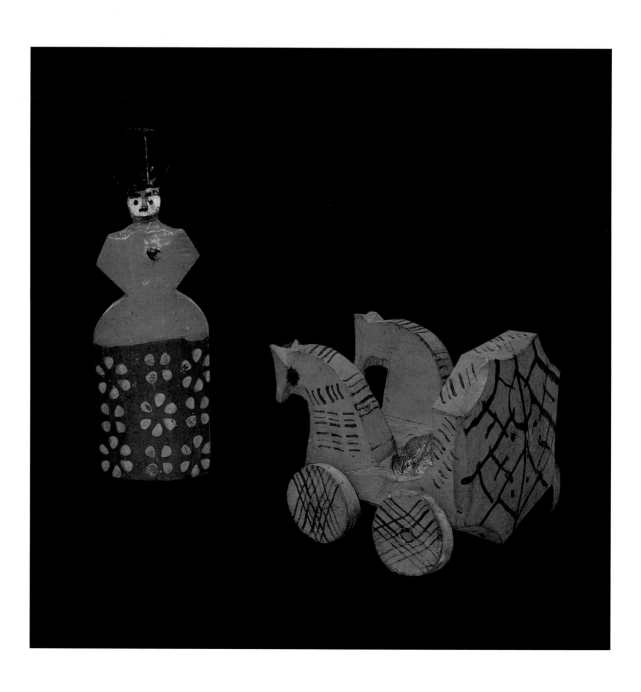

Olga Rozanova
Smithy. 1912
Oil on canvas. 90 x 98 cm
ЖБ-1322

Rozanova's work was clearly influenced by the Moscow school of painting. Stylistically similar to the works painted by Alexander Morgunov in the early 1910s, *Smithy* represents one stage in the artist's rapid assimilation of contemporary painting. The following year, Rozanova became interested in Futurism, extolling "abstract creativity" and "eternal renewal" in the *Union of Youth* manifesto. An early work, exemplifying Rozanova's dazzling and often breathtaking experiments, *Smithy* represents all that was "familiar and comprehensible" — concepts later soundly rejected by the artist. (*T. C.*)

Trunk. 19th century
Vologda Province
Paint on wood. 63 x 32 x 46 cm
P-2412

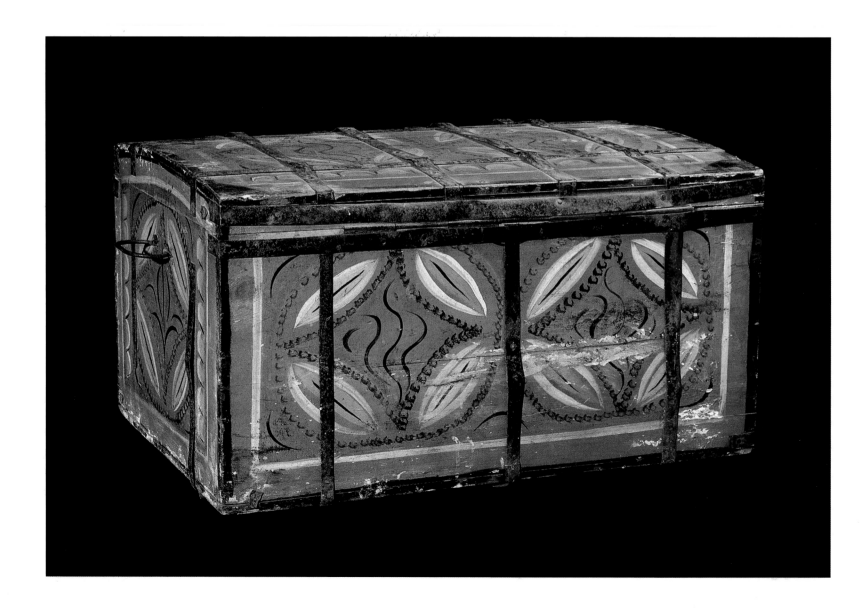

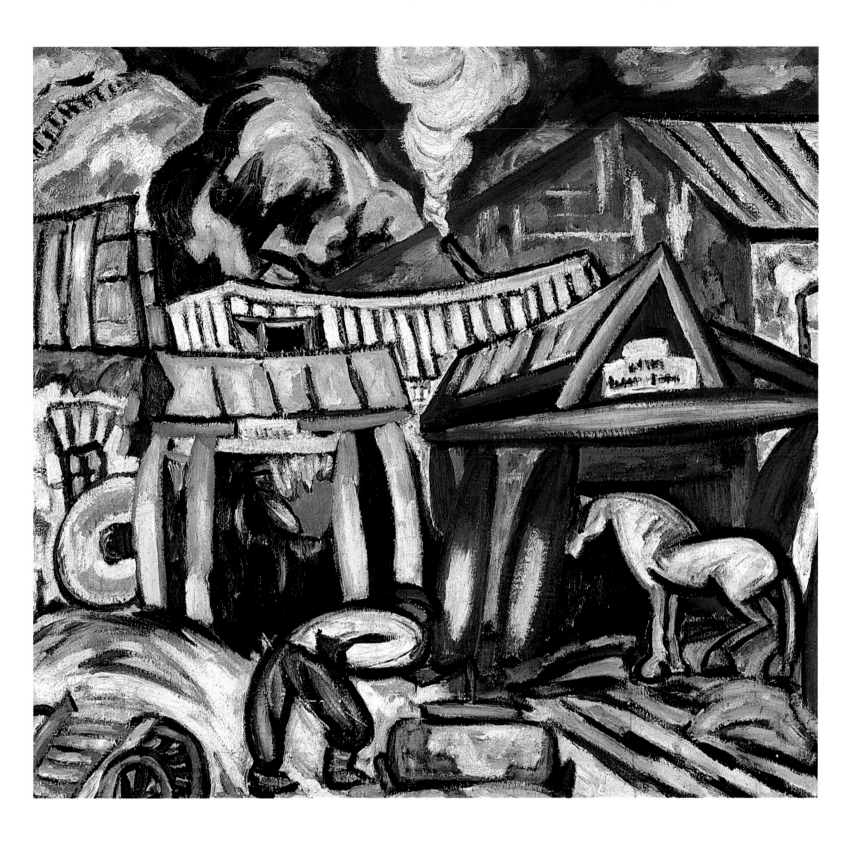

Wassily **K**andinsky
St. George (Version II). 1911
Oil on canvas. 107 x 95.2 cm
ЖБ-1698

Kandinsky often depicted the heroes of Old Russian painting in his oeuvre. One of his favorites was St. George, who is frequently encountered in the artist's painting and graphic art. Kandinsky transforms and reinterprets the image of the saint, gradually shedding realistic detail, while dramatizing the rhythmic harmony of color. The artist was convinced that by letting go of physical reality as his descriptive aim, he could better express the inner essence of the image. The rich and harmonic tones seem to strike a mighty chord, symbolizing the saint's heroism and the victory of good over evil. (*A. N.*)

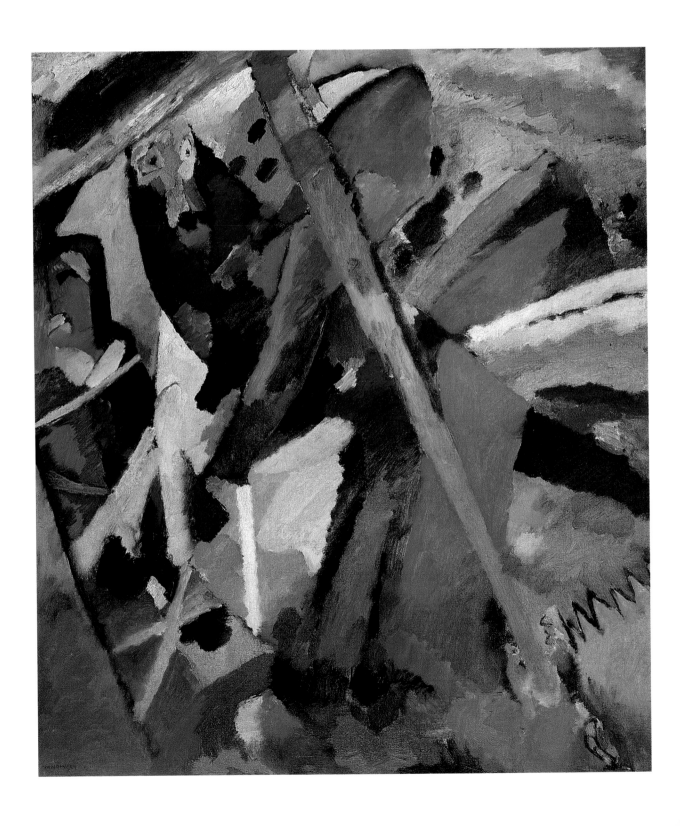

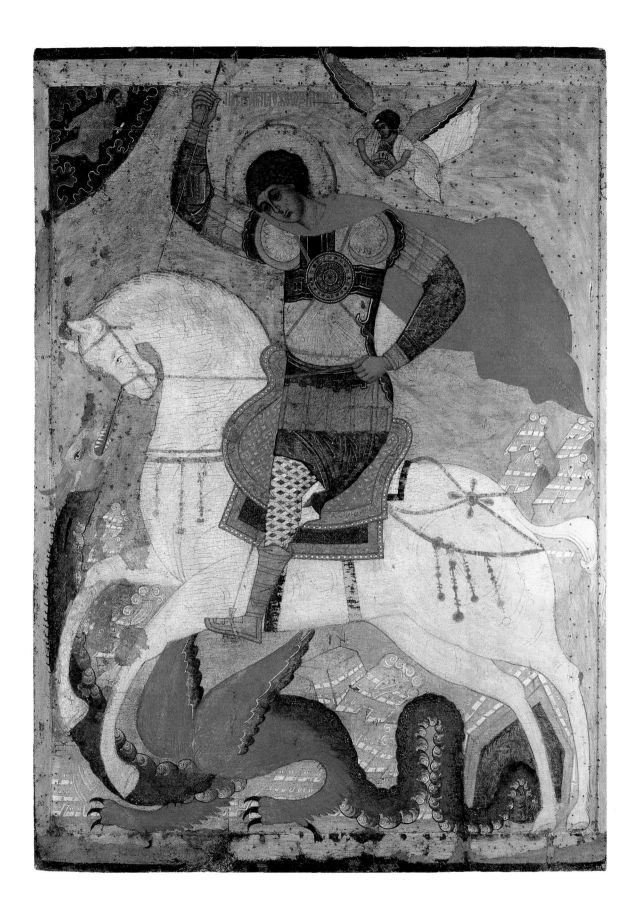

St. George and the Dragon.
Second half of the 16th century
Novgorod Province
Tempera on wood.
137.5 x 99.2 x 3 cm
Origin: Church of St. George,
Terebush parish, Leningrad Region
ДРЖ-2102

The story of St. George's battle against the dragon is one of the most popular subjects in Novgorod art and embodies the idea of heroism in battle. In folk circles, the composition was worshiped as a symbol of the victory of good over evil. St. George was also the patron saint of agriculture and cattle-breeding. Besides St. George's Day (*Yuriev den'*) on 23 April, Russia also celebrates the autumn festival of St. George (26 November), marking his rescue of the princess from the dragon. This icon depicts the shorter version of this story, which was just as popular in Russian art as the longer version. Folk motifs are particularly apparent in this extremely decorative icon. The icon unites the painterly devices of Novgorod Province and the Muscovite icon painting of the mid-sixteenth century. Echoes of Muscovite icon painting are present in the somewhat ponderous forms and festive yet solemn image. (*A. M.*)

Two-Piece Female Costume.
Second half of the 19th century
Master A. Y. Dorofeyeva, Trufanov Hill,
Pinega district, Archangel Province

Sarafan
Wool and paper. 121 x 130 cm
T-4076

Blouse
Linen and paper. 164 x 35 cm
B-8132

The distinguishing features of the
northern female attire from Archan-
gel Province are its austere beauty
and traditional combination of white
embroidered blouse with red slant-
edged, broadcloth sarafan (a mantle
or sleeveless cloak). (*I. B.*)

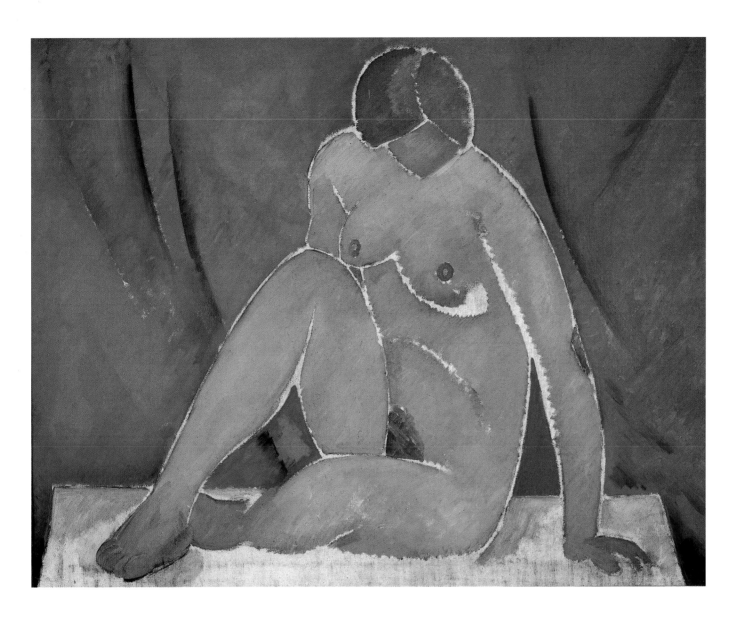

Vladimir **T**atlin
Artist's Model. Early 1910s
Oil on canvas. 104.5 x 130.5 cm
ЖБ-1330

In 1912, following his break with Mikhail Larionov and his group, Tatlin opened his own studio on Ostozhenka in Moscow, where he and a group of followers painted nudes after the live model. Tatlin's large paintings were influenced by Pablo Picasso's works, which the Russian artist could see in the private collections of Sergei Schukin and Ivan Morozov and at exhibitions of modern French painting in Moscow. Seeking his own form of Cubism, Tatlin borrowed liberally from the traditions of Old Russian icon painting. *Artist's Model* reflects his tendency towards generalization, synthesis, and expressive form. The large planes of color, the role of the silhouette, and the simplified contour of the figure add expressiveness to the artistic vision. The rhythmic forms and unmodulated areas of color maintain an equilibrium of pictorial attention throughout the canvas. Opening new doors in art, Tatlin successfully combined Old Russian icon painting and Cubism. (*A. N.*)

Vladimir **T**atlin
Sailor. 1911
Oil on canvas. 71.5 x 71.5 cm
ЖБ-1514

Although works by Tatlin are rarely seen, the artist remains one of the unchallenged pioneers of the Russian avant-garde. Tatlin's friendship with Mikhail Larionov led to the appearance of Neo-Primitive tendencies in his painting and graphic art in the early 1910s. The artist closely observed the environment, way of life, and physical appearances of the sailors, fishermen, merchants, and other colorful inhabitants of the southern port of Odessa. The level of generalization and the pictorial equivalence given to figure and ground, however, pay tribute to Old Russian icon painting. The sharp disjunction in scale between the main character and the figures in the background is reminiscent of icons depicting saints, creating a disquieting rhythm of contours and white patches on the sailor's face and clothes. *Sailor* unites elements of portraiture and caricature. The painting manages to incorporate the sitter's personal characteristics while allowing the artist to pursue his creative vision. It conveys the anxiety surrounding the impending upheaval of World War I and affirms the significance of the new heroes. (*A. N.*)

David **B**urliuk
Dniester Rapids. 1910
Oil on canvas. 49 x 69.5 cm
Ж-11132

*"Gravely and gloomily, the velvet
 and green canvases hung;
Others moved in mounds,
Perturbed, like black sheep,
Their surfaces rough and uneven."*
(*Velimir Khlebnikov*)

These lines convey Russian avant-garde poet Velimir Khlebnikov's impressions of the paintings of his friend and associate David Burliuk. One of the most remarkable features of Burliuk's art is the rich texture of his canvases. The artist achieves great expressiveness by exploiting the medium to its greatest plastic effect. The thick, gestural brushwork conveys a compelling sense of the rushing water. *Dniester Rapids* illustrates the artist's own statement that "once, painting could only see; now it feels." (*E. B.*)

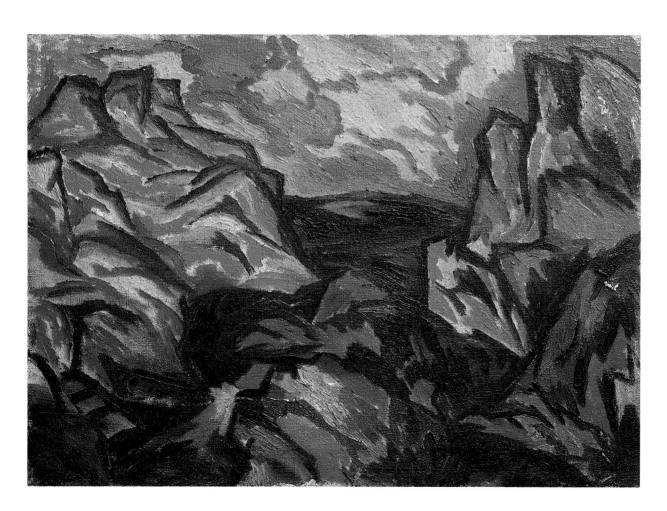

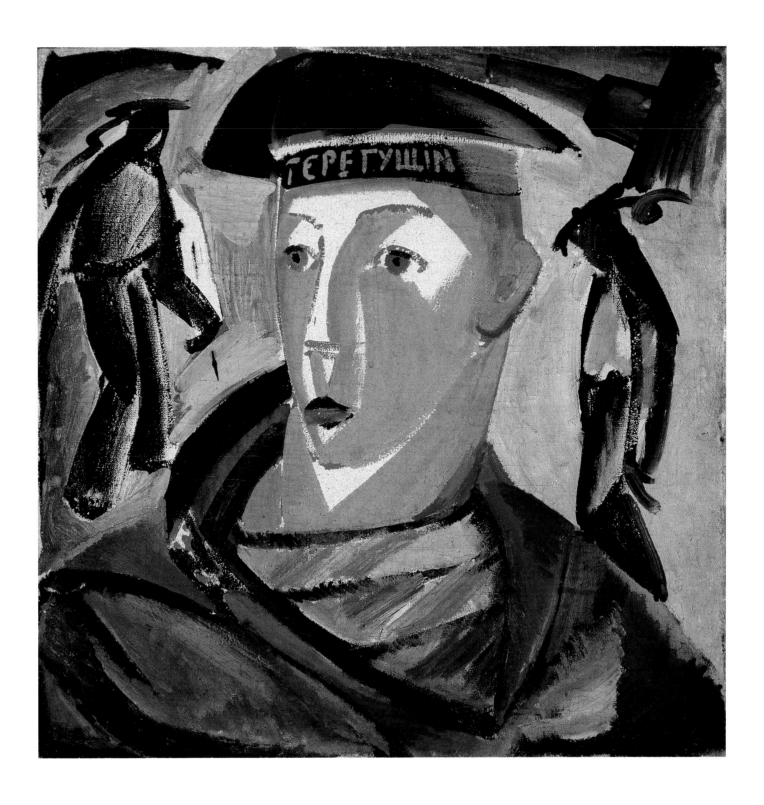

David **B**urliuk
Little Russians (Forbears
on the March). 1912
Oil on canvas. 36.5 x 55 cm
ЖБ-1650

Burliuk shared the interest in folk art
of the majority of the Russian Futur-
ists. He himself put together a collec-
tion of provincial signboards that has
unfortunately not survived. Later
given the alternative title of *Forbears
on the March*, both the subject and
the style of *Little Russians* reflect
Burliuk's interest in Ukrainian artistic
folk crafts. The painting evinces the
artist's attraction to the festive tones
of traditional Ukrainian weaving and
embroidery, while the coarse figures
of the striding Cossacks are reminis-
cent of painted wooden toys. The
numerous planar shifts were con-
ceived by the artist as a tribute to the
bold, geometric compositions of the
avant-garde of the early 1910s. (*E. B.*)

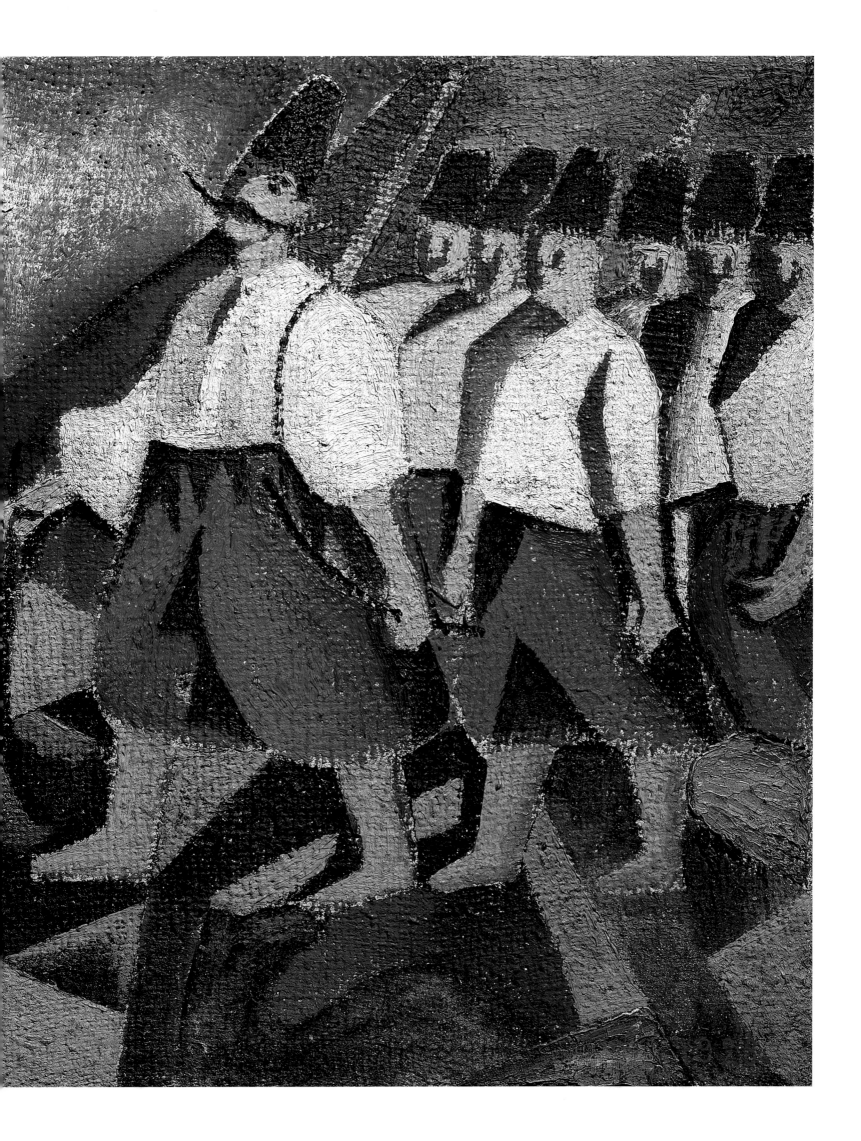

Pavel Filonov
Shrovetide. 1913–14
Oil on canvas. 79 x 99 cm
Ж-9026

Shrovetide (Mardi Gras) is a week of festivities in Russia dividing winter from spring. It is a time of large festivals and amusements, including the customs of troika rides, swings, sleigh rides, burning straw effigies, and rolling burning wheels down hills as a symbol of the sun. Filonov developed the theoretical tenets of his *Made Pictures* manifesto in 1913 and 1914, deriving much inspiration from Old Russian icons and folk art. The subject of the traditional colorful Russian festival permits the artist to achieve a more organic realization of his own creative ideas. The painting is constructed of shards of color that seem to "eat" into the flesh of the canvas. The grounds multiply, couples race past in decorated troikas, horses fly as if on a carousel. The festival of life and the world of painting are intertwined and mutually reflected by the creative will of the artist, who creates "made" works that do not so much imitate matter as manifest the deep processes of the construction of the world. (*A. N.*)

Sledge. 1915
Master A. Zhitkov, Danilovskoe,
Solvychegodsk district,
Vologda Province
Fretwork and paint on wood.
74 x 29 x 36 cm
P-2226

Brightly painted sledges were an important aspect of winter festivities in northern Russia. Sledging was one of the most popular pastimes of young people. Careering downhill, a young man would often stop to invite a young maiden to join him; men often courted their future wives in this way. Sledges were a popular present to fiancées. They were decorated with painted flowers, plants, birds, and other symbols of good luck. (*I. B.*)

Shaft Bow. 1888
Rakulka, Solvychegodsk district,
Vologda Province
Fretwork and paint on wood.
91 x 124 x 8 cm
P-3000

Decorated shaft bows were always a
feature of peasant weddings. Adorn-
ing the horse that pulled the bridal
coach, such bows were passed down
through several generations of vil-
lagers. (*I. B.*)

Pavel Filonov
Peasant Family
(The Holy Family). 1914
Oil on canvas. 159 x 128 cm
Ж-9578

Pavel Filonov's *Peasant Family (The
Holy Family)* belongs to his *Towards a
Universal Blooming* cycle of paintings.
By the term "universal blooming," the
artist implied a unified front that
would reveal and realize common
human values, with the artist as its
spiritual leader. Filonov called himself
an "artist of the universal blooming"
and conceived every painting as a
non-referential and organic develop-
ment of artistic forms. Like other con-
temporaries, Filonov treats canonical
subjects from the New Testament,
confirming their timelessness and
universal relevance. (*T. C.*)

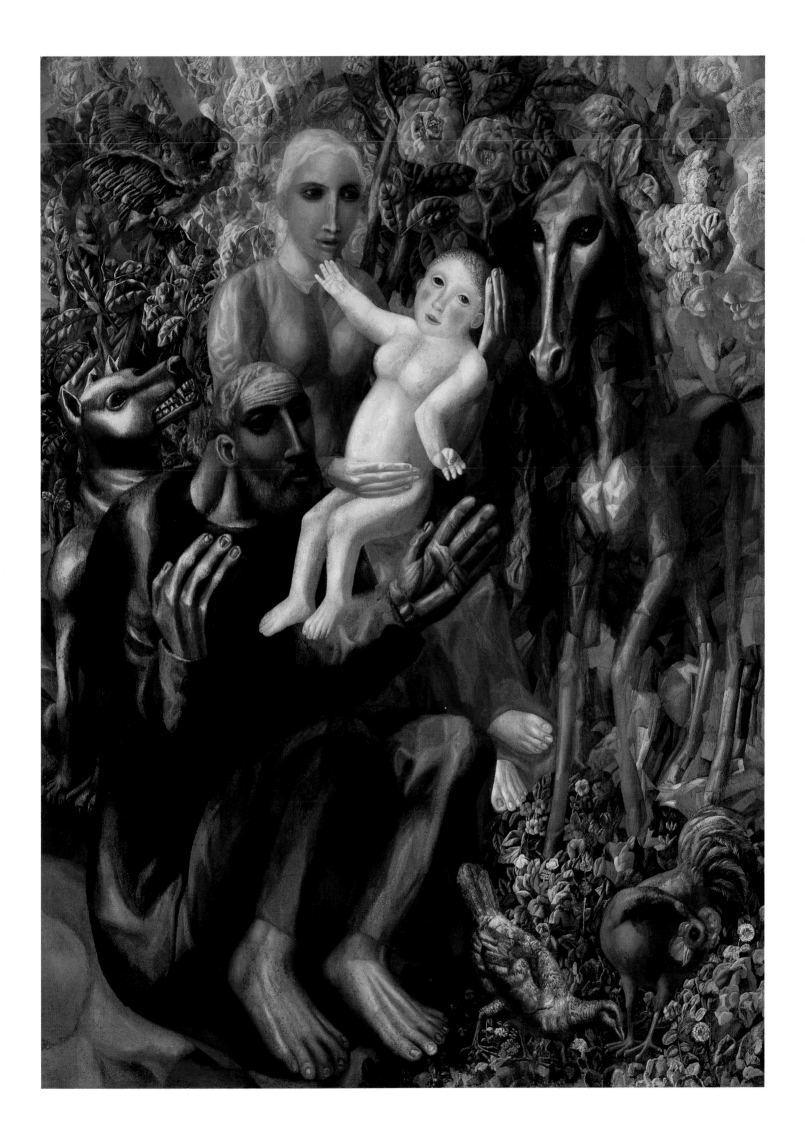

Pavel **F**ilonov
Oxen (Scene from the
Life of Savages). 1918
Oil on canvas. 62.5 x 80 cm
Ж-8579

Oxen (Scene from the Life of Savages)
depicts the anthropomorphic char-
acters encountered in so many of the
master's works. Although Filonov's
palette changed over time, he contin-
ued to express his ideas in the lan-
guage of parables. Although this par-
ticular painting appears to be devoid
of action, the human and the savage
merge to create an image evocative
of the drama of the Russian Civil War.
(*O. S.*)

Kazimir **M**alevich
Red Square (Painterly Realism
of a Peasant Woman in Two
Dimensions). 1915
Oil on canvas. 53 x 53 cm
ЖБ-1643

Red Square was painted in the mid-
1910s, when Malevich characterized
his art as the "final chapter in the de-
velopment of easel painting." Like
Black Square, this work is an epigraph
to the master's entire oeuvre and his
universal artistic system. "Draw in
your studios," Malevich wrote in 1920,
"the red square as a sign of the world
revolution of the arts" (Vitebsk Cre-
ative Committee Leaflet No. 1). The
alternative title of *Painterly Realism of
a Peasant Woman in Two Dimensions*
helps to throw light on Malevich's
concept. The artist's imagination
endows the "painterly realism of a
peasant woman" with a certain sym-
bolism, partially divinable and par-
tially representing a "quotation" from
his own theoretical statements, re-
flecting his knowledge of such topi-
cal works of philosophy as Peter Ous-
pensky's *Tertium Organum: The Key to
the Mysteries of the World* (1911). Ma-
levich's canvas transforms the sur-
rounding reality, which we perceive
in three dimensions, into an image or
sign interpreted in two dimensions
and, as such, far removed from con-
crete associations. The artist's *ABC of
Suprematism* regarded red and black
as the "heights of the pure tensions
of color and form, while white is the
highest tension of color in general."
Malevich sometimes even referred to
white as the "non-colored light." The
virtually indiscernible asymmetry,
dynamically uniting the white areas
of the background, helps the rich red
square to express the highly subjec-
tive essence of art. An important
influence on Malevich's Suprematism
was Russian icon painting, with its
specialized symbolism understood
only by the initiated. (*O. S.*)

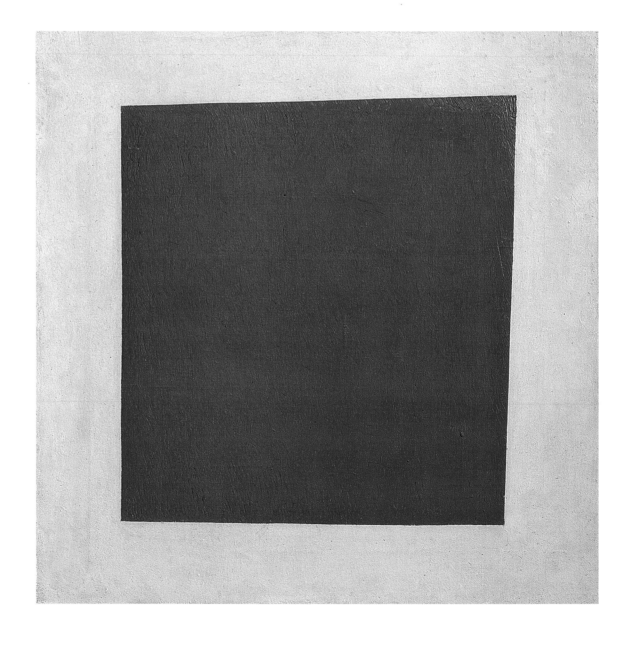

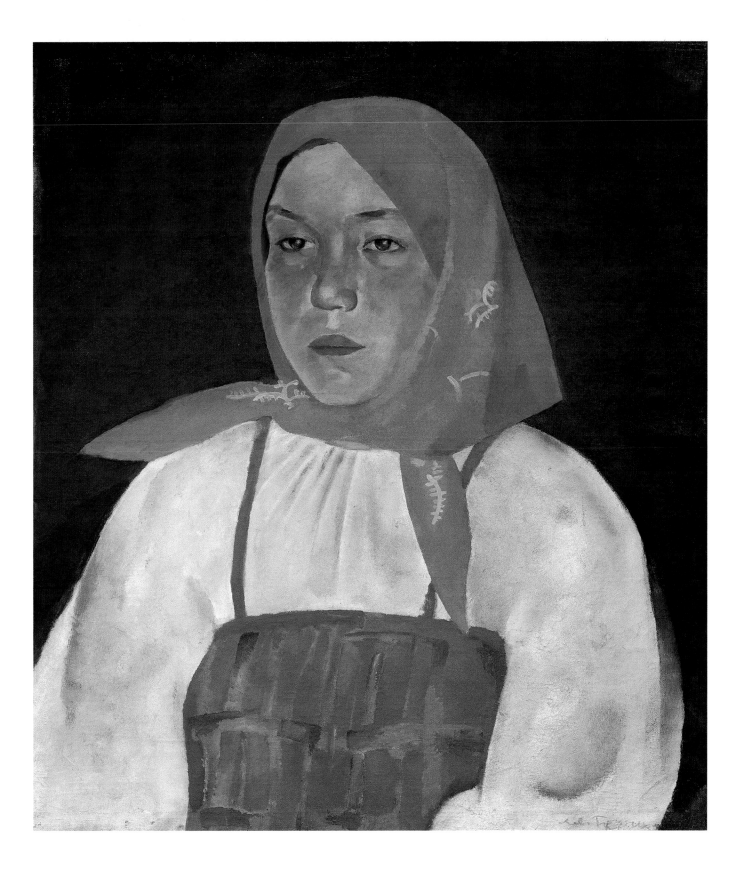

Lev Bruni
Peasant Woman. 1916
Oil on canvas. 68.5 x 61.5 cm
ЖБ-1346

In her writings, Lev Bruni's wife described the story of the creation of this portrait. The sitter was a girl called Nastya, a seasonal worker on the Balmont family estate in Ladyzhino in central Russia. Many young girls were brought in to work from the neighboring village of Dudino: "They all wore sarafans (a semicircular sleeveless overdress worn by peasant women) and bast sandals (flat boots woven from birchbark), and were extremely pleasant and modest." The artist asked if Nastya would pose for him for two hours every morning. She was shy and tried to avoid posing, saying that she would be teased by the other girls. The girl was relieved when the sittings finally came to an end. The artist gave her a present of a woolen shawl that he had bought in Tarusa. One of Bruni's earlier works, this generalized and iconic painting is constructed from large planes of decorative color combinations. (T. C.)

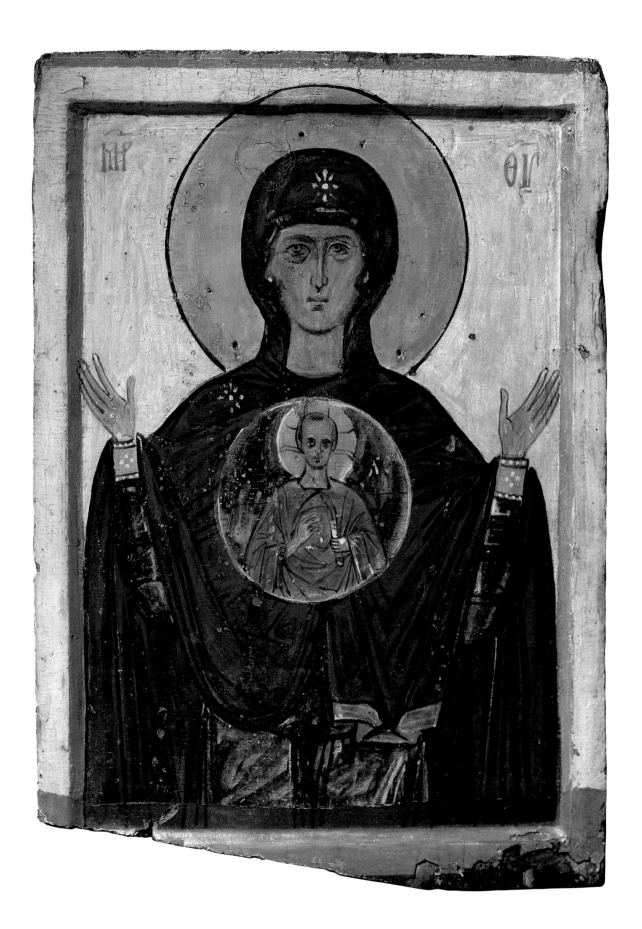

The Mother of God of the Holy Sign. 15th century
Northern Russia (Transonega)
Tempera on wood (lower edge filed
slantwise). 43 x 31 x 2.5 cm
Origin: St. Nicholas's Church,
Vegoruks, Karelia
ДРЖ-2900

Icons of this type were known in
Greece as *Oranta* ("praying") or *Pan-
agia* ("all-holy"). When it reached
Russia, the image acquired the name
of the Mother of God of the Holy Sign
(*Znamenie*). Icons of the Mother of
God of the Holy Sign were popular in
Novgorod in the twelfth century,
when one allegedly saved the besie-
ged city from an invasion by the
Suzdalites. When Archbishop Elijah of
Novgorod was praying, he heard a
voice commanding him to take the
image of the Virgin — the town's
patroness — from the Church of the
Transfiguration of the Savior and
hang it on the city wall. During the
procession, an enemy arrow struck
the icon. The Virgin turned her face
towards the city, giving a sign to the
people of Novgorod. The Suzdal regi-
ments were blinded and fled in ter-
ror. Following this miraculous sign,
the archbishop established an official
Russian Orthodox holiday in honor of
the Mother of God of the Holy Sign.
This fifteenth-century version of the
type was most likely made by a
northern Russian master. Such im-
ages of the Mother of God of the Holy
Sign remained popular in the Onega
region of northwest Russia right up
until the eighteenth century. (*A. M.*)

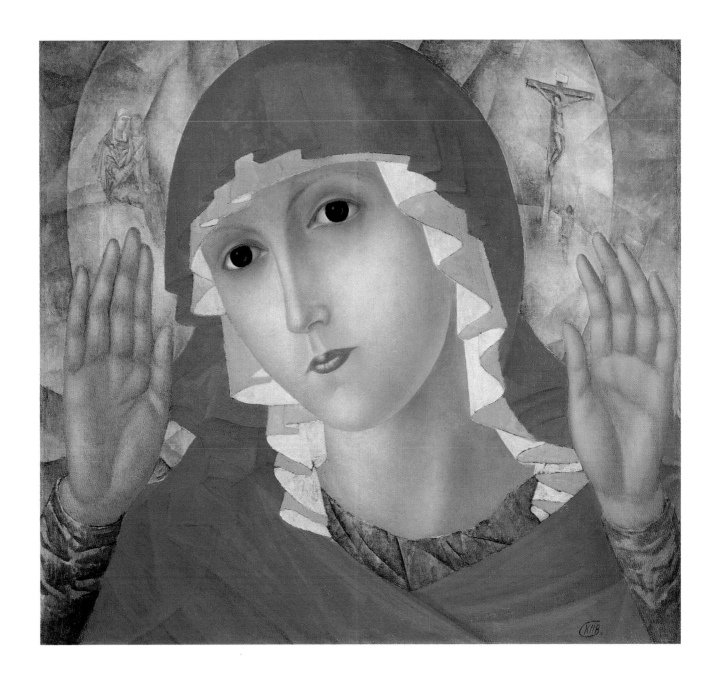

Kuzma **P**etrov-**V**odkin
The Mother of God of
Tenderness towards Evil
Hearts. 1914–15
Oil on canvas. 100.2 x 110 cm
ЖБ-11200

Petrov-Vodkin spent much time be-
tween 1913 and 1915 working on
murals in the cathedrals of Kronstadt
and Sumy. This may have been what
inspired the creation of this remark-
able canvas, which the artist chose to
entitle *The Mother of God of Tenderness
towards Evil Hearts*. In Orthodox icono-
graphy, the image is known as the
Mother of God of the Softening of Evil
Hearts. Created at the beginning of

the First World War, Petrov-Vodkin's
picture acquired a special significance
as the artist's spiritual response to the
war. Despite its small size, it has a visu-
al intensity that seems to burn with
the fire of a spiritual force. The artist
himself said that the face was "the
highest possible form of expression."
This haunting icon of the Virgin Mary
is one of the most powerful images in
Petrov-Vodkin's oeuvre. (*G. K.*)

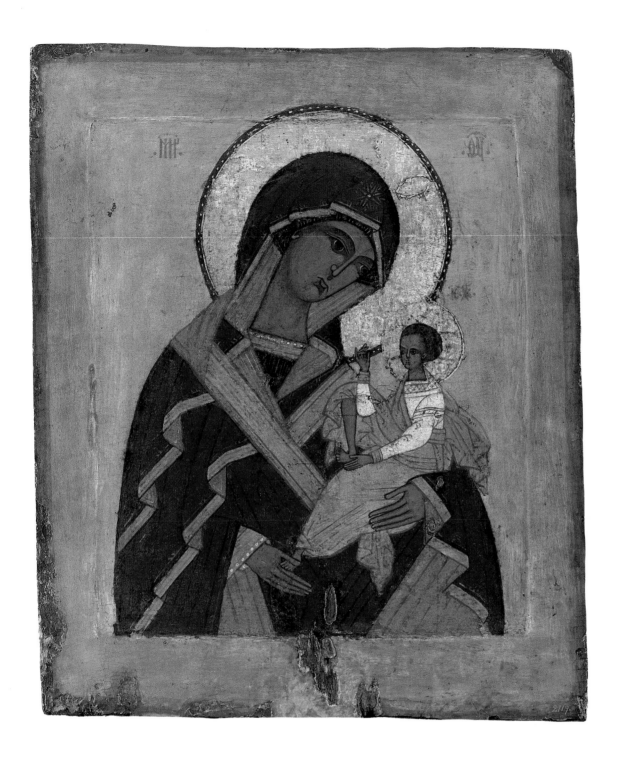

The Mother of God
Hodegetria of Shuya.
St. Leontius of Rostov.
17th century
Double-sided processional icon
Tempera on wood. 51.8 x 43.3 x 2 cm
ДРЖ-1475

Double-sided procession icons and wooden crucifixes were traditionally placed alongside the communion table on the altar. The special place allotted to double-sided icons in the church interior and their role in religious processions — marches around churches, monasteries, and whole cities on feast days or during national calamities, epidemics, and famines — explains their double-sided construction. The front generally depicted the Virgin and Child, symbolizing the Lord's assumption of human flesh and Mary's intercession on behalf of humanity. The back of the icon was also profoundly symbolic, generally depicting the Crucifixion — the dramatic culmination of Jesus Christ's life on earth. This particular image depicts the Mother of God Hodegetria of Shuya and St. Leontius of Rostov. The choice of subjects is unusual and possibly linked to the fact that the icon was created in central Russia. This work reproduces a miracle-working icon of the Theotokos from the town of Shuya in Vladimir Province. A work with this iconography was painted in the mid-seventeenth century and allegedly saved the town from an outbreak of plague when it was brought to the local Church of the Resurrection. Judging by extant sixteenth-century works, however, this particular iconographic type of Virgin and Child was popular in Russia long before the appearance of the Shuya icon. (N. P.)

Kuzma **P**etrov-**V**odkin
Mother. 1915
Oil on canvas. 107 x 98.5 cm
ЖБ-1250

The artist was particularly interested in national roots, ideals, and traditions at the start of the First World War. This painting was inspired by a live model, a young peasant woman breast-feeding her baby. However, the artist imbues her image with the divine grace of the Madonna and Child, thereby transcending the specificity of a mere portrait. The monumentality of the painting is intensified by the sonorous tones and dominant reds, the favorite color of the Russian people. (*G. K.*)

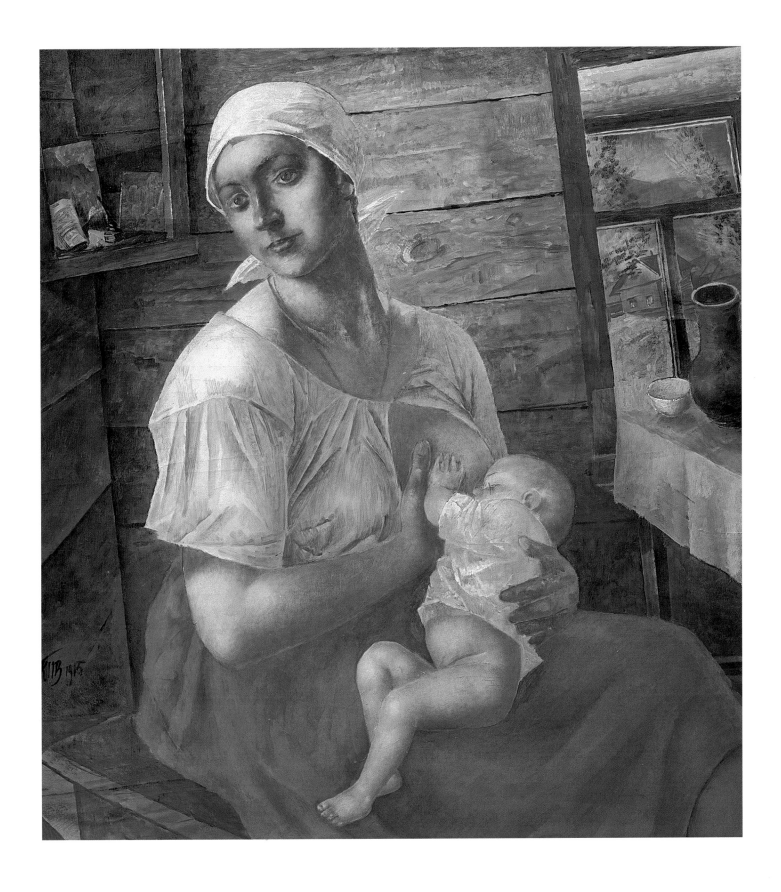

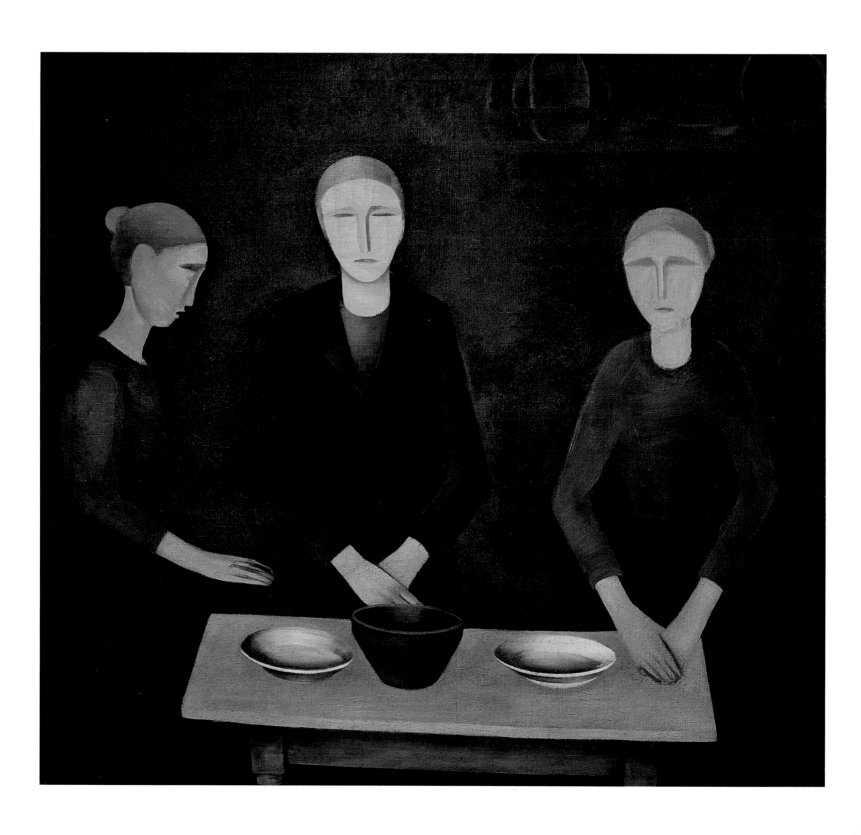

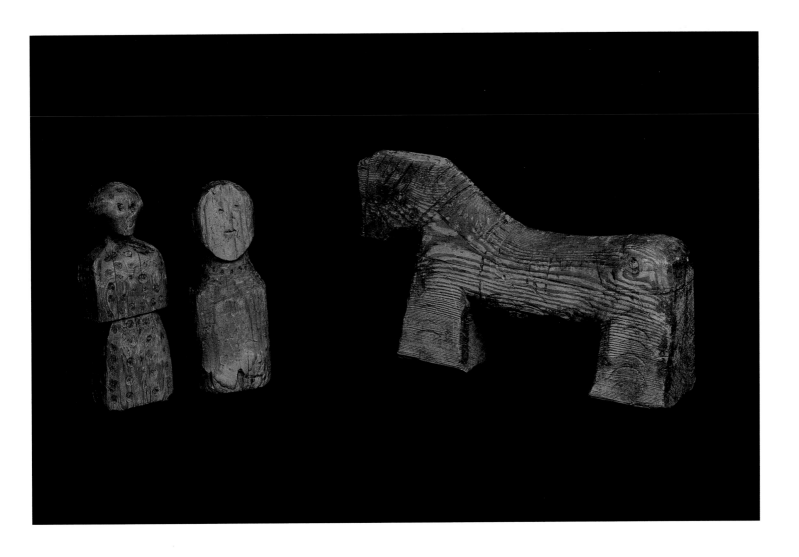

Doll. 19th century
Archangel Province
Fretwork on wood. 16 x 6 x 4 cm
Д-582

Doll. 19th century
Archangel Province
Fretwork on wood. 17 x 6 x 4.4 cm
Д-583

Horse. Toy. 19th century
Pushlakhta, Onega district,
Archangel Province
Fretwork on wood. 30 x 17.5 x 7.2 cm
Д-1949

Alexander **D**revin
Supper. 1915
Oil on canvas. 130 x 143 cm
ЖБ-1720

Drevin's *Supper* comes from the *Refugee Woman* series of paintings (1915–17) — the artist's response to the events of the First World War. Like many other refugees, Drevin was forced to leave his native Riga and settle in Moscow, as the Germans advanced deeper into Russian territory. The paintings of this cycle reflect the shock experienced by the artist and his sympathy for his uprooted compatriots. There was, however, one positive side to this period of trials and tribulations for the artist. Drevin departs from his former Impressionist landscapes and finds his own independent style in the *Refugee Woman* series, employing austere and simple forms. *Supper* depicts three pensive women sitting with downcast eyes at a table set with two empty plates and an earthenware cup. The arms of two of the women are folded as if in prayer. The gesture of the woman on the left inviting the guests to partake of the meal also has religious connotations. Time seems to have come to a complete standstill. Although it appears muted and restrained, the painting is nevertheless charged with drama and tension. (T. C.)

Alexander **D**revin
Refugee Woman. 1916
Oil on canvas. 100 x 89 cm
ЖБ-1404

Refugee Woman is typical of Neo-Primitivism in Russian painting in the 1910s, reflecting the strong influence of traditional folk art — in this case, the peasant wooden sculptures of the Baltic provinces. However, Drevin's works possess a gravity that distinguishes them from those of other Neo-Primitive artists. (*T. C.*)

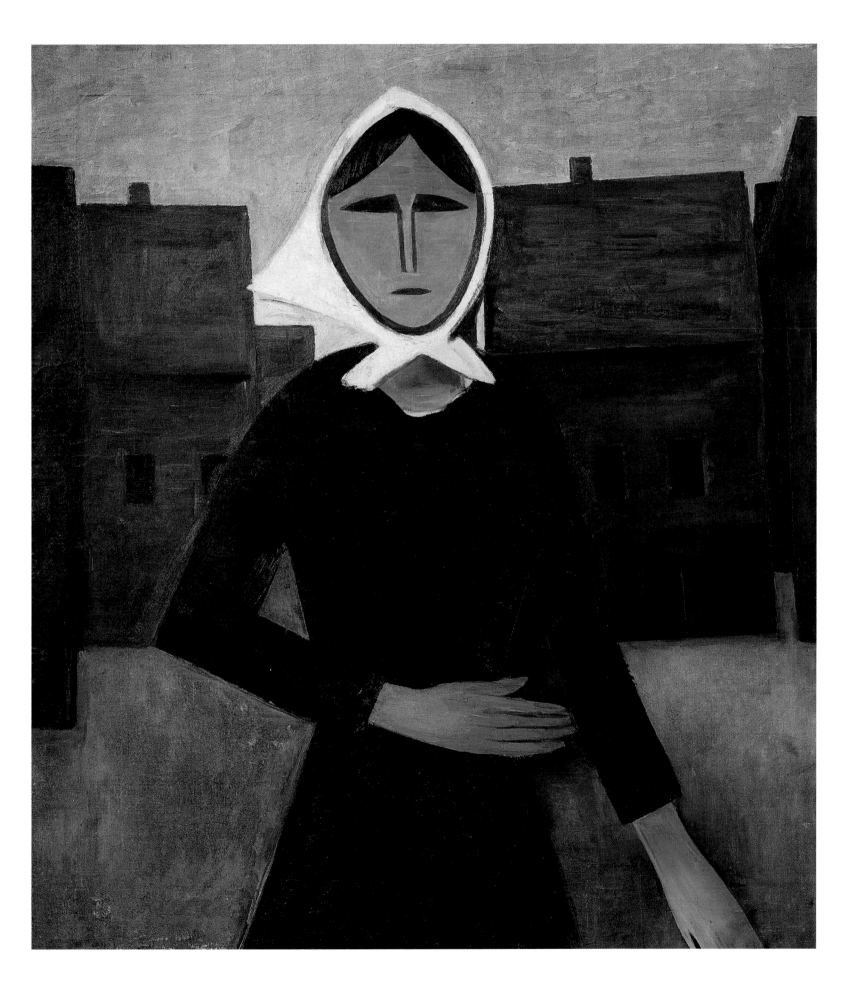

Boris **G**rigoriev
Land of the Peasants. 1916–17
From the *Raseya* cycle
Oil on canvas. 90 x 215 cm
ЖБ-989

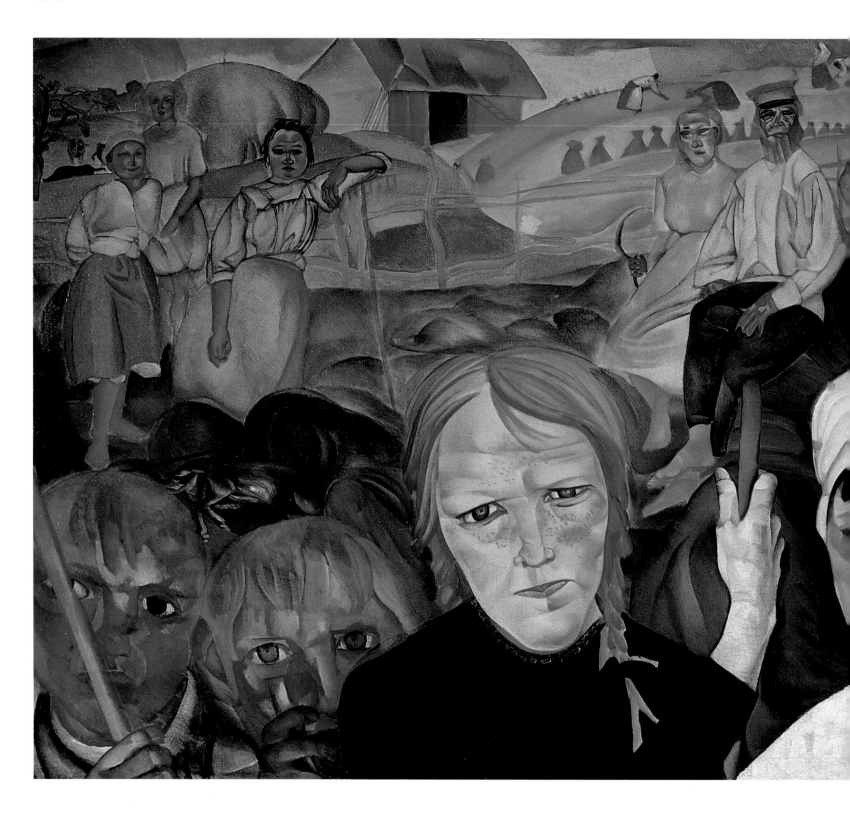

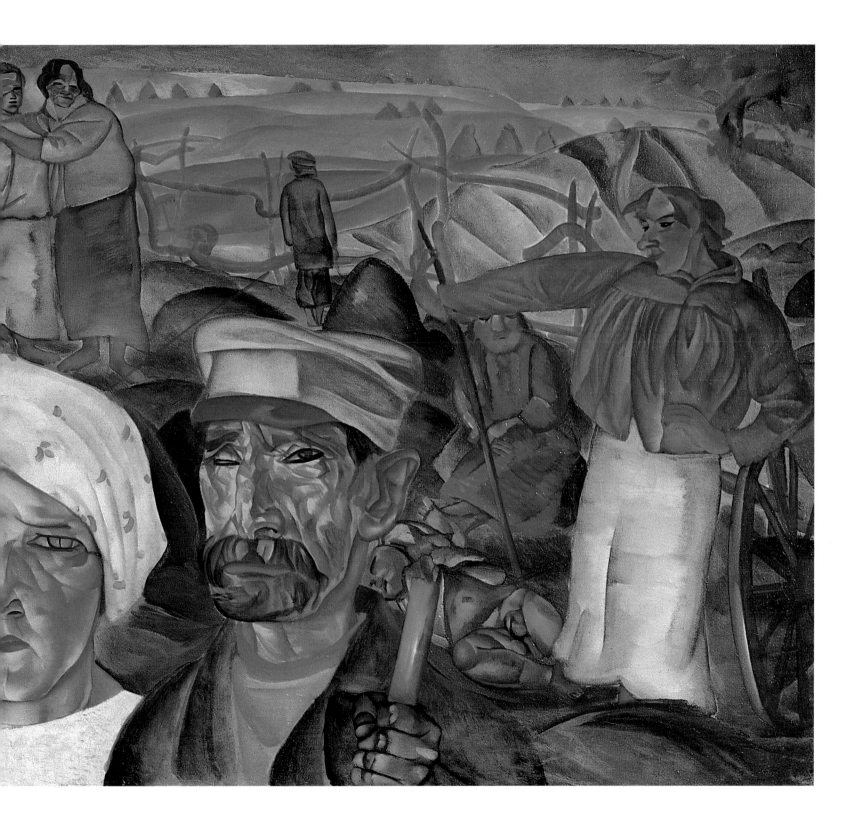

Painted when Russia was wracked by revolution and civil war, Grigoriev's *Raseya* cycle (1917–22) brought the artist nationwide fame and played a decisive role in defining his artistic identity. The series was regarded as a profound and expressive portrait of Russia in 1917. As in the other paintings of the cycle, the wary, rustic heroes of *Land of the Peasants* express psychological tension. The whole world is uprooted by recent revolutionary events, reflected in the untrusting looks of caution in the eyes of the child and the wary peasant. The artist's approach is both ironic and austere. Although the combination of Russian Neoclassicism and elements of Expressionism is, in itself, somewhat incongruous, the simple, grotesque forms and the restrained tones transform these common Russian peasants into the heroes of an age of drama. Contemporaries lauded *Land of the Peasants*, affirming that one day "this work will say far more than any chronicle or book, offering a far more profound insight into the history of the workers' and peasants' republic." Grigoriev completed the *Raseya* cycle after he left Russia, and it has been perceived as a nostalgic panorama of a lost homeland. (*A. N.*)

Wassily **K**andinsky
Female Rider and Lions. 1918
Oil on glass. 31 x 24.2 cm
ЖБ-1165

Kandinsky painted few canvases in the years 1915–18, producing instead works of graphic art and paintings on glass. The artist's glass paintings of the late 1910s were perceived as a further and highly original extension of his abstract experiments earlier in the decade. *Female Rider and Lions*, *Female Rider in Mountains*, *Golden Cloud*, and *White Cloud* address subjects once depicted by the Russian Symbolists. Kandinsky was drawn to Neo-Primitivism, inspired by the traditional pictures on glass sold at fairs and marketplaces. The artist had always been interested in glass as a medium. The material offered new spatial possibilities, while the use of foil and oil paints on the underside of the glass created an expressive textural effect. (*O. S.*)

Farewell. 1869

Painted lithograph. Image: 24 x
36.7 cm; sheet: 34.6 x 45.2 cm

Гр.луб.-1474

Pictures paired with the lyrics of Russian folk songs were often printed at lithograph studios in Moscow in the second half of the nineteenth century. They were generally printed on cheap, thin paper and crudely painted by hand or with the help of a rabbit's foot. The artist often failed to keep within the boundaries of the contours; this method of coloring was known as "painting the tops and tails." (O. V.)

ПРОЩАНІЕ

Ты неплачь, негорюй,
Моя миленькая
Не тужи, не тоскуй,
Ты хорошенькая,
Слезъ горючихъ неллей
Изъ прелестныхъ очей

Я твою ли слезу
На груди унесу,
И она среди сѣчь
Будетъ сердце мнѣ жечь!
Вражьи силы побьемъ
Мы огнемъ и мечемъ

Какъ изъ дальня пути,
Со крестомъ на груди,
Я къ тебѣ ворочусь,
Ко подругѣ своей,
На тебѣ я женюсь,
Ненаглядной моей!

Если жъ жизнь я свою
Положу на поляхъ,
Тогда душу мою
Помяни ты въ молебахъ,
Но не плачь, не тужи,
И себя не крушы!

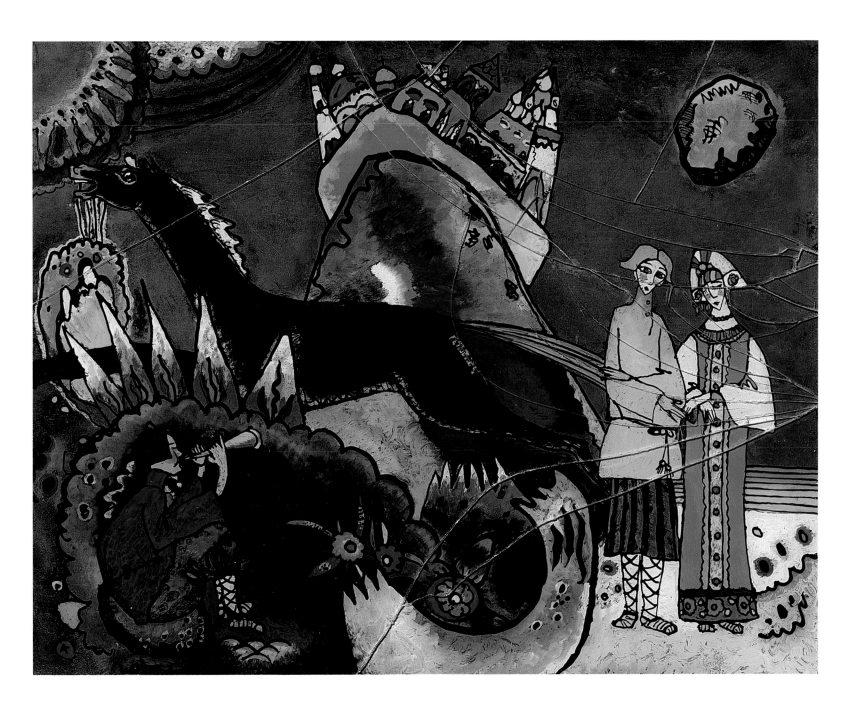

Wassily **K**andinsky
Golden Cloud. 1918
Oil on glass. 24 x 31 cm
ЖБ-1162

See p. 160.

Tray. 19th century
Lagutin workshop, St. Petersburg
Oil on metal. 56 x 71 x 4 cm
P-1547

Alexander Shevchenko
Still Life with Yellow Jug
and White Phial. 1919
Oil on cardboard. 75 x 74 cm
ЖБ-976

Shevchenko returned from the front in 1918 and plunged straight into the Moscow art world. One of the most active of the "left-wing" artists, he was perhaps the most consistent follower of Paul Cézanne. The Frenchman's artistic system clearly influenced the development of the Russian's own manner of painting. During a period of purification of his own style, Shevchenko sought to discover new textures, painterly constructions, and palettes. Although his still lifes are filled with unremarkable objects, the artist always manages to discern the sublime and the touching in the everyday. Contemporaries praised Shevchenko's ability to reinterpret the world of objects as something new, extolling his painting as the "pinnacle of artistry; the discovery of a new realism." (A. N.)

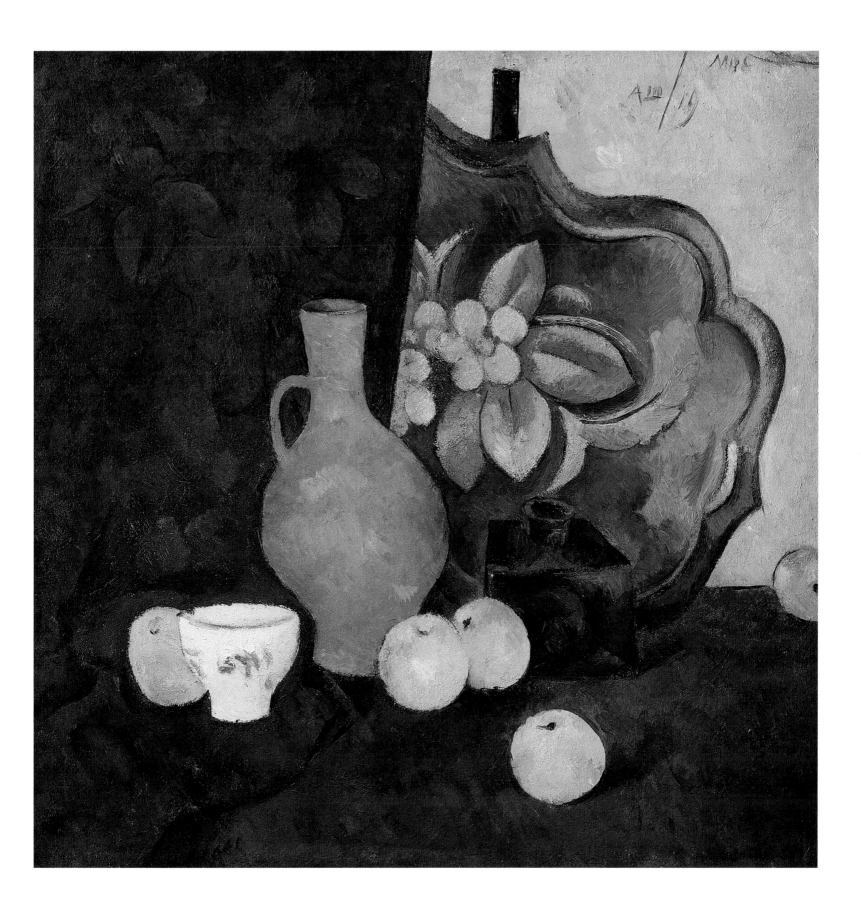

Bread and Fruit. Signboard.
Early 20th century
Oil on tin. 211 x 67 cm
P-5002

Signboards are not, strictly speaking, works of folk art. They are the individual creations of urban painters, whose scope was regulated by their guilds and the official censor — rather than the creative traditions of folk art. Their painterly merits were nevertheless an important influence on the artists of the Russian avantgarde, who highly rated the originality of signboards. (*I. B.*)

Jean **P**ougny
Still Life with Table. 1919
Oil on canvas. 103 x 73 cm
ЖБ-1696

A follower of Malevich, Pougny was clearly influenced by Suprematism. Pougny's approach, however, was something of a compromise. The artist employed abstract forms without entirely rejecting representational aims. Suprematism unites with Neo-Primitivism in Pougny's works; this particular still life combines the look of a *lubok* with elements of reality. The distinct edges of the shapes and the non-descriptive colors evince the influence of Malevich. (*A. N.*)

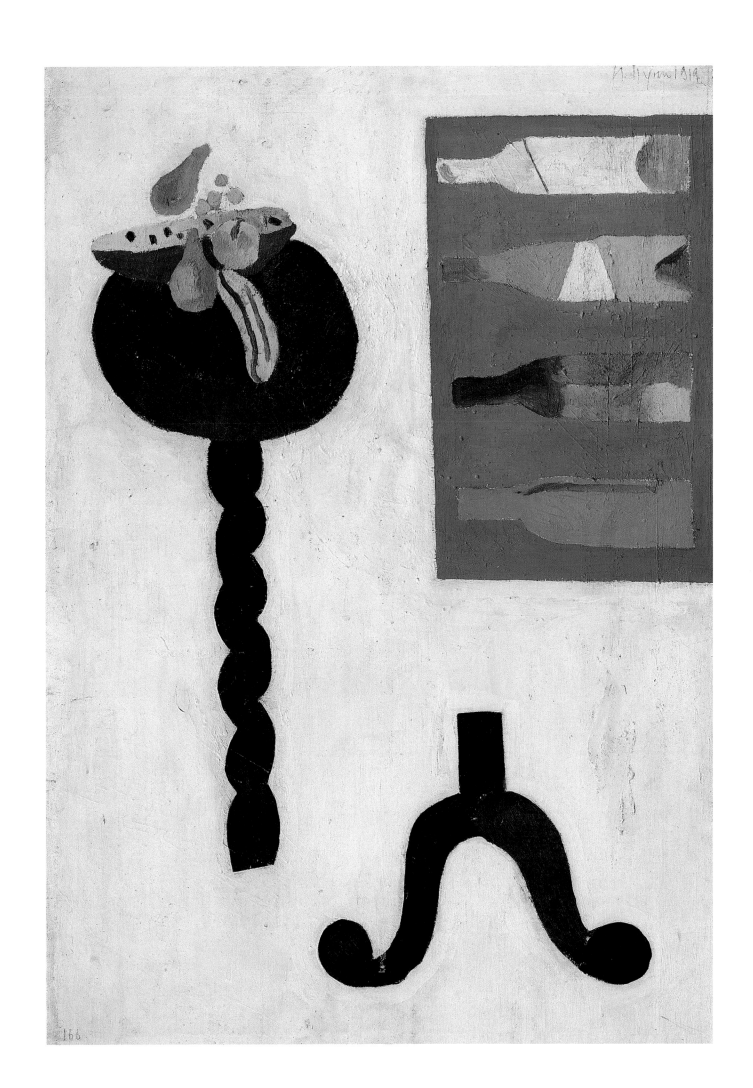

David **S**hterenberg
Still Life with Cherries. 1919
Oil on canvas. 68 x 67 cm
ЖБ-1540

Shterenberg's *Still Life with Cherries* is
one of the classic works in the oeuvre
of an artist who had, by the early
1920s, already produced a series of
extremely original still lifes. The artist
looks down at the scene from above,
placing the flat table top parallel to
the plane of the canvas. The plate
with cherries and the knife on the
edge of the table are also viewed
from above. The grain of the wood is
convincingly described; the form of
the tabletop in the bottom right-
hand corner is strangely elongated.
The cherries and the knife are extrem-
ely lifelike, almost to the point of col-
lage, while the background is cold
and empty. Although *Still Life with
Cherries* pays tribute to the Con-
structivist penchant for "ready-made
objects" and "truth to materials," the
artist does so by painterly means.
Shterenberg's still lifes of 1919 are
often interpreted as reflections on
the hungry years of war and revolu-
tion in Russia. (*T. C.*)

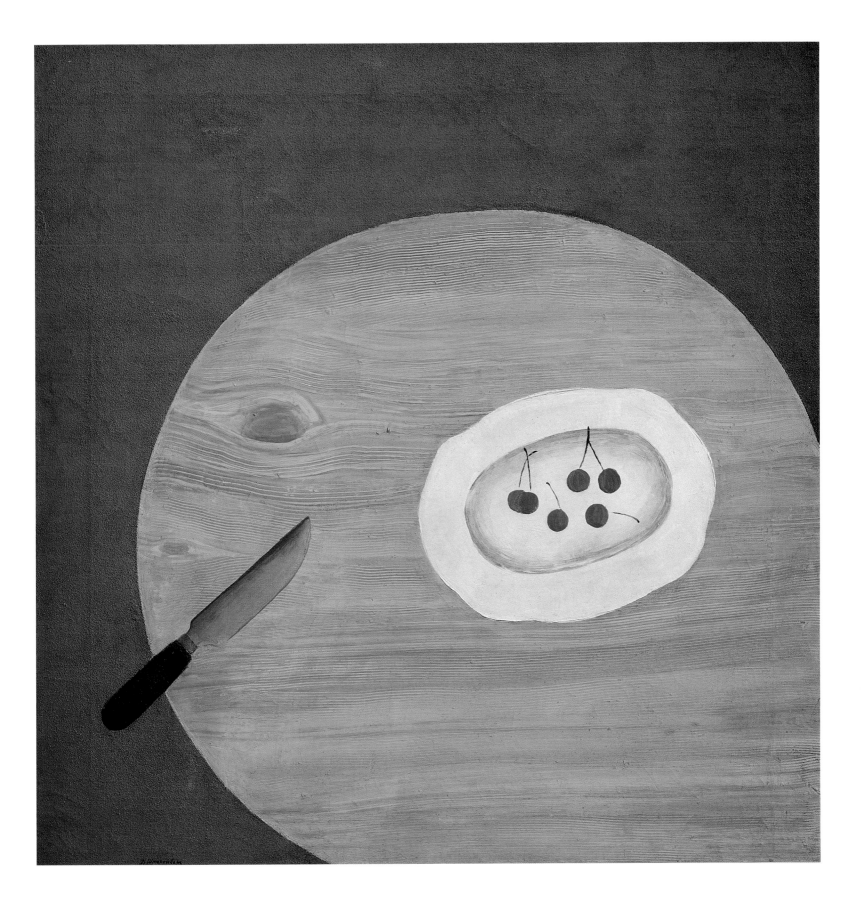

Wrap. Early 20th century
Zakhozhie, New Ladoga district,
St. Petersburg Province
Lace plaiting on linen. 100 x 102 cm
K-4002

David **S**hterenberg
Still Life with Crescent
Breadroll. 1919
Oil on canvas. 89 x 53.3 cm
ЖБ-1379

The palette of Shterenberg's still life consists of subtle hues of white. The artist appears to be attempting to dematerialize the painting; everything is in a state of flux. Covered with a white lace tablecloth, the corner of the table seems to rear up against the white background. There are only two objects on the sterile surface of the table—a vase and a horseshoe-shaped bread roll. In the late 1910s, Shterenberg experimented with textural effects in his manipulation of paint layers, introducing relief and carefully imitating the physical properties of such objects as lace and bread rolls. In the words of the Russian Constructivists, he "made things." Like *Still Life with Cherries*, *Still Life with Crescent Breadroll* was painted during the years of Civil War and economic ruin. (*T. C.*)

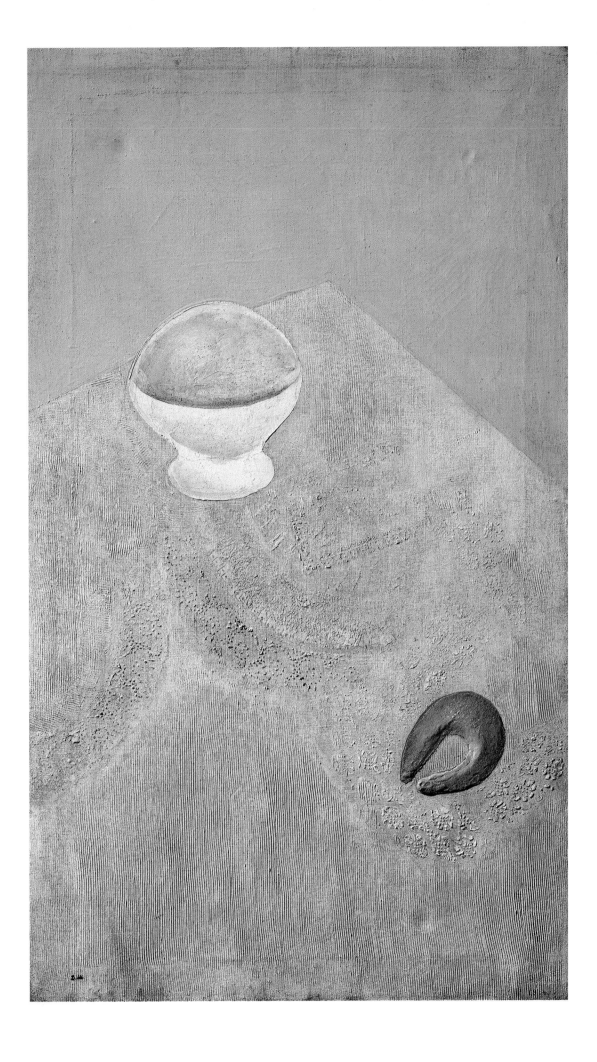

Vladimir Lebedev
Still Life with Boot. 1920
Oil on canvas. 107 x 77 cm
ЖБ-1424

Still Life with Boot reflects Lebedev's interest in the achievements of the leading masters of the period, particularly Kazimir Malevich. Equally apparent, however, are such other influences popular in the heyday of the avant-garde as the naïve straightforwardness and expressive details of Russian signboards. (*O. S.*)

Furniture Removal
Signboard. 1910s
Master K. M. Filippov
Oil on iron. 125 x 70 cm
Гр.Б-219

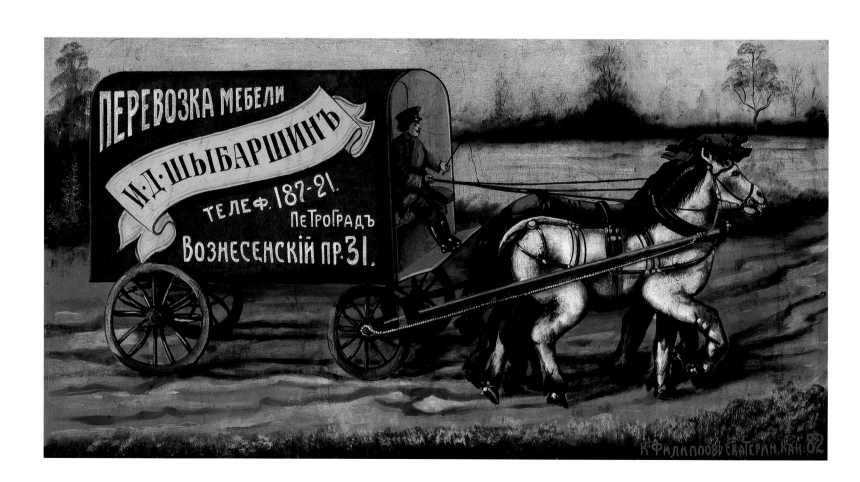

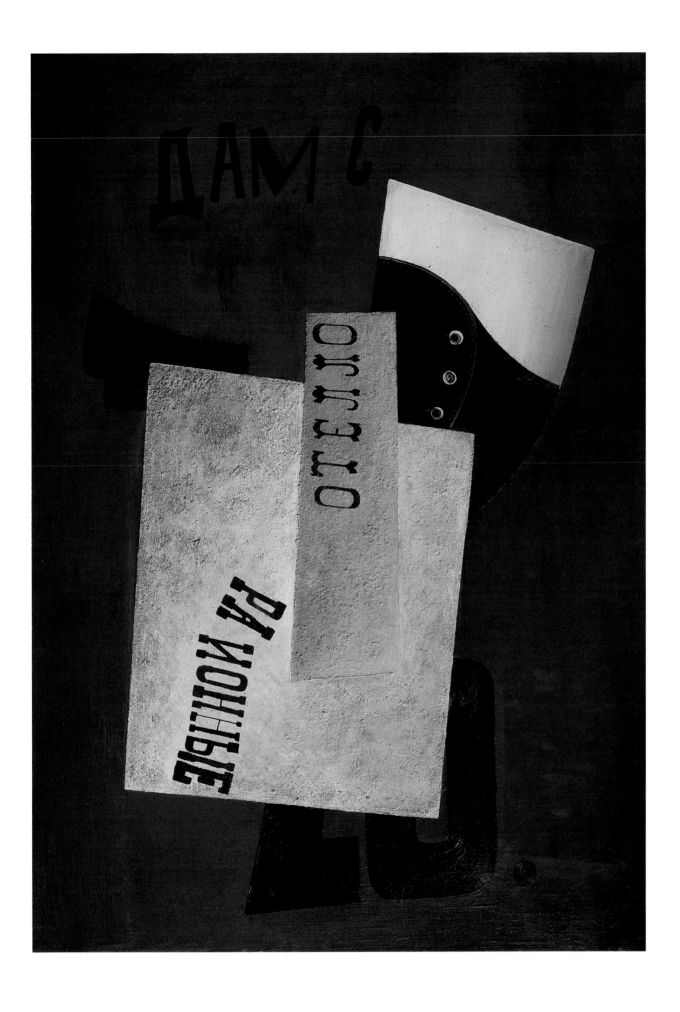

Alkonost Bird of Paradise

First third of the 19th century
Indian ink, quill and watercolors
on paper (copy of engraving)
Sheet: 44.5 x 36.4 cm;
image: 34.3 x 29.7 cm
Дуб-2415

The alkonost is a fabulous inhabitant
of Paradise, half woman and half bird.
In Russian folk art, it symbolized bea-
uty and the dreams of the coming joy
of the blessed. (O. V.)

Victor Palmov
Composition with
Red Rider. 1920
Oil and foil on canvas. 63 x 53.5 cm
Ж-1384

The decisive factor in Palmov's artis-
tic career was his friendship with
David Burliuk. In the mid-1910s, as a
student of the Moscow School of
Painting, Sculpture, and Architecture,
the artist became affiliated with the
Moscow Futurists. His works of this
period are obviously influenced by
the achievements of the leaders of
the avant-garde. The authority of Bur-
liuk, however, was foremost. This art-
ist encouraged Palmov's interest in
folklore traditions and infected him
with his sense of humor and love of
experimentation. The vibrant tones,
low-relief decoration, and frequent
use of foil, all traits of Russian and
Ukrainian folk art and crafts, contri-
bute to the festive character of this
painting. While the painting suggests
the influence of Russian icon paint-
ing, the image of the red horseman
conjures up associations with pagan-
ism and Dazhdbóg–the Slavonic god
of the sun riding his chariot. (O. S.)

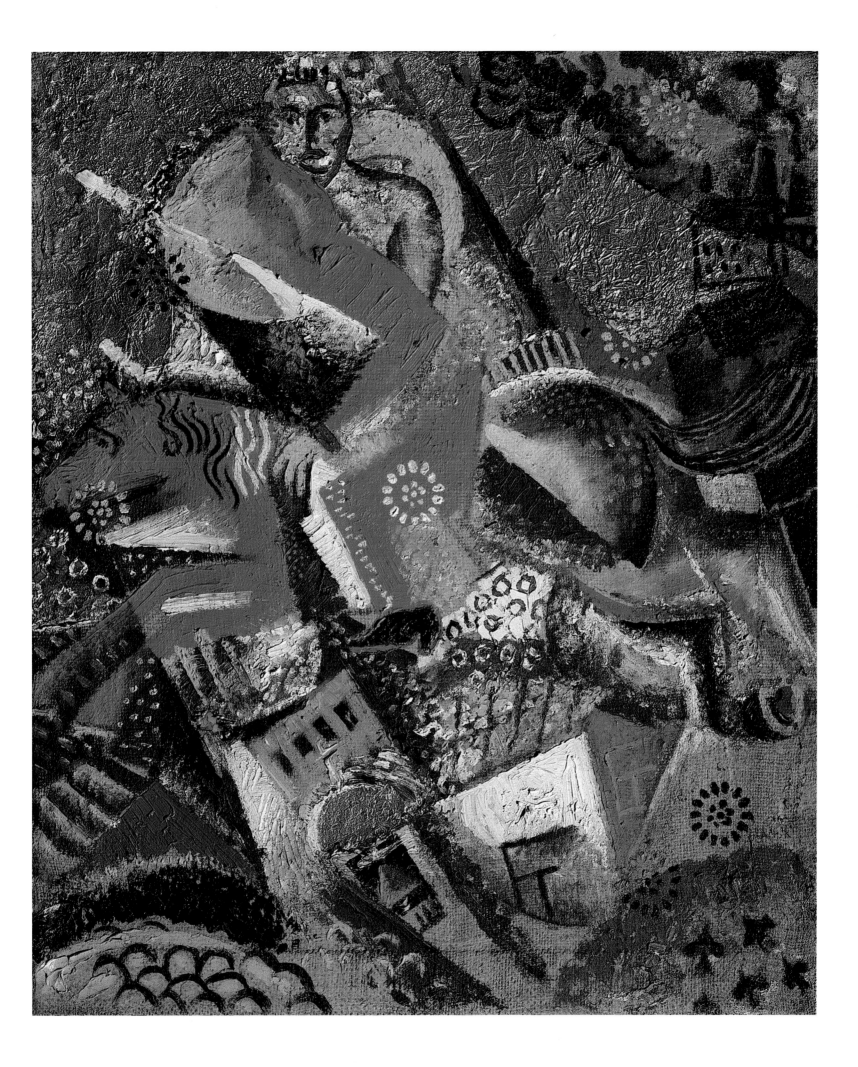

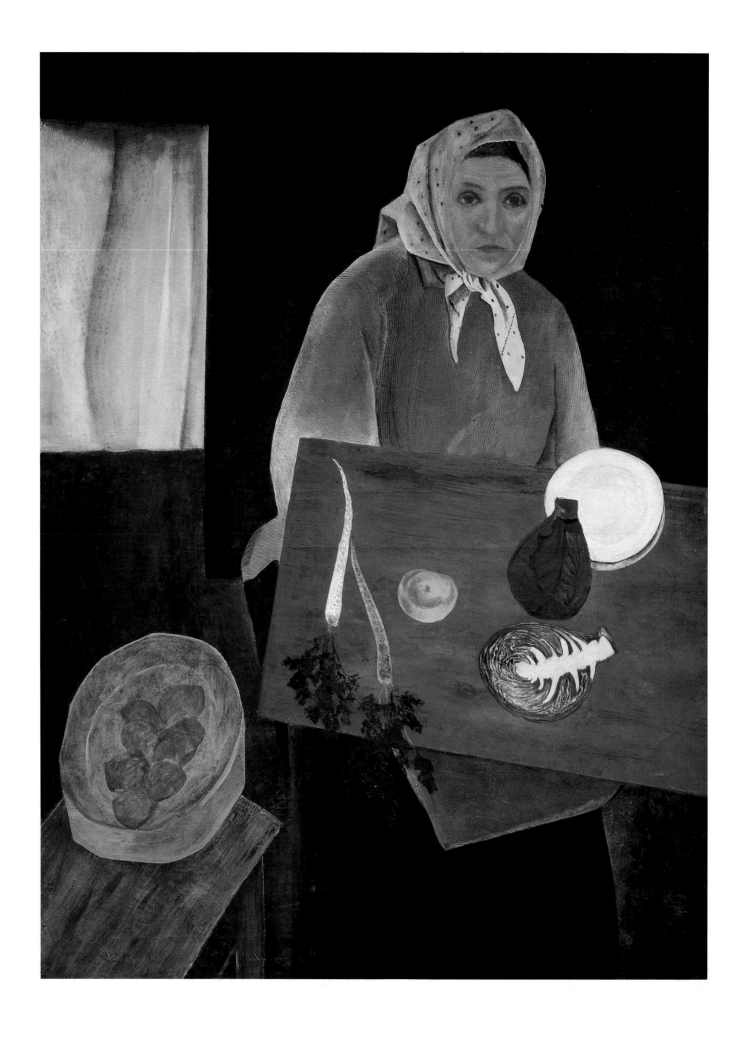

David **S**hterenberg
Aunt Sasha. 1922–23
Oil on canvas. 130 x 98 cm
Ж-10748

This is one of the few paintings in which Shterenberg combined a portrait and a still life in the one work. Supplementing and complementing one another, they could, in theory, have existed as independent works. The peasant-like woman assumes a weary pose, standing immersed in thought. Her unseeing eyes look into space, above the table with the simple vegetable still life. The theme of this work is everyday life. Sitting down for a minute to catch her breath, the unassuming heroine remains forever frozen in the space of the painting. The ascetic tones lend a meditative quality to this ordinary, everyday scene. (*T. C.*)

Dinner. Toy. Late 19th century
Bogorodskoe, Vladimir Province
Fretwork on wood. 22.5 x 15 x 5.5 cm
Д-2162

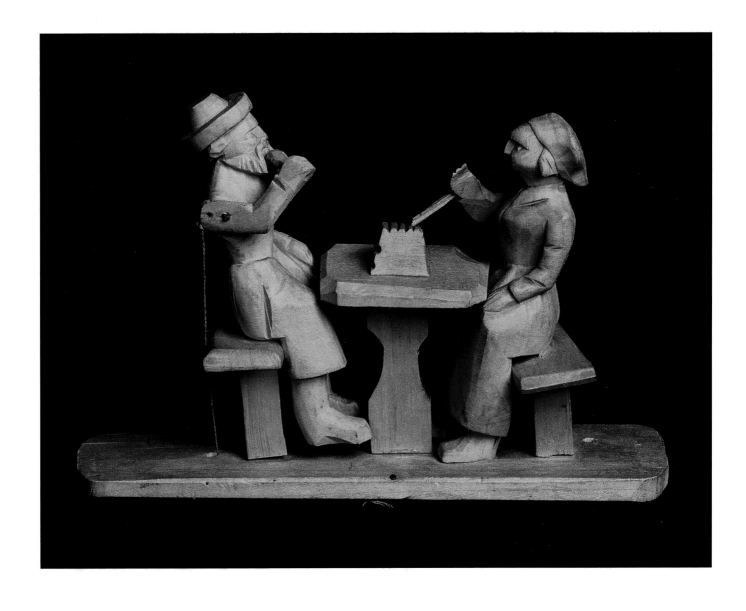

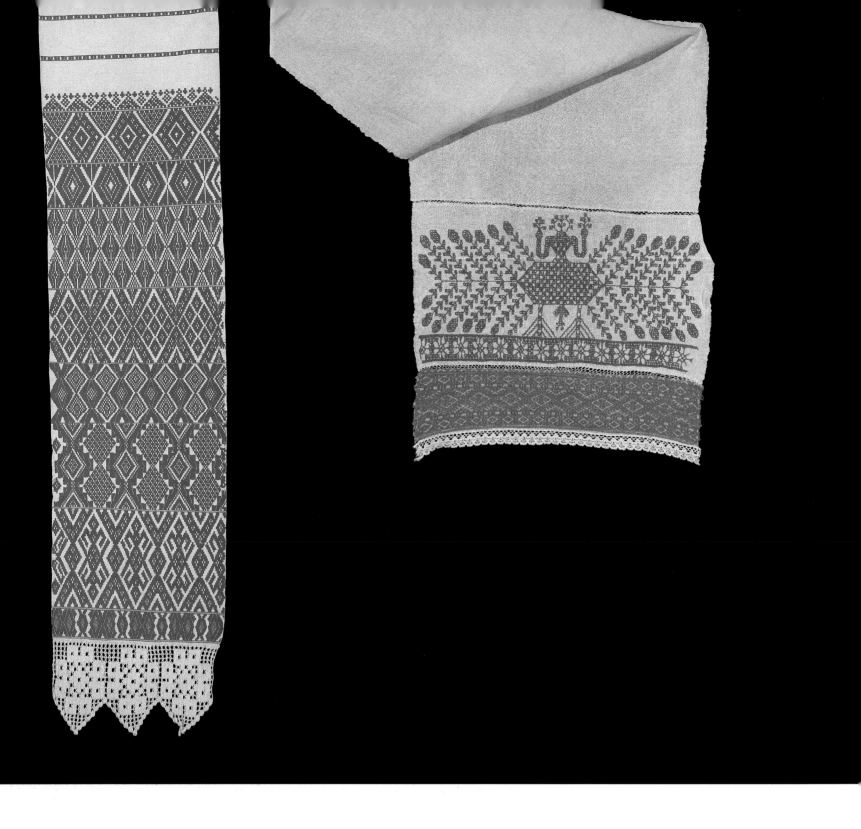

Towel. 1887
Kholmogory district,
Archangel Province
Cotton on linen. 37 x 320 cm
T-4362

Towel. Late 19th
or early 20th century
Ustyug district, Novgorod Province
Cotton on linen. 34.5 x 170 cm
B-9555

The towel played an important role in national folk life and was a vital element in many traditional rites. A dowry often included dozens of towels embroidered by the bride; their quantity and quality indicated the bride's financial position, talent, and diligence. Towels were decorated with patterned weaving, embroidery, lace, red cotton, and silk threads. Generally executed in red threads on white linen, the ornamental designs on towels brightened up the walls of wooden huts and framed the icons hanging on the wall, in the corner. While geometric motifs tended to dominate in the woven patterns, the compositions on North Russian towels dated back to the images of Slavonic mythology, personifying the fertility of the earth and the world of nature. (I. B.)

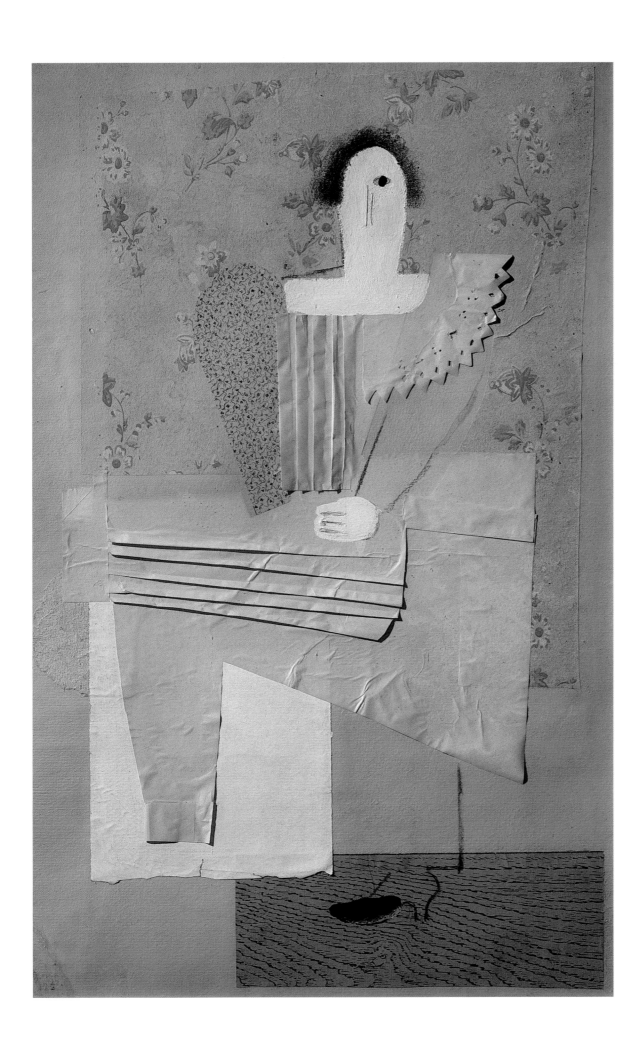

Vladimir Lebedev
Laundress (Ironer). 1925
Gouache, charcoal, and paper
(collage) on cardboard. 68 x 44.5 cm
Ж-10347

Laundress (Ironer) signals the start of
another period in the artist's career —
the assimilation of Cubism, which
remained popular in Russia in the
mid-1920s and was a starting point
for many avant-garde experiments.
Lebedev regarded Cubism not so
much as an object of imitation, but as
a school. The artist's Cubist composi-
tions helped him to realize his inter-
est in the construction of the object
and its plastic expression. Unique in
its own way, this particular collage is
one of a number of works that round-
ed off Lebedev's Cubist experiments.
Reminiscent of Pablo Picasso's own
collages and the textural experiments
of the Russian Futurists, *Laundress
(Ironer)* is enriched by figural ele-
ments inspired by traditional folk pic-
tures (*lubok*). (*O. S.*)

Valentin **K**urdov
Felt Boot. 1926–27
Oil on canvas. 90.5 x 54.7 cm
ЖБ-10644

This is one of the many Cubist compositions painted by Kurdov in 1926 and 1927, when the artist and his friend Yury Vasnetsov were studying Cubism under Kazimir Malevich. Kurdov preferred to depict objects that were simple in form and close to his heart — samovars, balalaikas, and felt boots (*valenki*). As the artist later recalled: "I wanted my Cubism to be Russian." The only concrete features in this generalized composition are the sole and the disk on the top of the boot. Although the artist was interested in the spatial positioning of the object on the plane, he himself confessed that he would much rather "extol" his objects than experiment with them. (*T. C.*)

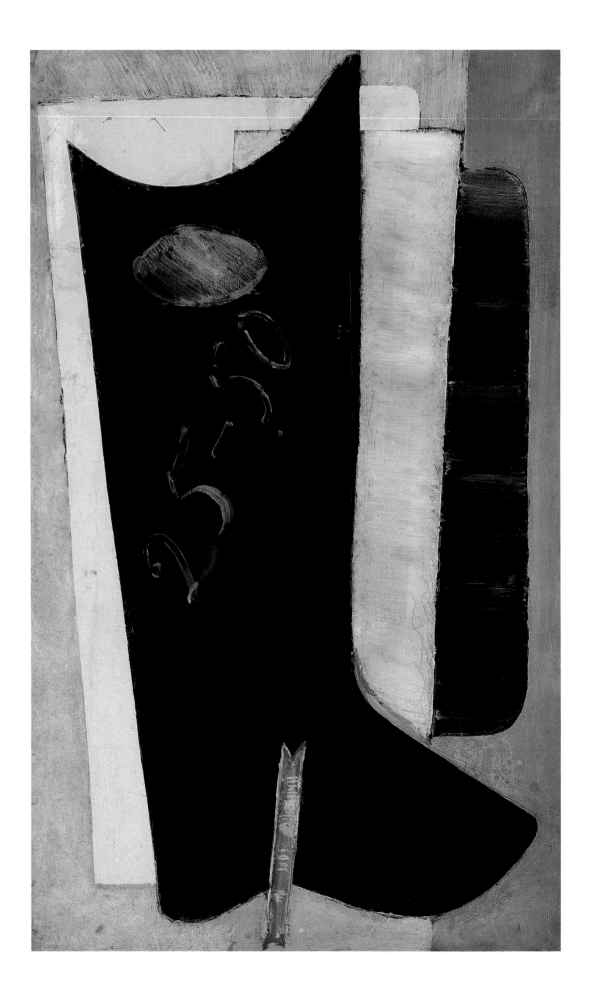

Yury **V**asnetsov
Lady and a Mouse
Between 1932 and 1934
Oil on plywood. 150 x 95 cm
Ж-10423

In 1932, Vasnetsov enrolled at the
Institute of Painting, Sculpture, and
Architecture in Leningrad and con-
ceived the idea of a picture portray-
ing the provincial way of life. Intend-
ed to depict a festive gathering aro-
und a table, the canvas had the
working title of *Glass Tumblers*. Al-
though Vasnetsov never painted the
conceived picture, he produced a
series of preliminary works depicting
the social types commonly found in
small provincial towns. *Lady and a
Mouse* is painted with a healthy dose
of artistic irony. (*A. N.*)

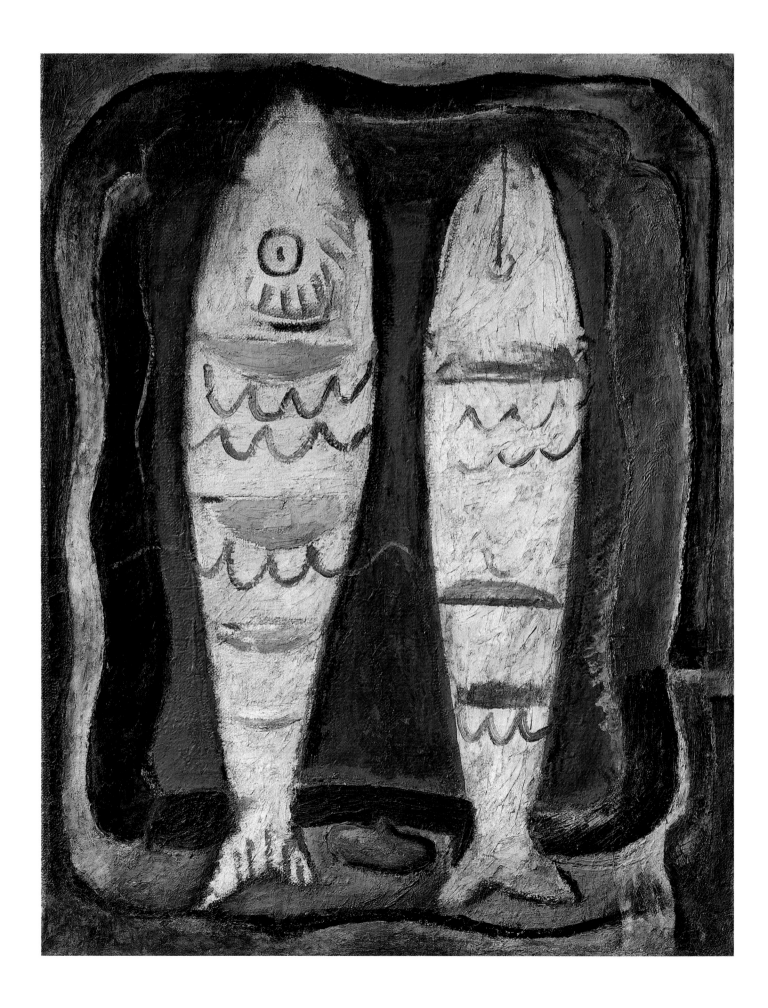

Yury **V**asnetsov

Composition with Tiny Fishes
Between 1928 and 1931
Oil on canvas. 116 x 93 cm
Ж-10412

Still Life with a Fish. 1934
Oil on canvas. 72 x 82 cm
Ж-8568

Vasnetsov's artistic personality was formed in the provincial town of Vyatka, where he grew up amid the all-pervading atmosphere of folk creativity. The artist retained vivid recollections of the colorful national festivals, dances, and fairs. Such impressions made an important contribution to the formation of his own personal tastes and artistic style. Vasnetsov's bright, eye-catching book designs and paintings reflect his interest in traditional handicrafts. The artist's works of the 1930s address questions of artistic form; his still lifes incorporate a high degree of generalization, rich tones, and decorative imagery. Vasnetsov later employed his creative experiments and compositional discoveries in his book illustrations and etchings, becoming an acknowledged master of both art forms. (A. N.)

183

Barrel. Mid-19th century
Permogorye, Solvychegodsk district,
Vologda Province
Paint on birchbark. 22 x 18.5 cm
P-1206

The barrel was made from birchbark and resembled a small wooden pail with a lid. It was used to store grain and flour, to carry food to people working in the fields, or to soak cloudberries and cranberries for winter. Each locality had its own unique style of decorating barrels with carvings and paintings of birds, floral designs, and genre scenes. (*I. B.*)

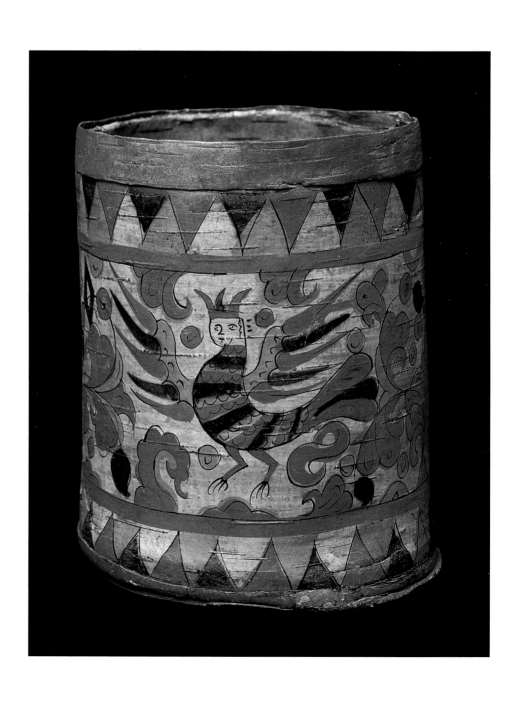

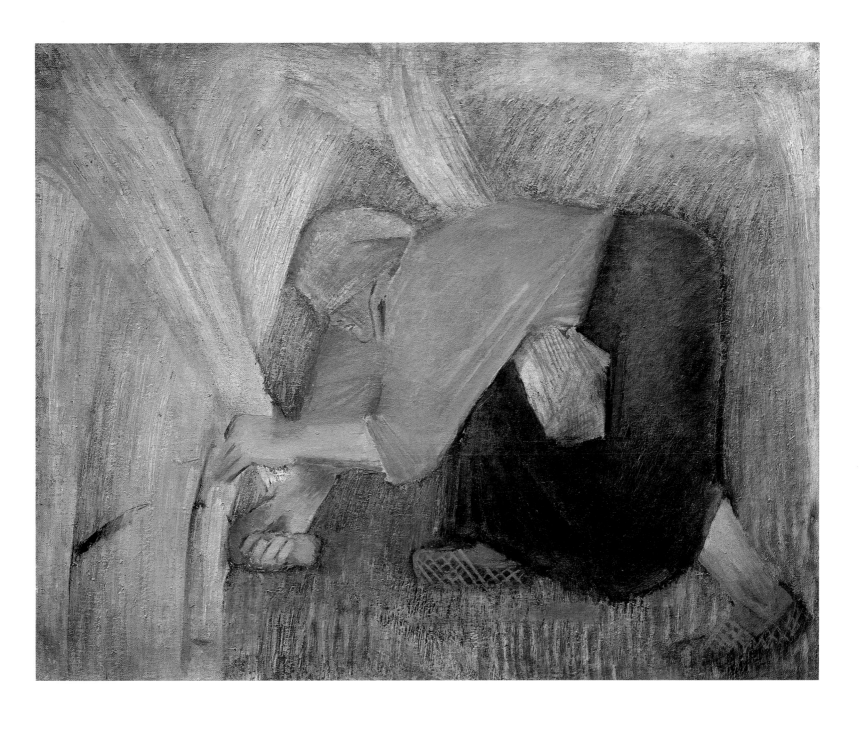

Alexei **P**akhomov
Woman Reaping. 1928
Oil on canvas. 85 x 106 cm
Ж-8603

A leading graphic artist and illustrator of children's books, Pakhomov was a prolific painter early in his career. The influence of the traditions of the art of Old Russia and the Early Renaissance can be seen in these works of the 1920s and 1930s. Combined with his experiments in modern art, these early works culminated in a unique painting style. As the artist himself later wrote: "Heartfelt elevation and high intentions are what…link ancient art to our time." His paintings resemble frescoes, though a broad range of other influences can also be discerned in the artist's technique, ranging from Pablo Picasso and Kazimir Malevich to Kuzma Petrov-Vodkin and Russian icons. The picture was intended to be part of a three-part decorative cycle for a canteen in Leningrad. Pakhomov's work is quite typical of the art of the mid-1920s and testifies to the renewed interest at that time in questions of monumentalism in painting. (O. S.)

Vyacheslav **P**akulin
Woman with Buckets. 1928
Oil on canvas. 187 x 151.5 cm
Ж-10265

This painting reflects Pakulin's gravi-
tation towards monumentalism in
art, which, in its turn, influenced the
choice of subject. The composition is
the result of the distillation of the
motif from the context of everyday
life, approached by Pakulin via a
series of studies entitled *Balance of
Movement*. One can clearly discern
the artist's attempt to assimilate the
experience of the avant-garde while
at the same time achieve a transcen-
dent meaning, as in the tradition of
Old Russian painting (icons and fres-
coes). Discarding some details and
highlighting others, Pakulin sacrifices
spatial coherence in favor of a free-
floating effect, while the repeating
contours of the figure give expres-
sion to the muscular effort necessary
to her task. The sense of rationality
permeating the artist's work in the
1920s was unable to deter his over-
riding interest in an expressive, as
opposed to imitative, use of color and
line to symbolize psychological insta-
bility. (*O. S.*)

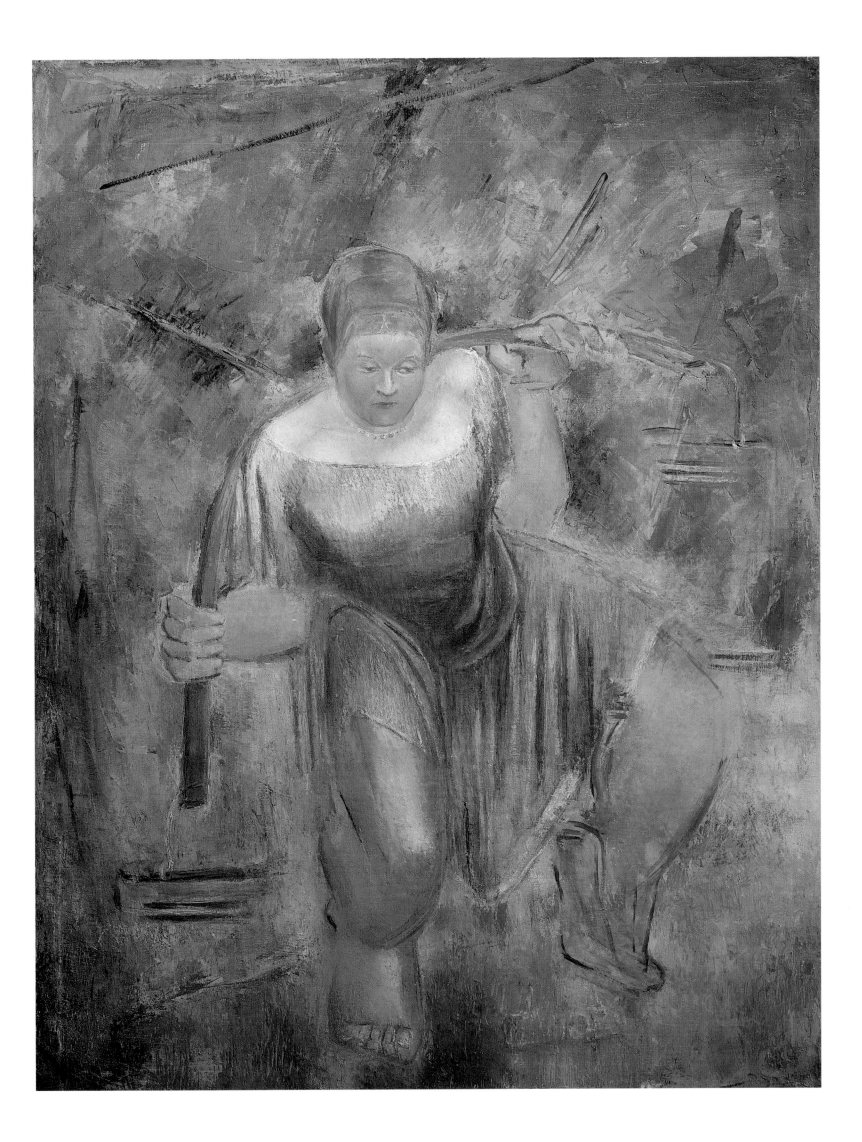

Sash. Second half of the 19th century
Zhtischi, Bezhetsk district, Tver Province
Wool. 2.8 x 196 cm
T-3181

Sash. Early 20th century
Priluk, Pinega district, Archangel Province
Cotton and wool. 1.8 x 292 cm
T-4082

Sash. Early 20th century
Vologda Province
Cotton and wool. 4.5 x 173 cm
T-4644

Sash. Early 20th century
Master E. A. Bogomolova
(1893–1976), Yudino, Vetluzhsky district, Kostroma Province
Wool and linen. 3.5 x 298 cm
T-5585

Sashes were an invariable part of male and female folk costumes and a prominent feature in the marriage ceremony. They were braided, knitted, or woven from linen and silk threads in many parts of Russia. Sashes were popularly believed to protect the wearer from evil spirits. The diamond-shaped motifs of the ornamental designs were enlivened with geometric human figures and pictures of horses and deer. Tassels set off the bright red and multicolored patterns. (*I. B.*)

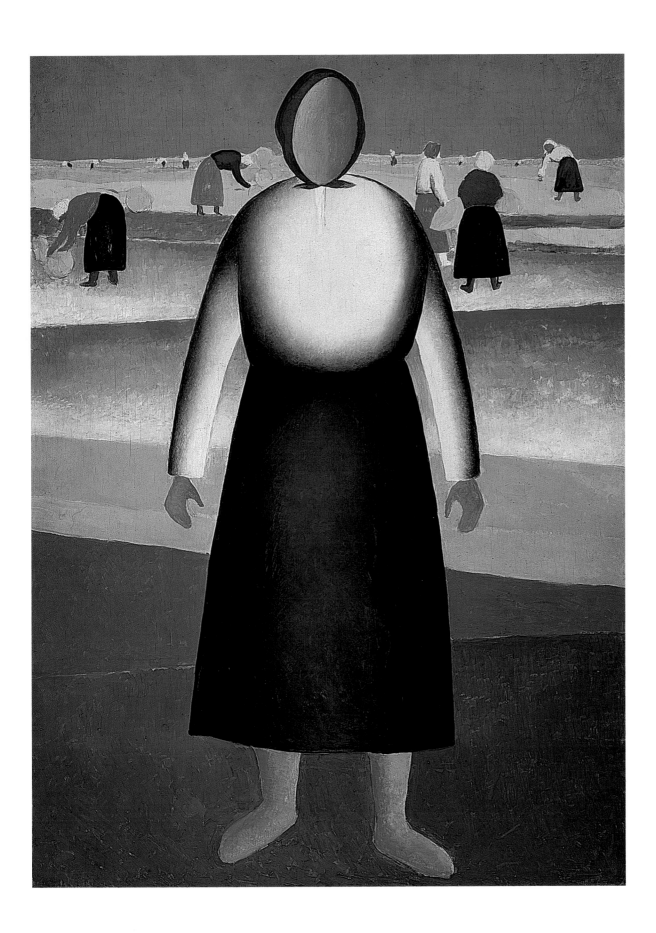

Kazimir **M**alevich
Reaping. Modello. 1928–29
Oil on plywood. 72.8 x 53.5 cm
Ж-9387

Like the images of peasants in which
the artist clothes his own thoughts
and feelings, the theme of peasant
labor permeates Malevich's entire
oeuvre. As the master himself wrote
in his autobiography: "I was fascinat-
ed by the life of the peasantry."
Transformed by the dying rays of the
setting sun, this scene of everyday
peasant life was entrenched in the
artist's memory from childhood. The
motif is constantly repeated in Male-
vich's works and constitutes an epi-
graph to his career. Like Gustave
Courbet, Malevich perceived aspects
of the eternal in everyday motifs. The
formal organization of the picture is
much influenced by the traditions of
Russian fresco painting, in keeping
with the essentializing aim of the
image. (O. S.)

David **B**urliuk
Portrait of the Futurist Poet
Vasily Kamensky. 1917
Oil on canvas. 104 x 104 cm
Ж-10133

Vasily Vasilyevich Kamensky (1884–1961) was a poet, writer, artist, and pioneer of Russian aviation. David Burliuk first met Kamensky in 1908 at the opening of the *Exhibition of Modern Trends in Art* in St. Petersburg. This meeting had important consequences for the history of Russian Futurism, as Kamensky then introduced David and Vladimir Burliuk to the artist and composer Mikhail Matiushin and his wife, Elena Guro, a poetess and artist. This meeting paved the

way for the first union of Russian Futurists, or *budetlyane*. Kamensky's poetic and artistic experiences coincided with the searches for new forms advocated by Burliuk, whose *Portrait of Vasily Kamensky* became the artist's pictorial manifesto. The image of the avant-garde poet is transformed into an "icon," and the inscription running along the "halo" translates as: "King of Poets Fighter-Bard Futurist Vasily Vasilyevich Kamensky 1917 Republic Russia." (*E. B.*)

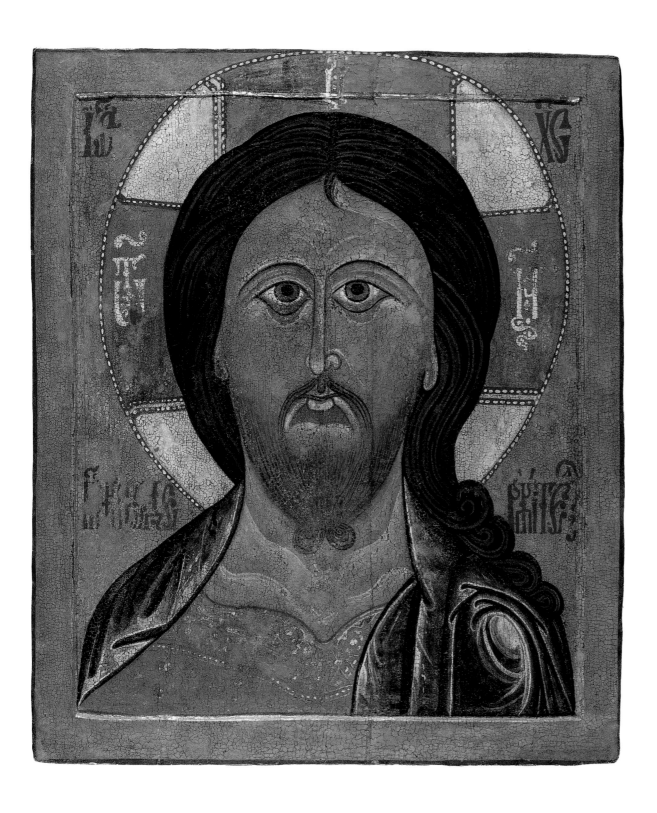

Christk the Almighty.
Last quarter of the 17th century
North Russia
Tempera on wood
89.2 x 76.5 x 3.5 cm
Origin: Church of the Intercession
of the Holy Virgin, Lyadiny,
Kargopole district, Archangelsk
ДРЖ-2974

The image of the Almighty (*Panto-crator*) is the main iconographic type of Christ in both Greek and Old Russian art. Icons with such representations appeared in Russia in the fourteenth century, accompanied by an inscription naming Christ as the King of Glory. The royal rank and austere pose of the judge, who will reappear before mankind on Judgment Day, are accentuated in the icon, which combines solemnity and austerity. The use of rich and bright tones in the halo and the branches of the cross — white, red, and blue — and the presence of imitation pearls (widely used in settings in northern Russia) betray a provincial icon painter. (*I. S.*)

Kazimir **M**alevich
Head of a Peasant. 1928–29
Oil on plywood. 69 x 55 cm
Ж-9473

Malevich often used the image of the peasant as a vehicle for the expression of his own thoughts and feelings. In particular, the theme of peasant labor recurs in Malevich's entire oeuvre. The artist regarded icons as a "form of high culture" offering an insight into the spiritual aspect of folk art. The composition and the format of the canvas are reminiscent of icons depicting saints. The solemn and austere face set against the red cross is a mystical insight into the artist's own tragic fate and the destruction of the Russian peasantry in the late 1920s. The landscapes painted in different styles — proceeding from Impressionism via Cubo-Futurism to Suprematism — represent the various stages in the artist's professional "ascent". The red Suprematist cross is Malevich's Golgotha. This image is the key to understanding the peasant theme in Malevich's oeuvre and the artist's own personal philosophy of the world. (*A. N.*)

Mikhail **L**arionov
Woman with a Flying Bird. 1913
Illustration to Alexei Kruchenykh and
Velimir Khlebnikov's *Worldbackwards*
Lithograph. Image: 17.8 x 13.4 cm;
sheet: 18.3 x 13.9 cm
Гр-41596

Mikhail **L**arionov
Reclining Nude. 1913
Illustration to Alexei Kruchenykh's
Half-Dead (Kuzmin and Dolinsky,
Moscow, 1913)
Lithograph. Image: 11 x 17.8 cm;
sheet: 15.3 x 20 cm.
Гр-42232

Mikhail **L**arionov
Illustrations to Alexei Kruchenykh
and Velimir Khlebnikov's
Worldbackwards. 1913. Lithographs

Akhmet
Image: 17.8 x 13.4 cm;
sheet: 18.5 x 14 cm
Гр-41594

Soldier Relaxing with a Pipe
Image: 13.2 x 15.8 cm;
sheet: 14.1 x 18.5 cm
Гр-41595

Akhmet is similar in style to *Ha[p]py
Autumn* (see p. 99). Many of Mikhail
Larionov's book illustrations of the
early 1910s are directly linked to his
Neo-Primitive canvases. This parody
of a poet looks more like a waiter and
appears to be a pastiche of petit-
bourgeois photographic portraits
and provincial signboards. (*N. S.*)

Mikhail **L**arionov
Fruit Peddler. Illustration to Alexei
Kruchenykh's *Pomade* (Kuzmin and
Dolinsky, Moscow, 1913)
Colored lithograph. Image:
8.4 x 6.2 cm; sheet: 8.7 x 6.9 cm
Гр-42224

Kruchenykh's *Pomade* was illustrated
by Mikhail Larionov and published
by Georgy Kuzmin and Sergei Dolin-
sky in Moscow in 1913. Larionov's
illustrations reflect the Futurist inter-
est in the traditions of folk art. Pages
of text alternate with lithographic
prints painted in watercolors. This
lends Larionov's illustrations a special
picturesqueness, similar to the first
Futurist collages. The Primitive period
in Mikhail Larionov's painting ended
around 1912/13, when the artist
began painting his first Rayonist can-
vases. *Pomade* contains a number of
compositions that approach these
abstract Rayonist compositions. (*N. S.*)

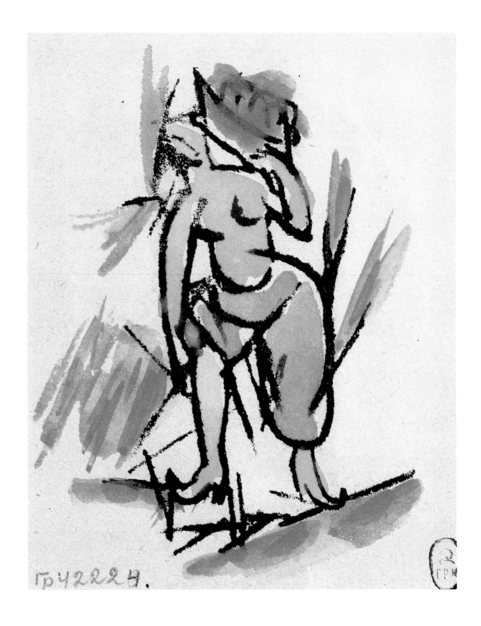

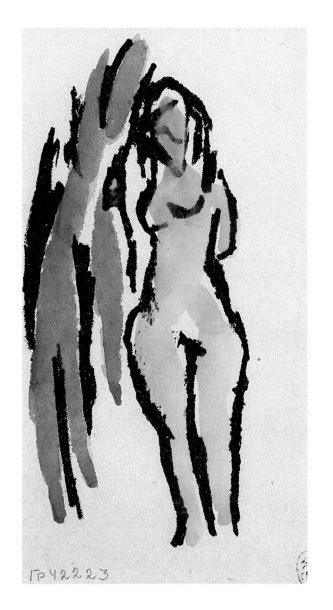

Гр 42223

Mikhail **L**arionov
Woman Bather
Illustration to Alexei Kruchenykh's
Pomade (Kuzmin and Dolinsky,
Moscow, 1913)
Colored lithograph. Image:
11.7 x 5.3 cm; sheet: 12.7 x 7 cm
Гр-42223

Mikhail **L**arionov
Person Walking
Illustration to Alexei Kruchenykh's
Half-Dead (Kuzmin and Dolinsky,
Moscow, 1913)
Lithograph. Image: 17.9 x 12.3 cm;
sheet: 18.6 x 15.7 cm
Гр-42233

Mikhail **L**arionov
Rayonist Portrait
Illustration to Alexei Kruchenykh's
Half-Dead (Kuzmin and Dolinsky,
Moscow, 1913)
Lithograph. Image: 17.5 x 13 cm;
sheet: 18.4 x 14.8 cm
Гр-42227

Mikhail **L**arionov
Three Coffinmakers. Illustration
to Alexei Kruchenykh and Velimir
Khlebnikov's *Worldbackwards*. 1913.
Lithograph. Image: 18 x 13.5 cm;
sheet: 18.2 x 15.5 cm
Гр-41593

Mikhail **L**arionov
Devil. Illustration to Alexei
Kruchenykh's *Half-Dead* (Kuzmin
and Dolinsky, Moscow, 1913)
Lithograph. Image: 18.2 x 11.7 cm;
sheet: 20.4 x 14.5 cm
Гр-42229

Published by Georgy Kuzmin and Ser-
gei Dolinsky in Moscow in 1913, Ale-
xei Kruchenykh's *Half-Dead* was illus-
trated by Mikhail Larionov. In the
1910s, the artist was developing a
new approach to abstraction that he
termed Realistic Rayonism. His litho-
graphic illustrations for Kruchenykh's
poem reflect these experiments. (*N. S.*)

Mikhail **L**arionov
Portrait of Natalia Goncharova
From a Series of Postcards Published
by Alexei Kruchenykh (1912)
Lithograph. Image: 11.6 x 9 cm;
sheet: 14 x 9.4 cm
Гр-41142

Mikhail **L**arionov
Portrait of the Poet
Alexei Kruchenykh
From a Series of Postcards Published
by Alexei Kruchenykh (1912)
Lithograph. Image: 14.2 x 9.5 cm;
sheet: 14.2 x 9.5 cm
Гр-41149

The other contributors to this series of postcards were Ivan Larionov, Natalia Goncharova, Alexander Shevchenko, Vladimir Tatlin, and Nikolai Rogovin. All the artists used the opportunity to make lithographic copies of their own pictures. *Head of a Soldier* is a version of Larionov's painting of the same name (1911, Krotoschin collection, Berlin), while *City* is based on *Tram* (1912, Mikhail Nesterov Museum, Ufa). Mikhail Larionov's work on the picture postcards coincided with the onset of his Rayonist period, and the paintings that served as the models for his postcards are reworked in this style. The compositions are constructed with the help of "power lines," sharpening the images and bringing out their inherent dynamism. (*O. V.*)

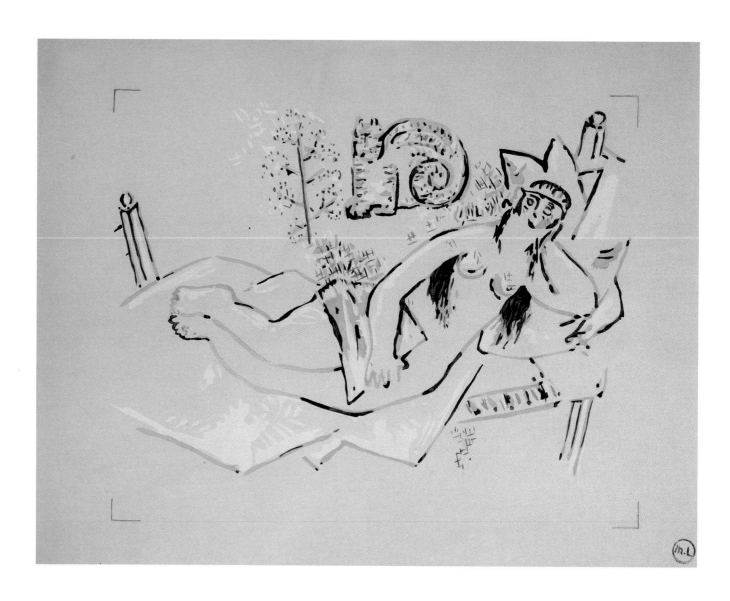

Mikhail **L**arionov
From the *Voyage en Turquie* Album.
Late 1920s

Katsap Venus
Gouache and stenciling on paper
20.5 x 26.7 cm
P-55651

Manya Kurva
Gouache and stenciling on paper
32.3 x 25 cm
P-55648

Published in the late 1920s, the *Voyage en Turquie* album consists of thirty-two works painted in gouache with the aid of a stencil, but nevertheless, these works still retain the liveliness and spontaneity of a sketch. The motifs and images of many of the gouaches are closely linked to Larionov's early Neo-Primitive period. *Katsap Venus* is a variation on the theme of a painting of the same name (1912, Nizhny Novgorod Mus. of Art) from the artist's *Venus* cycle. A similar composition was also included in the *16 Dessins M-e N. Gontcharoff et M. Larionoff* album of lithographs (1913). The coarsely drawn silhouette of the female figure in *Manya Kurva* is a direct quotation from *Soldier Relaxing* (1910–11, Tretyakov Gallery, Moscow), a painting from Larionov's *Soldier* series with a similar image depicted on a fence in the background. Although almost two decades had passed since these pictures first appeared, Larionov continued to uphold the avant-garde shock tactics of parodying the "eternal" themes of classical art. (*Y. S.*)

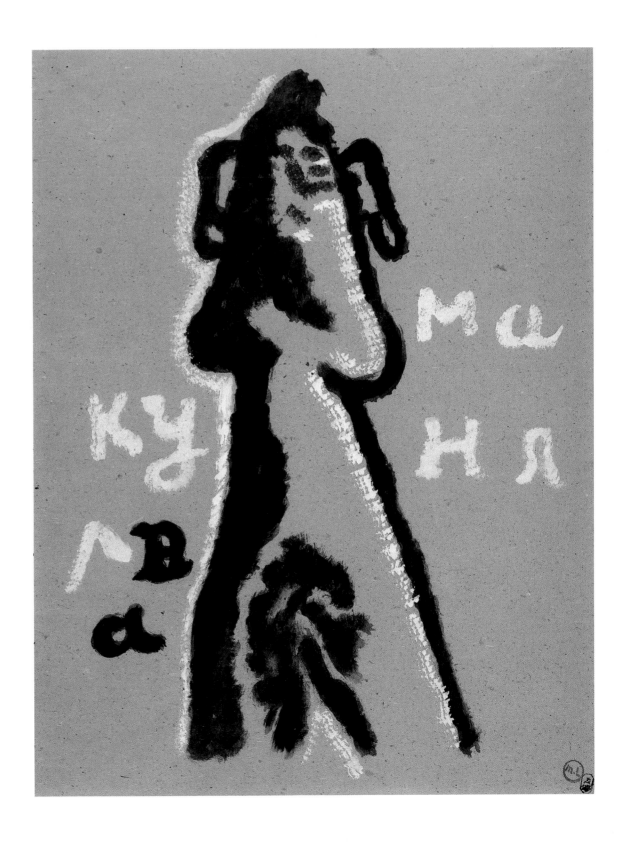

Olga **R**ozanova

Illustrations to Alexei Kruchenykh's
Duck's Nest of Bad Words (EUY,
St. Petersburg, 1913)
Colored lithographs

Illustration
Image: 16.1 x 10.7 cm;
sheet: 17.9 x 12.3 cm
Гр-41451

Two Figures
Image: 16.8 x 10.5 cm;
sheet: 17.5 x 11.7 cm
Гр-41450

Kruchenykh's *Duck's Nest of Bad Words* included a cover, eighteen sheets of illustrations, and a text lithographed by Rozanova. Some of the five hundred copies were hand painted by the artist. This collaborative effort is one of the first and most typical Futurist publications. Mechanical typesetting is secondary to the drawn and lithographed text. In their collection of miscellany entitled *Trap for Judges*, the Cubo-Futurists proclaimed handwriting "a component of the poetic impulse." Rozanova paints not just the illustrations, but also the pages of text, making each copy of the book unique. Embellishing the lithographic prints with watercolors, she creates a "color score for Alexei Kruchenykh's Futurist experiments in word creation." The whole book is subordinated to Rozanova's dynamic and expressive artistic manner and acute perception of color, line, and word. (*N. S.*)

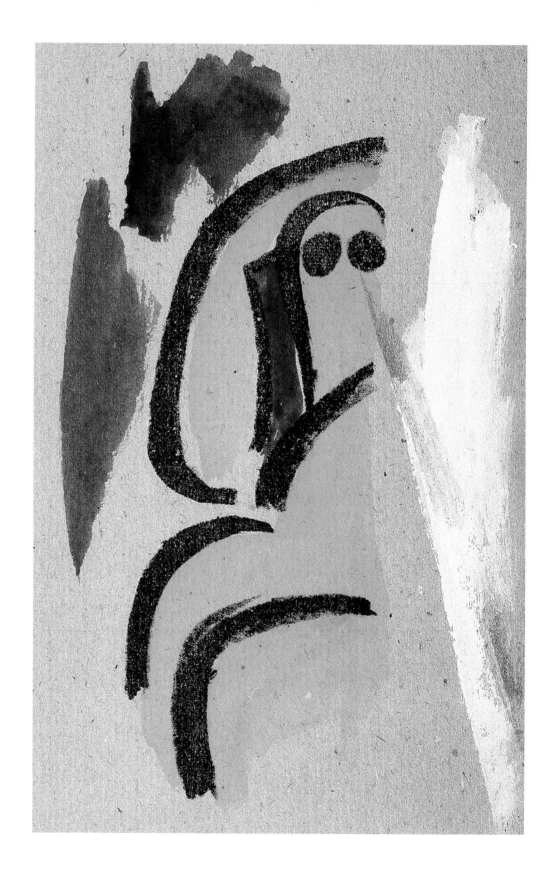

Natalia **G**oncharova
The Fairy. Illustration to Alexei Kruchenykh and Velimir Khlebnikov's *Worldbackwards* (Kuzmin and Dolinsky, Moscow, 1912)
Lithograph. 18 x 13.2 cm
Гр-41588

One of the first lithographic publications of the Russian Futurists, *Worldbackwards* was typical of their experiments in the early 1910s. Goncharova's cursory and seemingly amateurish technique in such lithographs as *Journey Round the Whole World (Savage Woman)*, *Journey Round the Whole World (People Walking)*, and *The Fairy* were firmly in keeping with the deliberate attempt of the Russian Futurists to create "homemade" lithographic compilations. Alexander Benois referred to such works as "silly little buffoonish albums." *Worldbackwards* included an excerpt from Velimir Khlebnikov's poem *The Fairy and the Wood Spirit*, which was based on motifs from Slavonic mythology. The "major shift" in Goncharova's lithograph of the same name is typical of many of her Futurist compositions. (*N. S.*)

Natalia **G**oncharova
Illustrations to Alexei Kruchenykh's *Hermits* (1913)
From *16 Dessins M-e N. Gontcharoff et M. Larionoff*
Lithographs

Hermit, Demon, and Angel
Image: 18.3 x 13.9 cm;
sheet: 18.5 x 14.3 cm
Гр-42241

Two Startsy
Image: 18.1 x 14.3 cm;
sheet: 18.2 x 14.4 cm
Гр-42236

Published in 1913, Alexei Kruchenykh's poem *Hermits* parodies the lives of Christian anchorites. Goncharova's fourteen lithographic illustrations are grotesque and dramatic, providing a nearly overwhelming graphic accompaniment to the seven pages of text. Goncharova's compositions dominate the book. Filling the whole sheet and satisfying works in their own right, each drawing does not so much illustrate as figuratively interpret the text, intensifying its impact. (*N. S.*)

Natalia **G**oncharova
St. Michael the Archistrategus
From *Mystical Images*
of the War (1914)
Lithograph. Image: 32.2 x 24.5 cm;
sheet: 32.7 x 24.7 cm
Гр-43164

See p. 215.

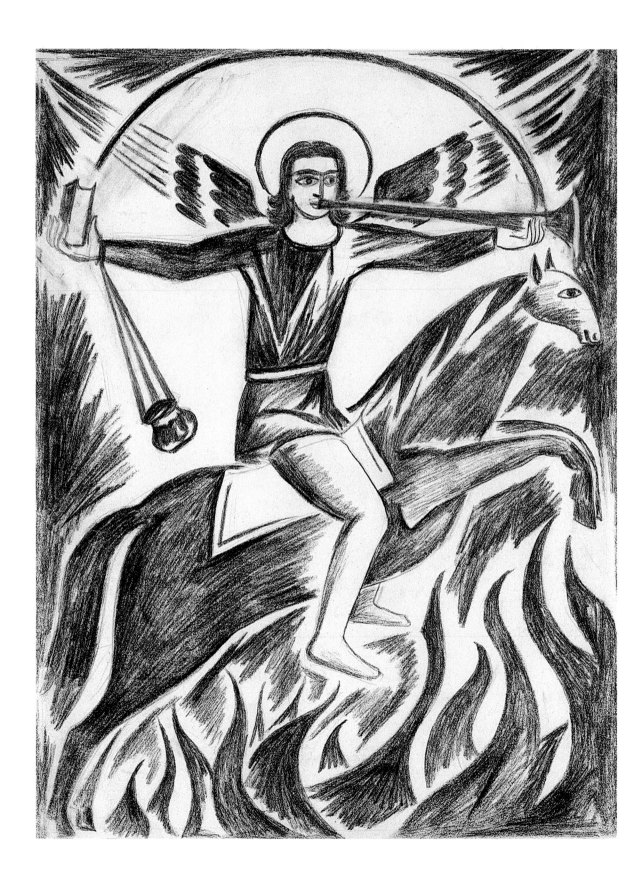

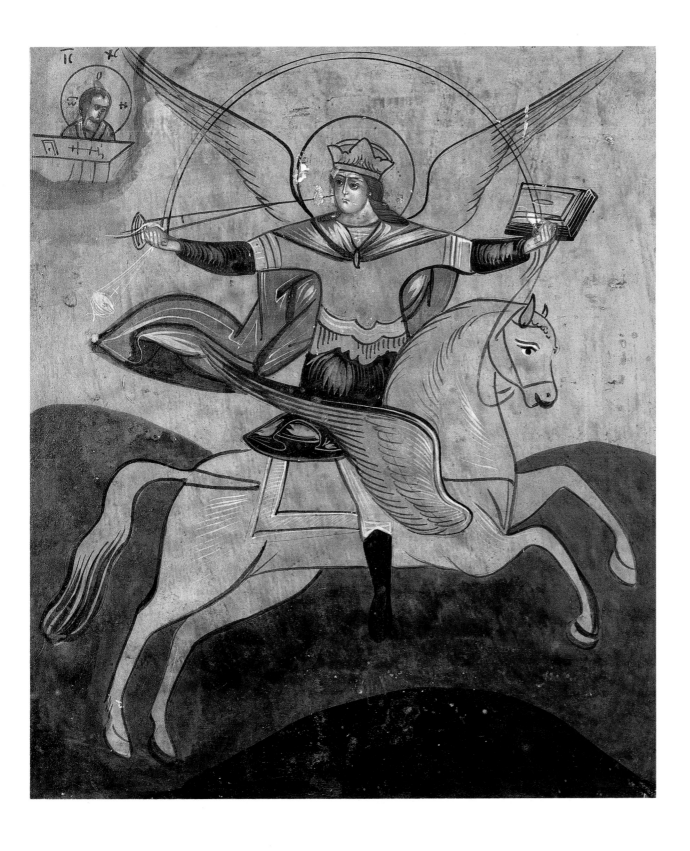

St. Michael the Archangel, Commander of Formidable Forces. Late 19th or early 20th century

Tempera on wood.

35.3 x 30.6 x 2.2 cm

B-1110

This icon is similar to the inexpensive, mass-produced works of art known as *krasnushki* ("pretty") icons. Distinguished by their predominant tones of brown-red or red-ochre, *krasnushki* could be found in virtually every home and church in Russia. Such icons were often painted with the knowledge that most of the image would be covered by a setting made of cheap metal or foil. This explains why the face is painted in more detail than the other parts of the icon; only the faces and hands would have been visible through the gaps in the foil. Although discovered in Archangelsk, in the far north of Russia, this icon may well have been painted in Mstiora. The image of the archangel with fiery wings, riding a fiery winged horse, and wielding the Gospels, a censor, and a trumpet is linked to the Book of Revelation. Such images were particularly popular among the Old Believers, members of a religious movement that arose in Russia in the mid-seventeenth century in opposition to Patriarch Nikon's reform of the church rituals and texts. Icons depicting the archangel Michael as the Angel of the Apocalypse or the Commander of Formidable Forces were popular in Russia from the seventeenth century onwards. St. Michael had, however, always played a pivotal role in the national consciousness of the Russian people. The archangel accompanied the human soul as it left the physical body and passed on its journey to the throne of the Maker. Images of St. Michael the Archangel were thus often endowed with the features not only of an archistrategus or celestial warrior, but the angel of death. (*I. Sn.*)

St. George and the Dragon

First half of the 16th century
Vologda

Tempera on wood. 95 x 60 x 3.5 cm
Origin: Church of St. Theodore the
Recruit, Berezhok, Vologda Province
ДРЖ-2750

St. George of Cappadocia was a sol-
dier of noble birth who was put to
death under Emperor Diocletian at
Nicomedia on 23 April 303 for pro-
testing against the emperor's perse-
cution of the Christians. St. George
was soon venerated throughout
Christendom as an example of brav-
ery in defense of the poor, the
defenseless, and the Christian faith.
Widely worshiped throughout Pales-
tine, Asia Minor, the Balkans, and Eur-
ope in the fifth century, St. George
was also the patron saint of the Byz-
antine emperors. When Russia ac-
cepted Christianity in 988, the wor-
ship of St. George spread to Kiev.
Churches of St. George were built
across Russia, and icons of the saint
were also popular. In the twelfth and
thirteenth centuries, icons of St. Ge-
orge tended to be majestic and mo-
numental images. In the fourteenth
century, Russian icon painters began
to paint works chronicling the life of
the saint. The most famous episode
from his life is his legendary slaying
of the dragon plaguing the city of
Selem. The blue background is a typ-
ical feature of icons from Vologda.
Thinly painted, the blue background
helps to bring out St. George's snow-
white charger — symbol of purity,
sanctity, and burning faith. (M. F.)

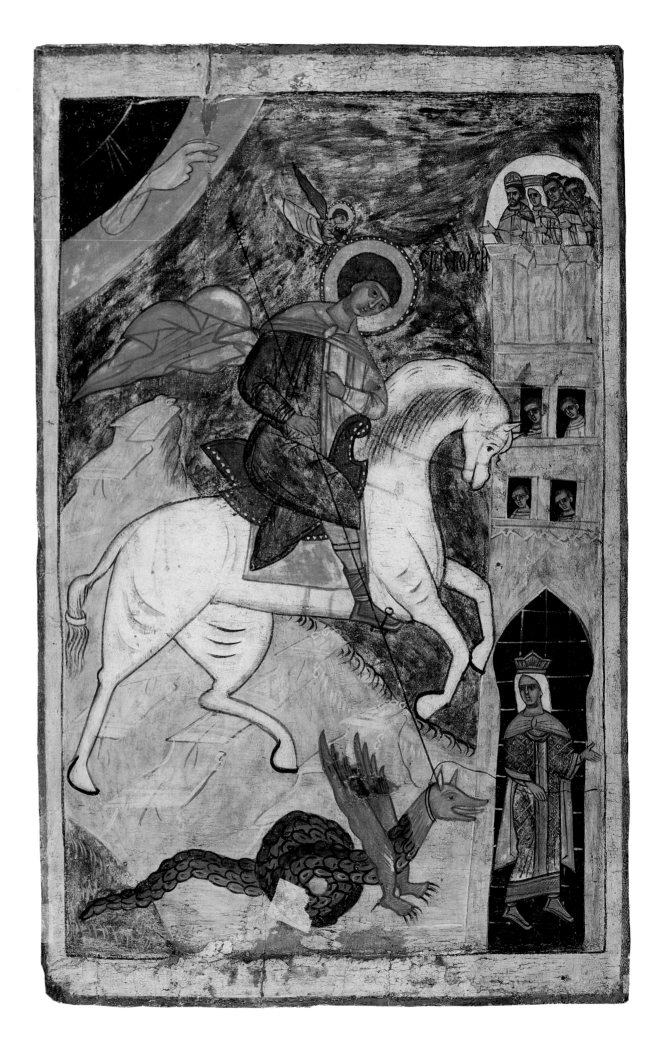

Natalia **G**oncharova
St. George
From *Mystical Images
of the War* (1914)
Lithograph. Image: 31.4 x 23 cm;
sheet: 32.2 x 24.8 cm
Гр-43158

See p. 215.

Natalia **G**oncharova
French Cockerel
From *Mystical Images
of the War* (1914)
Lithograph. Image: 31.7 x 23 cm;
sheet: 32.4 x 24.1 cm
Гр-43161

See p. 215.

Natalia **G**oncharova
British Lion
From *Mystical Images
of the War* (1914)
Lithograph. Image: 24.3 x 31.9 cm;
sheet: 24.7 x 32.8 cm
Гр-43160

See p. 215.

Design above the Entrance
to a Peasant House
Early 20th century
Sharnovo, Buisk district,
Kostroma Province
Paint on wood. 44.5 x 112 x 4 cm
P-3605

North Russian peasants decorated
both the interiors and the exteriors of
their houses. Lions were often carved
above the entrance to a peasant hut,
as they were believed to guard the
home and its inhabitants against evil
and misfortune. (*I. B.*)

Natalia **G**oncharova
The Pale Horse
From *Mystical Images
of the War* (1914)
Lithograph. Image: 32 x 24.3 cm;
sheet: 32.2 x 24.4 cm
Гр-43169

Natalia **G**oncharova
Vision
From *Mystical Images
of the War* (1914)
Lithograph. Image: 30.6 x 23.3 cm;
sheet: 32.8 x 24.7 cm
Гр-43165

Goncharova continued the tradition of the Russian Futurist "anti-book" with a series of large-scale engravings without text for an album entitled *Mystical Images of the War* (1914). Although the lithographs of the album do not represent a direct continuation of one another, the position of the sheets nevertheless creates a fresco-like cycle in the spirit of the artist's monumental Futurist canvases. *Angels and Aeroplanes*, *Doomed City*, *Most Pious Army*, and *Vision* are typical examples of Russian Futurist engravings, both in terms of their motif and the expressive manner of their execution. (*N. S.*)

Pavel Filonov
Illustrations for Velimir Khlebnikov's
A Night in Galicia
Lithograph

Idols
Image: 16.5 x 10.8 cm;
sheet: 19.3 x 14 cm
Гр-43415

Beast. Colophon
Image: 6.8 x 11.2 cm;
sheet: 19.4 x 14.3 cm
Гр-43419

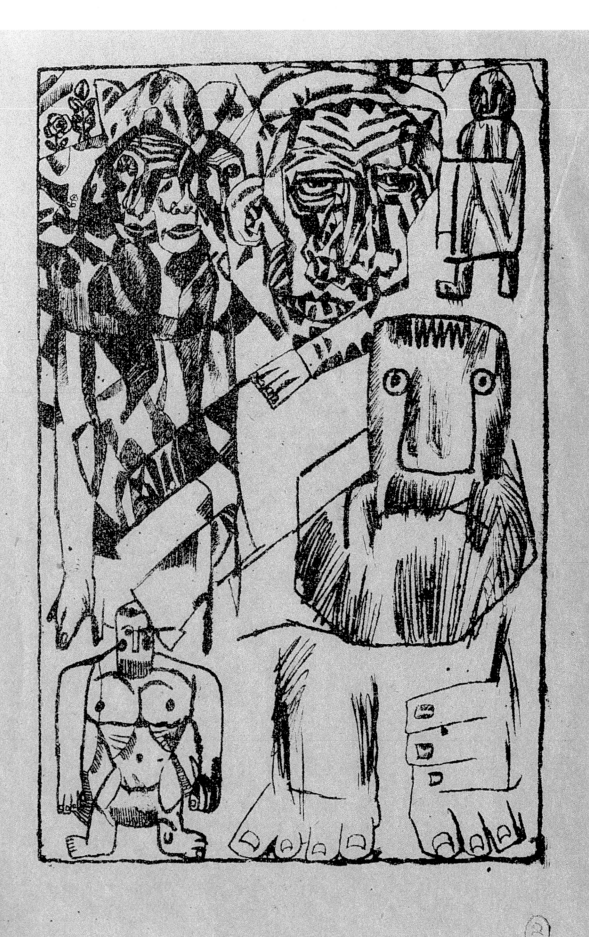

НАШ МЕЛЬКАЕТ ОБРАЗ ГРѢШЕН

ИНОГДА ГЛАЗА ПРОКОЛЕТ

НАМ РЫБАЧЬЯ ОСТРОГА

ДРУЧЕЙ НЕСЕТ И ХОПІТЪ

И НЕСЕТ СКВОЗЬ БЕРЕГА

ЛУСКАЙ КЪ ПНЮ ТОМУ ПРИЛЬНУЛА

ТУША БѢЛАЯ ОВЦЫ

И КЪ СВИРѢЛИ ПРОТЯНУЛА

ОБНАЖЕННЫЕ РѢЗЦЫ

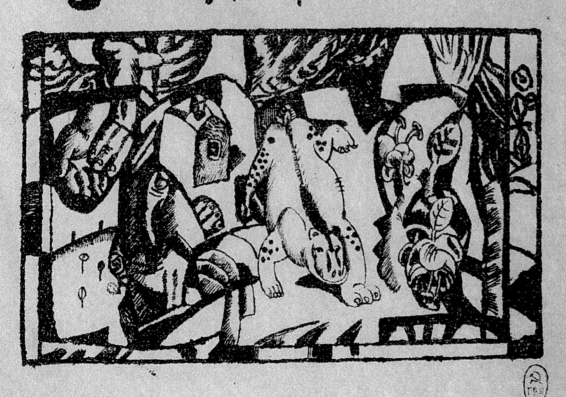

Filonov lithographed eleven illustrations and the texts of two of Velimir Khlebnikov's verses — *Perun* and *Night in Galicia* — for Khlebnikov's *Miscellany of Poems* (1914). The artist expresses Futurist anti-urbanist sentiments in his illustrations, dominated by Khlebnikov's "souls of beasts implanted in man…and animal towns built in the heart." The *Miscellany of Poems* represents a Futurist synthesis of the poetic and the graphic, consisting of signs and images similar to "ideograms." The individual letters become "Glagolitic" drawings incorporating entire concepts. "Sound writing" returns to its sources — pictographs and hieroglyphs. As Nikolai Burliuk wrote, "ideographic writing" is the prototype of the artist's creative method, combining two kinds of sensory experience — sound and vision — in the Futurist book. (*N. S.*)

Artist

BIOGRAPHIES

BRUNI, Lev Alexandrovich
1894, Malaya Vishera (near St. Petersburg)–
1948, Moscow

Painter, graphic artist, teacher. Studied at A. I. Titov and V. M. Schultz's studio in St. Petersburg (1904–9), Higher School of Art, Imperial Academy of Arts (1909–11), and the Académie Julien in Paris (1912). Contributed to the exhibitions: World of Art (1915), Jack of Diamonds (1917), Freedom for Art (1917), Makovets (1924–25), and the Four Arts (1925–26). Taught at the Free Art Studios (1920–30), Moscow Textile Institute (1930–31), and the Moscow Institute of Fine Arts (1931–38). Founder and head of the Studio of Monumental Painting (1935–48). (T. C.)

BURLIUK, David Davidovich
1882, Semirotovschina (Kharkiv Province)–
1967, Long Island (New York)

Painter, graphic artist, book illustrator, poet, art critic. Studied at the Kazan School of Art (1898–99), Odessa School of Art (1899–1900, 1910–11), Königliche Akademie in Munich (1902–3), Fernand Cormon's studio in Paris (1904), and the Moscow School of Painting, Sculpture, and Architecture (1911–14, expelled). Organized the Link exhibition in Kiev (1908) and the first Jack of Diamonds exhibition (1910). Participated to the exhibitions: Union of Russian Artists, Fellowship of South Russian Artists (1906–7), Union of Youth (1910–12), Der blaue Reiter (1912), and the Jack of Diamonds (1912–16). Lived in the Urals, Siberia (1917–19), Japan (1920–22), and the United States (1922–67). (E. B.)

DREVIN (Drevinsh),
Alexander (Rudolf-Alexander) Davidovich
1889, Wenden (Livland Province)–1938, Moscow

Painter, graphic artist. Studied under Vilhelms Purvits at the Riga School of Art. Contributed to exhibitions from 1911. Participated in the exhibitions: Green Flower (1913), World of Art (1922), Association of Extremist Innovators of Painting (1922), Moscow Painters (1925), Association of Artists of Revolutionary Russia (1926), Society of Moscow Artists (1928), and Thirteen (1931). Worked for IZO Narkompros (1918–20). Taught at the Free Art Studios/Higher Art and Technical Institute in Moscow (1920–30). (T. C.)

FILONOV, Pavel Nikolaevich
1883, Moscow–1941, Leningrad

Painter, graphic artist, theatrical designer, book illustrator, poet, art critic. Studied at painting studios in St. Petersburg (1897–1901), Lev Dmitriyev-Kavkazsky's school of painting and drawing (1903–8), School of Drawing, Society for the Encouragement of the Arts (1893–1901), and the Higher School of Art, Imperial Academy of Arts (1908–10, occasional student). Founding member of the Union of Youth (1910). Contributed to the exhibitions: Non-Party Society of Artists (1913), Union of Youth (1910–14), Community of Artists (1921–22). Founded the Made Pictures studio of painters and draftsmen (1914) and the Masters of Analytical Art group (1925–41). (O. S.)

GONCHAROVA, Natalia Sergeyevna
1881, Nagayevo (Tula Province)–1962, Paris

Painter, graphic artist, theatrical designer. Studied sculpture at the Moscow School of Painting, Sculpture, and Architecture (1901–9) and painting independently, enjoying the advice of Mikhail Larionov and attending Konstantin Korovin's studio. With Larionov organized the exhibitions: Jack of Diamonds (1910), Donkey's Tail (1912), Target (1913), and No. 4. Futurists, Rayonists, Primitive (1914). Contributed to the exhibitions: Golden Fleece (1908–10), Second Post-Impressionist Exhibition (1912), Der blaue Reiter (1912), and Erste deutsche Herbstsalon (1913). Joint exhibition with Larionov at the Galerie Paul Guillaume in Paris (1914),

introductory article to catalogue written by Guillaume Apollinaire. Illustrated and designed Futurist books. Designed for Sergei Diaghilev's Ballet Russes. Left Russia for Switzerland and then Italy to work for Diaghilev (1915). Settled in Paris (1919). (E. B.)

GRIGORIEV, Boris Dmitriyevich
1886, Moscow–1939, Can-sur-Mer (France)

Painter, draftsman. Studied under Dmitry Scherbinovsky at the Stroganov Central School of Art and Industry (1903–7) and under Alexander Kiselev and Nikolai Dubovsky at the Imperial Academy of Arts (1907–12). Contributed to the exhibitions: Impressionists (1909), Fellowship of Independents (1912–13), and the World of Art (1913, 1915–18, member from 1918). Emigrated (1919) and lived in Finland, Germany, and France. (A. N.)

KANDINSKY, Wassily (Vasily Vasilyevich)
1866, Moscow–1944, Neuilly-sur-Seine (France)

Painter, graphic artist, art theorist. Studied law at the Moscow University (1885–93) and art at Anton Ažbě's school in Munich (1896–97) and under Franz von Stuck at the Königliche Akademie in Munich (1900). Helped to found the Phalanx society (1901) and the Neue Künstlervereinigung in Munich (1909). Contributed to the exhibitions: Vladimir Izdebsky Salon (1909–11), Jack of Diamonds (1910, 1912), Salon des Indépendants (1905, 1908), Der blaue Reiter (1911–12, published the *Blaue Reiter* almanac with Franz Marc), and Der Sturm (1913). Member of IZO Narkompros (1918), director of the Museum of Painterly Culture in Moscow (1919–20). Lived in Germany (1921–33) and France (1933–44). (E. P.)

KONCHALOVSKY, Pyotr Petrovich
1876, Slavyansk (Kharkiv Province)–1956, Moscow

Painter. Studied at a school of drawing in Kharkiv, evening classes at the Stroganov School of Technical Drawing in Moscow, Académie Julien in Paris (1897–98), and the Higher School of Art, Imperial Academy of Arts (1898–1905). Attended classes in Konstantin Korovin's studio at the Moscow School of Painting, Sculpture, and Architecture (until 1909). Helped to organize the first Jack of Diamonds exhibition (1910). Contributed to the exhibitions: Jack of Diamonds (1912–17), Golden Fleece, Salon d'Automne (1908, 1910), Salon des Indépendants (1910–12), and the Moscow Fellowship of Artists (1911). Founding member of the Moscow Painters (1924–25). (E. B.)

KURDOV, Valentin Ivanovich
1905, Mikhailovskoe (Perm Province)–1989, Leningrad

Painter, graphic artist. Studied at the Perm Technical College of Art (1918–19), Perm Free Art Studios (1921), Sverdlovsk Institute of Art and Industry (1922), Higher Art and Technical Institute in Leningrad (1923–26), and under Kazimir Malevich at the Institute of Artistic Culture (1926–27). Contributed to exhibitions from 1932. Worked under Vladimir Lebedev at the State Publishing House. Helped to organize and design the posters of Fighting Pencil (1939). Worked at the experimental lithographic studio of the Leningrad branch of the Union of Artists (from 1939). (E. P.)

LARIONOV, Ivan Fyodorovich
1884, Tiraspole–1920

Brother of Mikhail Larionov, became an artist under his brother's direct influence. The artist's painting reflects features of Primitive and Naïve art. Did not receive a formal art education. Graduated from the Nautical College in Archangel and served in the Russian Navy. Studied painting independently. Contributed to the exhibitions: Vladimir Izdebsky Salon (1909–10, 1910–11), the Union of Youth (1910), and such shows organized by Mikhail Larionov as Donkey's Tail (1912) and Target (1913). (E. B.)

LARIONOV, Mikhail Fyodorovich
1881, Tiraspole–1964, Fontenay-aux-Roses (France)

Painter, graphic artist, book illustrator, theatrical designer. Studied under Isaac Levitan, Valentin Serov and Konstantin Korovin at the Moscow School of Painting, Sculpture, and Architecture (1898–1910, with intervals). Helped Sergei Diaghilev to organize the Russian section at the Salon d'Automne (1906) and held the first Jack of Diamonds exhibition (1910) and the exhibitions of Donkey's Tail (1912), Target (1913), and No. 4. Futurists, Rayonists, Primitive (1914). Contributed to the exhibitions: Union of Russian Artists (1906–7), Link (1908), Golden Fleece (1908–10), Union of Youth (1910–12), Der blaue Reiter (1912), and Erste deutsche Herbstsalon (1913). Joint exhibition with Goncharova at the Galerie Paul Guillaume in Paris (1914), introductory article to catalogue written by Guillaume Apollinaire. Created the theory of Rayonism, one of the first experiments in non-objective art. Co-author of the *Rayonists and Futurists* manifesto (1913). Designed for Sergei Diaghilev's Ballet Russes. Left Russia for Switzerland and then Italy to work for Diaghilev (1915). Settled in Paris (1919). (*E. P.*)

LEBEDEV, Vladimir Vasilyevich
1891, St. Petersburg–1967, Leningrad

Painter, graphic artist, book illustrator, poster and theatrical designer. Studied at A. I. Titov's studio in St. Petersburg (1909), under François Rouband at the battle-painting studio, Higher School of Art, Imperial Academy of Arts (1910–11), and at the Mikhail Bernstein and Leonid Sherwood School of Painting, Drawing, and Sculpture (1912–14). Occasional student of the Higher School of Art, Imperial Academy of Arts (1912–16, with interval). Contributed to exhibitions from 1909. Member of the Union of New Trends in Art (1921–22) and the Four Arts (from 1928). Taught at the Free Art Studios in Petrograd (1918–21). Headed the propaganda department of the Russian Telegraph Agency in Petrograd (1920–22) and the artistic editorial office of the Children's Publishing House in Leningrad (1924–33). Worked for TASS (1942–45), Military Publishing House, and the *Red Army Man* magazine in Moscow. Collaborated with the *Satiricon* and *Argus* magazines. (*O. S.*)

LENTULOV, Aristarkh Vasilyevich
1882, Vorona (Penza Province)–1943, Moscow

Painter, theatrical designer. Studied at the Nikolai Seliverstov School of Art in Penza (1888–1900, 1905), Kiev School of Art (1900–5), and Dmitry Kardovsky's studio in St. Petersburg (1906–7). Worked independently at Henri le Fauconnier's studio in Paris (1911). Member of the Jack of Diamonds (from 1910), Association of Artists of Revolutionary Russia (1926–27), and the Society of Moscow Artists (1928–29). Contributed to the exhibitions: Wreath (1907), Link (1908), Wreath/Stephanos (1908), Union of Russian Artists (1908), and the World of Art (1911, 1912). Headed the theatrical design studios at the First Free Art Studios (1919) and the department of theatrical design at the Higher Art and Technical Studios (1920). Taught at the department for raising theatrical designers' qualifications at the Institute of Fine Arts in Moscow (1932). (*O. S.*)

MALEVICH, Kazimir Severinovich
1878, Kiev–1935, Leningrad

Painter, graphic artist, art theorist. Studied at the Kiev School of Art (1895–96) and Fyodor Roehrberg's studio in Moscow (1905–10). Contributed to the exhibitions: Moscow Fellowship of Artists (1911), Jack of Diamonds (1910–11, 1914, 1917), Donkey's Tail (1912), Target (1913), Union of Youth (1912–14), Tramcar V. First Futurist Exhibition (1915), 0.10. Last Futurist Exhibition (1915–16), and Store (1916). Worked for IZO Narkompros (1918–19). Lecturer and director of the Vitebsk School of Art (1919–22). Founded the UNOVIS group (1920). Director of the Museum/ Institute of Artistic Culture in Petrograd/Leningrad (1923–26). Taught at the Kiev Institute of Art (1929–30) and the House of Arts in Leningrad (1930). (*O. S.*)

MALYAVIN, Philipp Andreyevich
1869, Kazanki (Samara Province)–1940, Nice (France)

Painter, draftsman. Studied under Ilya Repin at the Imperial Academy of Arts (1892–99). Academician of painting (1906). Contributed to exhibitions from 1895. Contributed to the exhibitions: World of Art (1899–1903), Union of Russian Artists (1903–23), Salon d'Automne (1923, 1924), Exposition Universelle (1900, gold medal), and the International Exhibitions in Venice (1901, 1907, 1926, 1928) and Rome (1911). (*G. K.*)

MASHKOV, Ilya Ivanovich
1881, Mikhailovskaya (Saratov Province)–1944, Moscow

Painter. Studied at the Moscow School of Painting, Sculpture, and Architecture (1900–4, 1907–8). Contributed to exhibitions from 1909. Founding member and secretary of the Jack of Diamonds (1910–14). Contributed to the exhibitions: World of Art (from 1916), Moscow Painters (from 1925), Association of Artists of Revolutionary Russia (1925–30, 1932), and the Society of Moscow Painters (1928). Founded and headed an art studio in Moscow. Taught at the Higher Art and Technical Studios/Institute in Moscow (1920–29). (*E. B.*)

PAKHOMOV, Alexei Fyodorovich
1900, Varlamovo (Vologda Province)–1973, Leningrad

Painter, graphic artist. Studied at the Baron Stieglitz Central School of Technical Drawing (1915–17, 1920–22) and the Academy of Arts/Higher Art and Technical Institute (1922–25). Contributed to exhibitions from 1922. Member of the Association of New Trends in Art (1921–22) and founding member of the Circle of Artists (1926–32). Worked for the children's department of the State Publishing House (from 1925) and the *Hedgehog* magazine for children (1929–35). Taught at the Leningrad Institute of Painting, Sculpture and Architecture (1948–73). (*O. S.*)

PAKULIN, Vyacheslav Vladimirovich
1900, Rybinsk–1951, Leningrad

Painter, graphic artist, theatrical designer. Studied under Alexei Karev and Vladimir Lebedev at the Baron Stieglitz Central School of Technical Drawing (1916–17, 1919 (?), 1920–22) and under Alexei Karev and Alexei Savinov at the Higher Art and Technical Institute (1922–25). Attended Vsevolod Meyerhold's master-classes on stage production (1918). Contributed to exhibitions from 1922. Member and contributor to the exhibitions of the Union of New Trends (1922) and the Circle of Artists (1926–32, founding member and chairman). Worked as a designer at the Decorative Institute (from 1922). (*O. S.*)

PALMOV, Victor Nikandrovich
1888, Samara–1929, Kiev

Painter, graphic artist. Studied at the Moscow School of Painting, Sculpture, and Architecture (1911–14). Contributed to exhibitions from 1919. Member and contributor to the exhibitions: Green Cat and Creativity in Chita (1919–23), Call in Zagorsk (1924), Association of Artists of Chervonnaya Ukraine (1929), and the Association of Independent Artists of the Ukraine (1932). Worked for the *LEF* magazine of Constructivists in Moscow (1923–24). Taught alongside Malevich, Tatlin, and Bogomazov at the Academy of Arts in Kiev (1925–29). (*O. S.*)

PETROV-VODKIN, Kuzma Sergeyevich
1878, Khalynsk (Saratov Province)–1939, Leningrad

Painter, graphic artist, theatrical designer, art critic. Studied at Fyodor Burtsev's school of painting and drawing in Samara (1894–95), Baron Stieglitz Central School of Technical Drawing (1895–97), under Abram

Arkhipov, Nikolai Kasatkin and Valentin Serov at the Moscow School of Painting, Sculpture, and Architecture (1897–1904), at Anton Ažbè's school in Munich (1901), and private studios in Paris (1905–8). Contributed to the exhibitions: Golden Fleece (1908), Union of Russian Artists (1909–10), and Fire-Color (1924). Member of the World of Art (from 1910) and Four Arts (1925–28). Taught at the Elizaveta Zvantseva School of Painting and Drawing in St. Petersburg (from 1910) and the Higher School of Art, Academy of Arts (1918–32). (G. K.)

POUGNY, Jean (Puni, Ivan Albertovich)
1894, Kuokkala–1956, Paris

Painter, graphic artist, theatrical designer, book illustrator, art critic. Studied at the Military Academy in St. Petersburg (1900–8). Visited Italy and France and studied at the Académie Julien in Paris (1910–12). Contributed to the exhibitions: Union of Youth (1912–13), Salon des Indépendants (1913, 1914), Jack of Diamonds (1916, 1917), and the Four Arts (1928). Helped to organize the Tramcar V. First Futurist Exhibition (1915) and 0.10. Last Futurist Exhibition (1915–16). Taught at the Free Art-Academic Studios in Petrograd (1918) and under Marc Chagall at the Vitebsk School of Art (1919). (E. B.)

ROERICH, Nicholas (Nikolai Konstantinovich)
1874, St. Petersburg–1947, Naggar (India)

Painter, graphic artist, theatrical designer. Graduated from the St. Petersburg University (1898). Studied under Arkhip Kuindzhi at the Higher School of Arts, Imperial Academy of Arts (1893–97) and at Fernand Cormon's studio in Paris (1900–1). Academician of painting (1909). Member of the Union of Russian Artists (1903) and the World of Art (1910), life member of the Salon d'Automne (1906). Contributed to exhibitions from 1899. Director of the School of Drawing, Society for the Encouragement of the Arts (1906–16). Designed for theatres in Moscow and St. Petersburg and Sergei Diaghilev's Ballets Russes (from 1907). Emigrated (1918). Collaborated with his wife Helena on his main theoretical work *Agni Yoga: The Teaching of Living Ethics* (1920s). Initiated the Roerich Pact, an international agreement for the protection of art in wartime. Painted works on themes from the history of northern Europe, folklore, and religious mythology. (G. K.)

ROZANOVA, Olga Vladimirovna
1886, Melenki (Vladimir Province)–1918, Moscow

Painter, graphic artist, designer of Futurist books, art critic. Studied at the Stroganov Central School of Technical Drawing in Moscow (1904–10) and the Elizaveta Zvantseva School of Painting and Drawing in St. Petersburg (1911). Contributed to the exhibitions: the Union of Youth (1911–14), Espozizione Libera Futurista Internazionale (1914), Tramcar V. First Futurist Exhibition (1915), 0.10. Last Futurist Exhibition (1915–16), Store (1916), and Jack of Diamonds (1916, 1917). Member of the Supremus group (1916). Joined IZO Narkompros and Proletcult, headed the applied art subsection (1918). (E. B.)

SHEVCHENKO, Alexander Vasilyevich
1883, Kharkiv–1948, Moscow

Painter, graphic artist. Studied under Konstantin Korovin and Mikhail Vrubel at the Stroganov Central School of Technical Drawing in Moscow (1898–1907) and under Valentin Serov and Konstantin Korovin at the Moscow School of Painting, Sculpture, and Architecture (1907–10, expelled). Worked at Eugène Carrière's studio and the Académie Julien in Paris

(1905–6). Contributed to the exhibitions: Donkey's Tail (1912), Union of Youth (1912), Target (1913), No. 4. Futurists, Rayonists, Primitive (1914), World of Art (1913, 1917–21), Makovets (1921–25), Shop Floor of Painters (1926–30), and the Society of Moscow Artists (1932). Taught at the First Free Art Studios (1918–20), Higher Art and Technical Studios/Institute (1920–29), Central School of Art and Industry, and the Moscow Textile Institute (1940–42). (O. S.)

SHKOLNIK, Josif Solomonovich
1883, Balta (Ukraine)–1926, Leningrad

Painter, theatrical designer. Graduated from the Odessa School of Art (1905) and studied at the Imperial Academy of Arts, St. Petersburg (1905–7). Exhibited with the Triangle group (1909). Organizer and active member of the Union of Youth (1910–14), secretary and editor of a number of its publications. Helped to design the sets for *Vladimir Mayakovsky: A Tragedy* (1913). Member of IZO Narkompros (1918), headed its theatrical-decorative section, later transformed into the Decorative Institute (1920). Professor and head of the decoration class at the Free Art Studios in Petrograd (1919–26). (E. B.)

SHTERENBERG, David Petrovich
1881, Zhitomir–1948, Moscow

Painter, graphic artist, theatrical designer. Studied at a private studio in Odessa (1905) and the Académie Vitti in Paris (1905–12). Contributed to the Salon de Printemps and Salon d'Automne (1912–17). Commissar for Fine Art in Petrograd (1917–18). Taught at the Higher Art and Technical Studios/Institute (1920–30). Exhibited with Nathan Altman and Marc Chagall in Moscow (1922). Member of the Four Arts (1924). Founding member and chairman of the Society of Easel Artists (1925–30). (E. B.)

TATLIN, Vladimir Yevgrafovich
1885, Moscow–1953, Moscow

Painter, graphic artist, theatrical designer, monumentalist, designer of architectural and engineering projects. Studied at the Penza School of Art (1904–10) and under Valentin Serov and Konstantin Korovin at the Moscow School of Painting, Sculpture, and Architecture (1902–3, 1909–10). Visited Berlin and Paris (1913). Contributed to the exhibitions: Donkey's Tail (1912), Jack of Diamonds (1913), Union of Youth (1911–14), Tramcar V. First Futurist Exhibition (1915), 0.10. Last Futurist Exhibition (1915), and Store (1916). Member of the Association of New Trends in Art (1921–23). Chairman of the Left Federation of Artists in Moscow (1917), head of the Moscow committee of IZO Narkompros (1918–19). Active initiator of the creation of the Museum of Painterly Culture, Museum of Artistic Culture and the Institute of Artistic Culture. Headed the department of material culture at the Institute of Artistic Culture. Taught in Petrograd, Kiev, and Moscow. Headed a Narkompros experimental laboratory (1929–32). (E. B.)

VASNETSOV, Yury Alexeyevich
1900, Vyatka–1973, Leningrad

Painter, graphic artist, children's book illustrator, theatrical designer, applied artist. Studied under A. I. Stolbov in Vyatka (1910s), at the Free Art-Academic Studios in Petrograd (1921–26), Institute of Artistic Culture (1926), Kazimir Malevich's studio (1927–28), and the Institute of Painting, Sculpture, and Architecture (1932–34). Contributed to exhibitions from 1932. Member of the Union of Artists (1932). Head artist at the Toy Institute in Zagorsk (1943–45). People's Artist of Russia (1966). (A. N.)

INDEX OF ARTISTS

Bruni, Lev *149*
Burliuk, David *18, 27, 38–40, 50,* ***138, 140,*** *174,* ***190***

Drevin Alexander ***155, 156***

Filonov, Pavel *19, 29, 30–32, 35–37,* ***142, 144, 146, 216, 217***

Goncharova, Natalia *7, 12–16, 18, 22, 24, 27–29, 32–34, 36–41, 49, 50, 52, 54, 60, 66,* ***80, 82, 84, 86, 88, 89, 91,*** *200, 201,* ***206, 208, 211, 212, 214, 215***
Grigoriev Boris ***158, 159***

Kandinsky, Wassily *7, 11, 12, 28, 30, 33, 34, 37, 47, 50, 65, 66,* ***74, 134, 160, 163***
Konchalovsky, Pyotr *7, 16, 103,* ***112, 115, 119***
Kurdov, Valentin ***180***

Larionov, Ivan *13,* ***70, 201***
Larionov, Mikhail *7, 12–16, 18, 23, 27–30, 33, 34, 38–41, 48, 50, 51, 53, 57, 60, 66,* ***92, 94, 97, 98, 100, 194–198,*** *200,* ***202, 203***
Lebedev, Vladimir *22,* ***172, 179***
Lentulov, Aristarkh *7, 16, 18, 29, 37, 40,* ***109, 110***

Malevich, Kazimir *7, 12, 13, 20–22, 27, 29, 32, 33, 35, 37–40, 50, 53, 57, 61, 66,* ***148,*** *180,* ***189, 192***
Malyavin, Philipp *10, 11, 32,* ***77, 78***
Mashkov, Ilya *16, 18, 37, 40,* ***103, 104, 106, 117***

Pakhomov, Alexei *22,* ***185***
Pakulin, Vyacheslav *22,* ***186***
Palmov, Viktor ***174***
Petrov-Vodkin, Kuzma *19, 20,* ***151, 153***
Pougny, Jean ***166***

Roerich, Nicholas *10–13, 32,* ***72, 73***
Rozanova, Olga *12, 18, 19,* ***128, 130, 132, 204***

Shevchenko, Alexander *29, 32–34, 40, 47, 48, 52, 66,* ***164,*** *201*
Shkolnik, Josif ***120, 123, 125, 126***
Shterenberg, David *7, 22,* ***168, 171, 177***

Tatlin, Vladimir *19, 20, 29, 32, 33, 40,* ***137, 138,*** *201*

Vasnetsov, Yury *22,* ***181, 183***

ISBN 0-911886-56-7

© 2003, State Russian Museum
© 2003, Trustees of the Walters Art Gallery
© 2003, Palace Editions

Internet: www.rusmuseum.ru
E-mail: info@rusmuseum.ru

Printed in Italy by
GraficArt s.n.c. - Formia (LT)

Distributed by Antique Collectors' Club (USA)
Wappingers Falls, NY 12590
Telephone: (845) 297-0003
www.antique-acc.com